CHURCHES
OF
ROME

CHURCHES OF ROME

Text by
Pierre Grimal

Photography by
Caroline Rose

THE VENDOME PRESS

TO CHRISTINE AND LAURENCE

First published as Églises de Rome
by Imprimerie Nationale
27, rue de la Convention
F-75732 Paris Cedex 15
France

Published in the USA in 1997 by
The Vendome Press
1370 Avenue of the Americas
New York, NY 10019

Distributed in the USA and Canada by
Rizzoli International Publications
through St. Martin's Press
175 Fifth Avenue
New York, NY 10010

Library of Congress Cataloging-in-Publication Data
Grimal, Pierre, 1912–
Churches of Rome / text by Pierre Grimal ; photographs by Caroline Rose.
p. cm.
Includes bibliographical references.
ISBN 0-86565-990-7
1. Catholic church buildings—Italy—Rome. 2. Rome (Italy)—
Buildings, structures, etc. I. Rose, Caroline. II. Title.
NA5620.A1G75 1997 97-11934
726.6'0945'632—dc21 CIP

Translated by Edmund Jephcott
Design and layout: Hélène Lévi
Maps: Els Baekelandt
Headings by Frank Jalleau

Color separation and printing by Imprimerie Nationale

CONTENTS

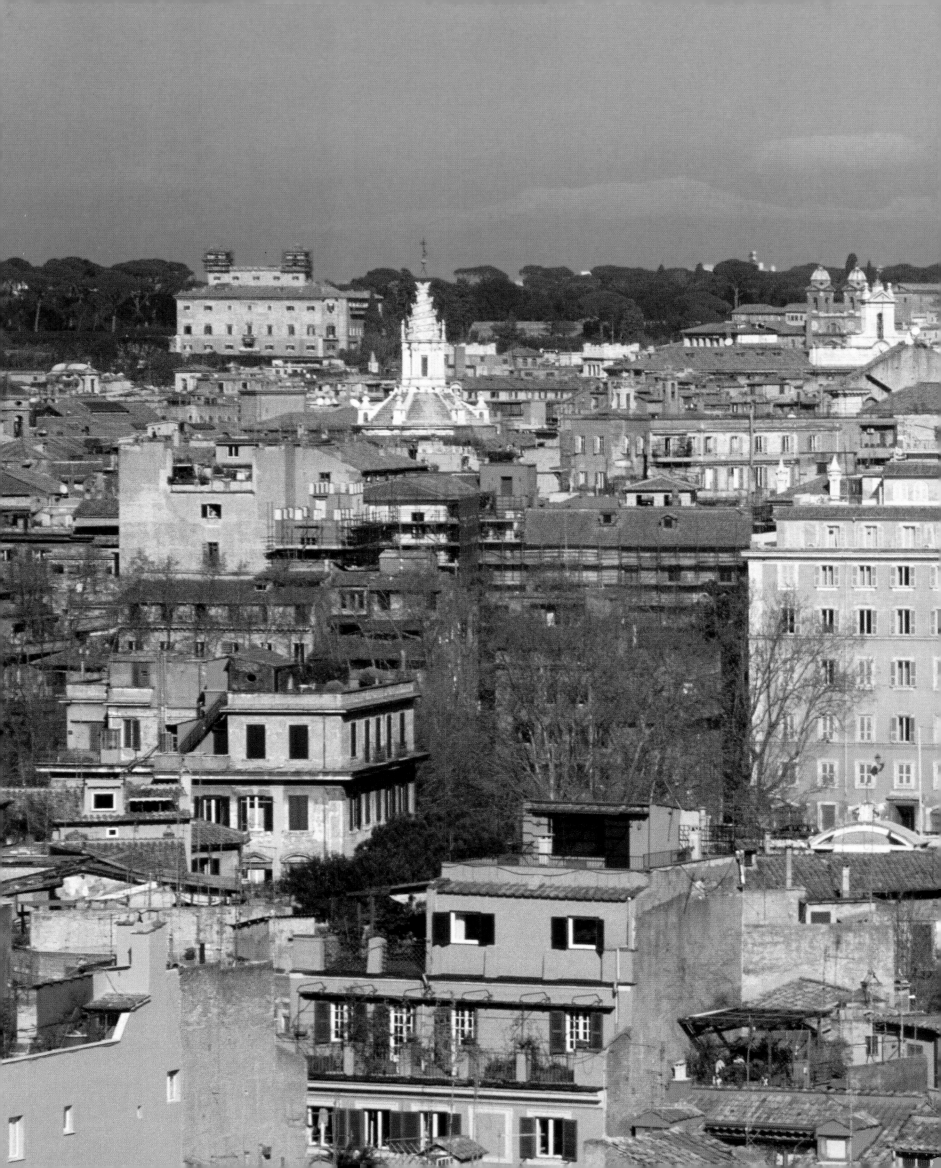

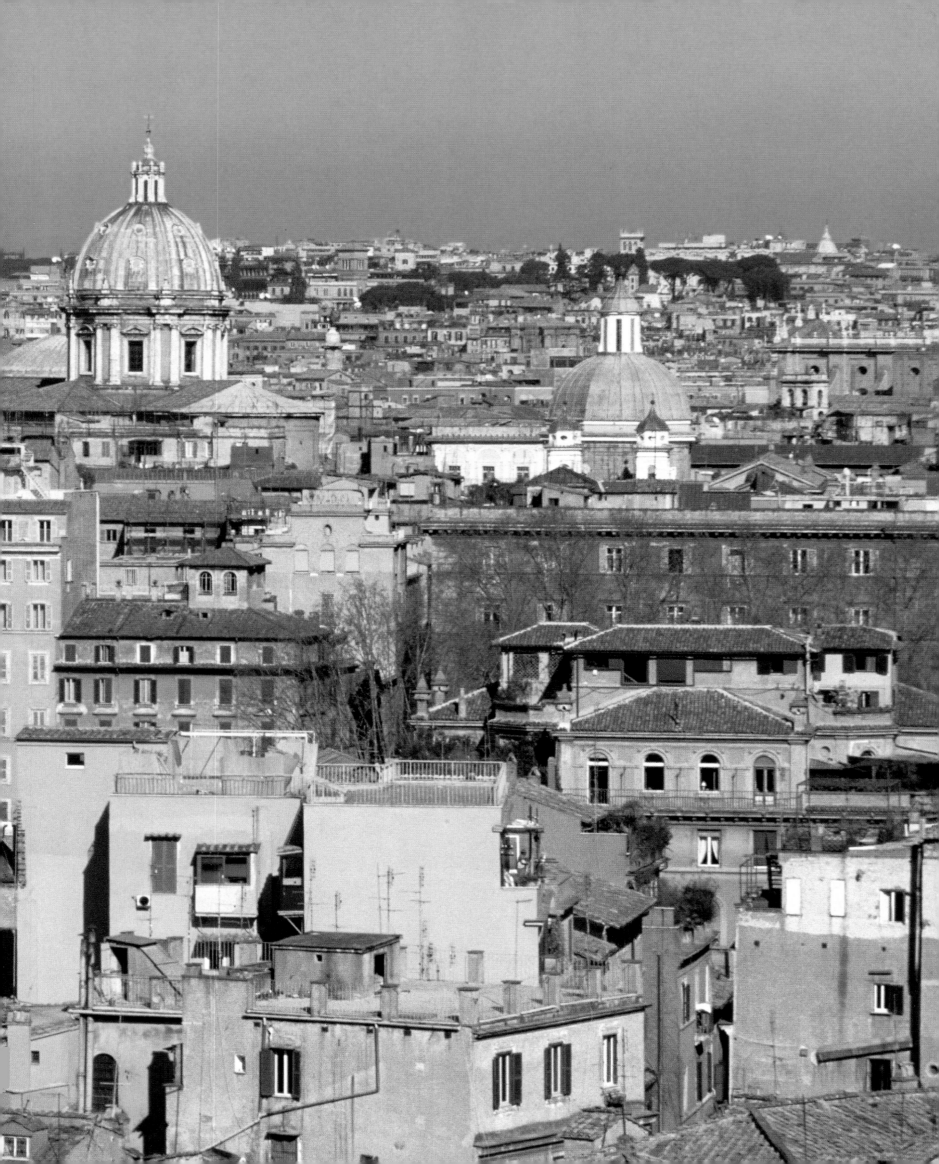

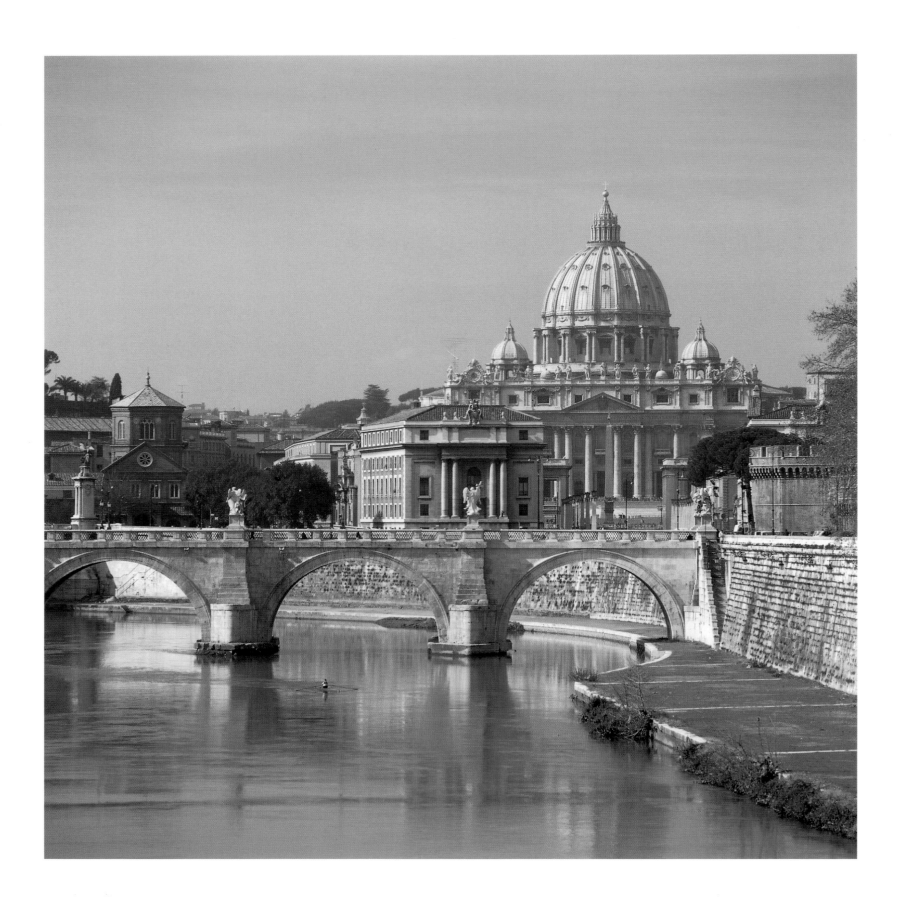

Surely it would surprise few to learn that Rome boasts more churches than any other city in the world. Today the ancient soil supports over two hundred Christian houses of worship. Many of them rest on the sites or foundations of earlier churches. Yet even those with their original walls intact have frequently undergone major alteration, affecting not only interiors but also structure, décor, and purpose. Some were built to accommodate large congregations; others are like private oratories more than places open to all comers. Some belong to monasteries, whereas others open their doors to pilgrims from every part of the globe. All bear witness to the fact that, despite schism, Reformation, and Counter-Reformation, Rome remains the capital of Christianity.

The Rome that lived through all this history is the Imperial City, which saw itself as the rightful master of the universe. The same sense of purpose drives Christian Rome, the city of the great basilicas erected after the Emperor Constantine converted to Christianity in the early fourth century A.D. At the same time, however, other churches came into being, intimate places that proved more suited to the communion of souls with the Almighty. They were often built over the tombs of martyrs whose intercession the faithful sought in their prayers for divine grace. The multiplication of sanctuaries reflected the spiritual riches offered by the new religion, imported from Palestine at a time when the successors to Augustus ruled the known world.

It is not within the scope of the present volume to account for or catalog every last church in Rome. Rather than a complete history and chronology of Rome's Christian monuments, the book serves as a collection of memories, memories that, by their very nature, cannot escape being somewhat arbitrary. Indeed, they well up here and there in

PAGES 6–7: Rome and the domes of its churches

The basilica of Saint Peter's

both time and space. Yet however personal, reminiscences must be ordered in some way if they are to have meaning for others. And herein lies the challenge. Should we organize exploratory "walks"? Needless to say, itineraries, which approach the buildings one after the other as they appear along the street, are useful to those actually visiting Rome, but the order thus established is no more than an artifice. It precludes the discovery of other paths, deeper ways into the subject, like that of the spirit that animates the world of Roman churches, explaining its formation. This means falling back on time as the ordering principle, even while taking account of the fact that, as noted earlier, none of the churches belongs to a single period. Like all living things, they are, every one of them, engaged in the process of becoming. Some have been struck by terrible catastrophe. Inevitably, owing to the ravages of ages, they have often been rebuilt, renovated, and brought into line with new styles and tastes. More subtly, the buildings have had to serve the needs of changing spirituality, or of society itself, right along with changes in the world outside. There were, of course, the schisms, the most serious of which—the division of the Eastern and Western Churches—has left very deep traces. Also playing a major role were the various heresies. The architecture and painting of Catholic Rome, for example, are no longer what they were before the Council of Trent (1545–1563), which launched the Counter-Reformation. In its outward manifestations, the Christian faith is not a monolithic and immutable moment. Doctrine, of course, remains constant, but the means and manners of perceiving it alter along with the rhythm of life itself.

It is precisely the history of these privileged moments, of that continuous rediscovery of Christian spirituality, that we have attempted to trace here, taking churches as our witnesses and our guides. Such a history is indissolubly bound up with that of Rome itself. It begins before the conversion of the Imperial City, which then inflected or transfigured what had existed earlier but in no way nullified it. The history evolved from century to century, like an ongoing creation, down to our day.

House of the Faithful and Basilica of God

Our story begins with a question: What do we mean by the word "church"? For us, it does not so much designate a particular, physical monument as evoke the entire body of the faithful, living or dead. In other words, "church" signifies all those who participate in the City of God, just as in a Greek city, where *ecclesia* meant the assembly of everyone

Altar of the *mithraeum* in the second basement of the basilica of San Clemente. Relief of Mithra cutting the bull's throat. On the left is one of the two protective spirits, Cautes and Cautopathes; with torch raised or lowered, these two were images of day and night or sun and moon.

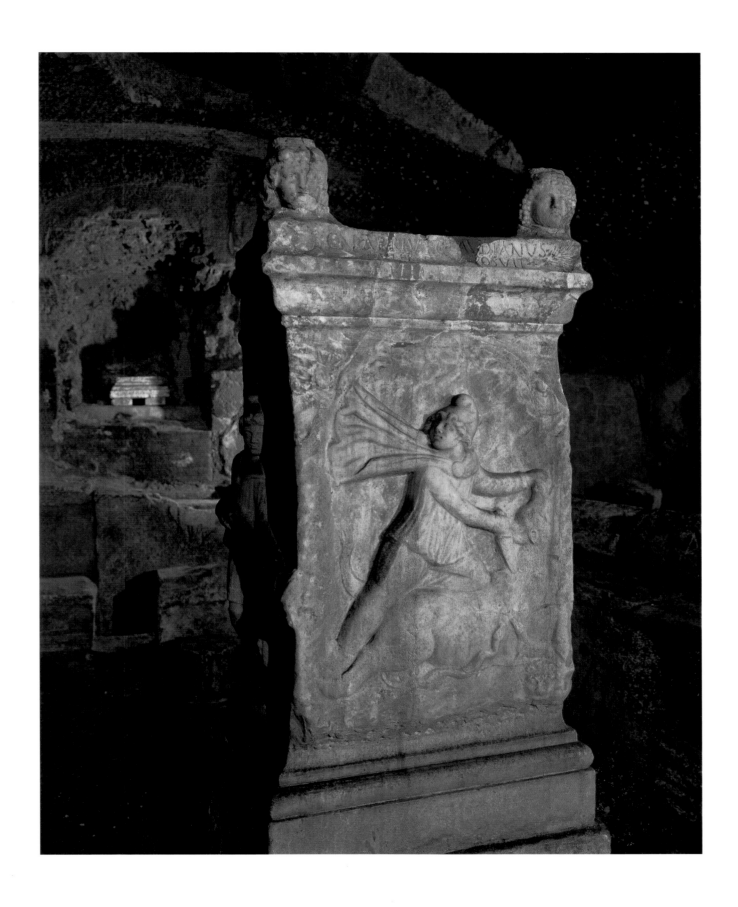

who, legally or religiously, enjoyed the status of citizen. Any single, and inevitably finite, congregation assembled in a given place is nothing more than an imperfect image of the total Church. A particular church is merely a house utilized by a portion of that total; thus, it is commonly called "the house of the Church" *(domus ecclesiae)*. "Domus" would therefore long serve as the term for the building where worshiping Christians found shelter, and it was this function rather than its sometime role as the seat of a bishop that made it the *domus* par excellence—*il duomo*. Sometimes the Church is known as *dominicum*—"that which belongs to the Lord"—as on a great feudal estate, where the master's house was home and hearth to all those who served him.

For all these reasons, each church had to be the symbol of the home par excellence, an image of the heavenly abode, becoming a magical place and not merely a room in which one heard the teachings of the fathers, received the sacrament, and joined in common prayer. Every church stood apart from terrestrial life, a fact that in the course of time would have important consequences. Thus, the Constantinian basilica of the Vatican was entered through a quadrangular peristyle courtyard in the center of which rose a large fountain decorated with peacocks, symbols of the Resurrection. By its very disposition, therefore, the basilica promised life eternal, a promise borne out by the name given to the forecourt: "paradise." This tradition, which held the church to be an image of the heavenly abode, has never died out. Indeed, it would triumph in the Baroque, a style whose opulence it would justify.

So the very concept of the church gave rise to an art meant to express the place's mystical significance; but this art could come into the open only in a Rome that had ceased to regard Christians as the enemies of the human race—that is, after the conversion of Constantine at the beginning of the fourth century. Until this happened, what was the church? We know that Christians did not wait for the persecutions to end before establishing meeting places where they could worship together. Church archaeologists and historians have shown great ingenuity in their efforts to discover these primitive "churches." One long-favored theory, developed during the twentieth century, held that they were to be found in the *tituli* mentioned by the ancient ecclesiastical historians. The *tituli* were nothing other than the private houses lent by their owners to the Christian community and more or less adapted for religious services. These houses would have continued to be known by the names of their proprietors, identified in an inscription

Under the nave and aisles of San Clemente, suites of small rooms around a central courtyard formed the ground floor of a warehouse. This was built at the end of the Republic or the beginning of the Empire. The walls are reticulated.

(titulus) engraved upon the façades. Unfortunately, the theory proved to be fragile, since the word *titulus,* inherited from the earliest days of Christianity, is, by itself, a juridic term. It signified an inscription attesting to the legality of a donation or, more often, to a deed of property.[1] A *titulus* for a church would therefore have been impossible prior to the legal recognition of Christianity, when the right to own a house or land in the interests of Christianity simply did not exist. Such property would of necessity have been a special place, furnished for the purposes of worship and endowed either by a donor or by a legacy.

Private residences were certainly utilized as "church houses" during the period of the persecutions. A prime example, albeit at some distance from Rome, has survived at Dura Europos on the banks of the Euphrates, where a private dwelling, discovered only in the 1920s, was converted into a church before A.D. 256 at a time of relative tolerance. Yet this solution to the problem of Christian worship could not be more than a mere expedient, given the limited capacity of an atrium or a peristyle. Such a venue sufficed as long as the community remained small, but it ceased to be adequate once the number of the faithful grew, which happened throughout the third century. Then other solutions had to be devised, first of all by modifying the interior disposition of the existing structures. In an *insula* (a residential building with numerous tenants), for example, the room partitions could be eliminated in order to obtain a surface large enough to impose a basilican plan. This is what occurred in the course of the fourth century, as we know from such Roman churches as San Clemente and Santa Pudenziana. We cannot prove, however, that such a solution was put into effect before Constantine. Until our present knowledge can be modified by new excavations or unexpected discoveries, we should probably assume that an architecture characterized as ecclesial did not begin to take form, in Rome at least, until the arrival of Constantine.

Already present in Rome, however, were structures serving the various pagan religions, places of worship and assembly that could be adapted to Christian needs. Some are well known, among them the famous underground "Pythagorean basilica" discovered in 1917 not far from the Porta Maggiore on the Esquiline and dating, very likely, from around A.D. 50. Here, it would seem, the Pythagoreans gathered, those initiates to the mysteries earlier revealed to Pythagoras, the pre-Socratic "Sage of Samos." Yet the hall could not accommodate more than several dozen people. Also available were the

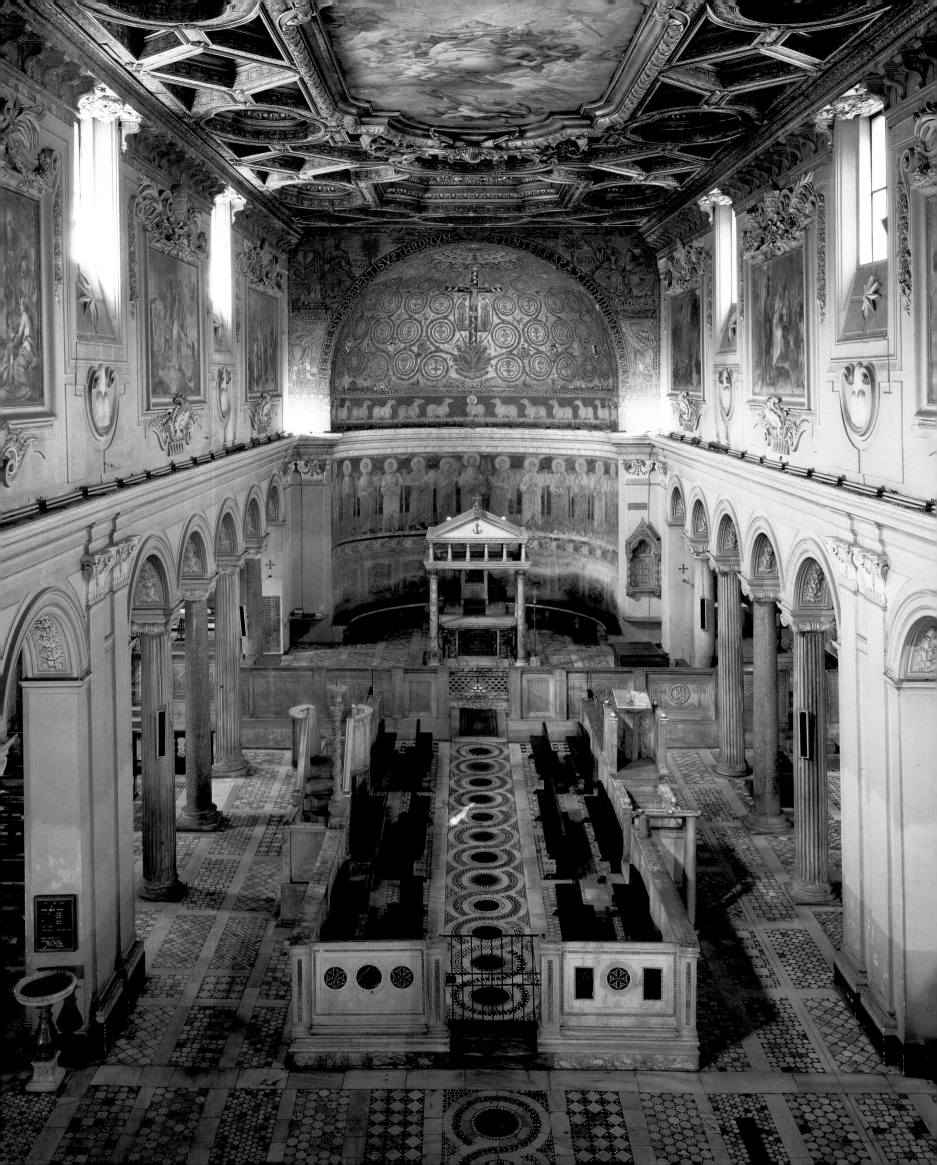

"grottoes of Mithras," one of which was discovered in the mid-nineteenth century on the Caelian Hill at San Clemente beneath the lower church. Here, as in all the other Mithraic temples, the structure is tiny, adapted as it was to the theoretically secret rites of the Mithraic religion, which included the sacrifice of a bull to benefit a chosen member of the faithful. Such a bloody rite is hardly to be compared with the sacrament at the heart of the Christian Mass.

Still earlier, two centuries before the advent of Christianity, there had been the cenacles or dining halls of the Bacchantes, initiates into the religion of Dionysus who also met secretly. Not a trace of these buildings remained, however, thanks to the scandal provoked by the Bacchantes and the repression this brought, which in turn left the Romans with a profound dislike of all religions practiced in secret, a dislike that would long extend to the Christians.

There were still other models, in several Eastern provinces as well as in Rome, from which the adepts of the new religion could and did take inspiration. It was not possible, however, simply to imitate the architecture of the established religions—the temples dedicated to the pagan dieties. Christian faith was too far removed from the ritual practices of those who followed the "false gods." Moreover, quite apart from the sense that such venues lay beyond the moral pale, there was the problem of their physical limitations. Churches, like houses, had to accommodate the congregations of the faithful, a function not required of the pagan temples. Never had these been the gathering point for suppliants come to seek the favor of a god or goddess, represented by a statue whose material residence the temple was. The *cella* within the temple was generally of modest dimensions. From time to time, of course, the Roman Senate decreed that expressions of public thanksgiving be made to one divinity or another whose protection had been manifest in the course of a war, for example. On such occasions, however, it was enough merely to open the temple doors wide, while everyone passed in front, on the exterior esplanade, which spread before the steps leading to the sanctuary within, where an altar usually stood.

Civil architecture, though, offered other possibilities, beginning with the basilicas, those vast halls inspired by Hellenistic precedent and first built in Rome at the outset of the first century B.C. Here, sheltered from the elements, merchants and bankers carried out their business, mingling with litigants whenever magistrates held court in the "tribunal," a situation not uncommon under the Empire. Every city of any size possessed at

least one basilica. It is therefore easy to imagine that buildings of this kind might serve the communal interests of Christians, particularly if built for the purpose. Still, certain modifications had to be made, and were already being formulated, as can be seen in the new basilica Maxentius had erected along the Via Sacra. With this enormous and prestigious monument, Maxentius marked the approaches to the old Forum with the symbol of his own glory, just as Trajan had done when he built his forum and the Basilica Ulpia. Until then Roman basilicas had been rectangular with straight sides all around; yet the new structure, as originally planned, would open into an apse at the western end facing the entrance at the eastern extremity. This semicircular, vaulted recess was obviously meant to house a statue of the emperor, whose majesty would thereby be glorified. Constantine, after defeating Maxentius, renewed work on the basilica and added a second apse in the north wall opposite a new entrance without eliminating the first. Now the majesty of the new emperor replaced that of the vanquished one. The colossal ruins of this basilica, which stand today near Santa Francesca Romana, would be a source of inspiration for Bramante and Michelangelo when, in the early sixteenth century, they undertook to create the new Saint Peter's in the Vatican.

The Basilica of Maxentius may be regarded as a model for what would become, a few years later, the first Christian basilicas. Not only did the architecture solve the problem of space, but the space itself was deemed sacred. In numerous monuments dedicated to civil purposes, basilican spaces had been "inaugurated" religiously and equipped with an axial apse housing a sacred image. A case in point is the Curia built by Domitian and reconstructed by Diocletian following a fire in 283, but such coupling of the civil and the sacred can be found in still earlier structures. There is, for example, the Basilica Fanum (at the end of the Via Flaminia on the Adriatic), constructed by Vitruvius during the reign of Augustus. Overlooking the dais or rostrum of the tribunal stood "a cult statue on a curvilinear base covered by an arched half-dome opening on the short side of the *cella* facing the entrance."[2] This disposition transformed the basilica into a sacred space, a veritable *templum* placed under the protection of the *numen Augusti,* the mystical power of the prince. It had not been planned by Vitruvius but, rather, adopted from the arrangement devised, a half-century earlier, by Julius Caesar for the Temple of Venus Genitrix at the center of his forum, and then used by Augustus for the Temple of Mars the Avenger (Mars Ultor), which commemorated the defeat and punishment of

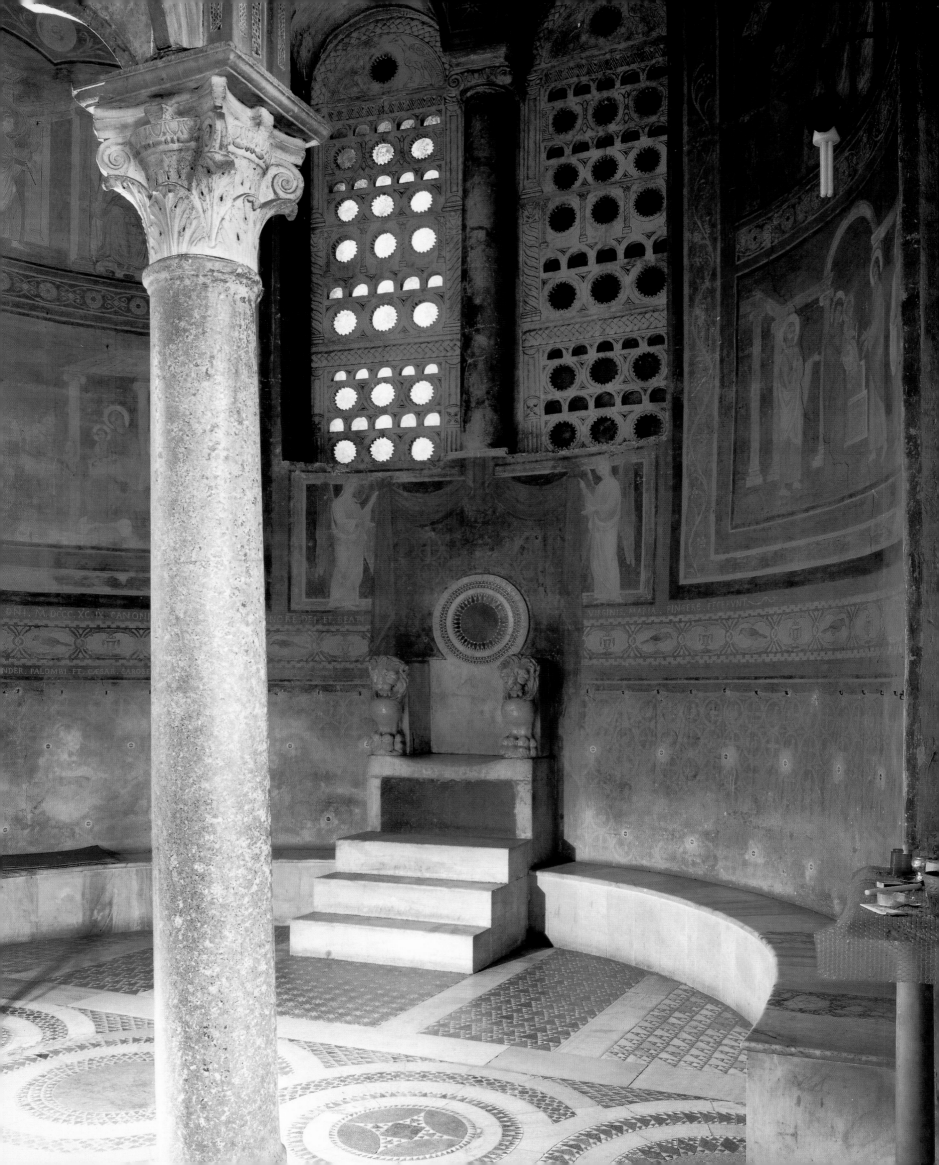

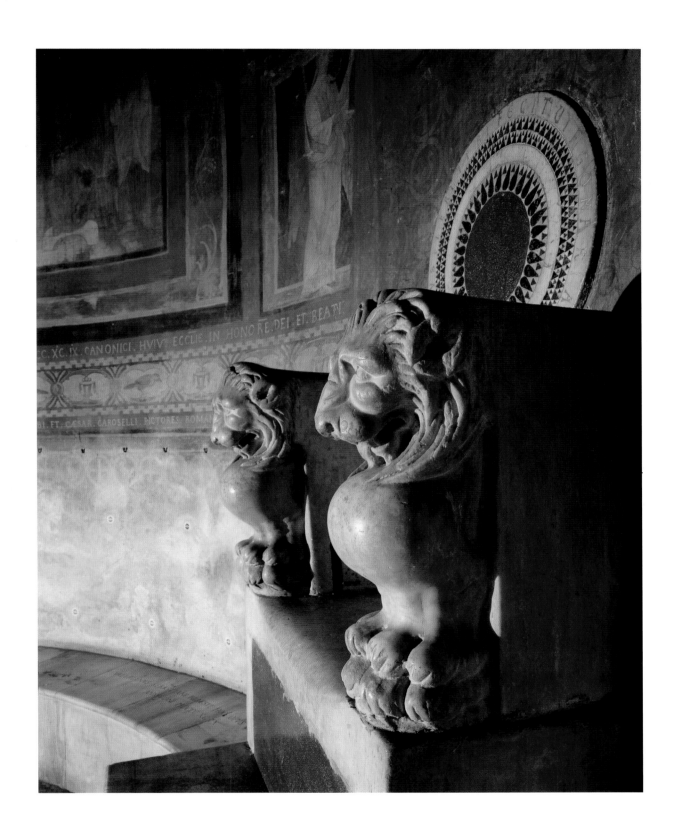

Episcopal throne in
the apse of Santa
Maria in Cosmedin,
a church founded in
the sixth century and
restored in 1120.
The pavement and
Cosmatesque decora-
tion of the throne are
the work of Roman
marble masons.

Atrium and entrance
courtyard of the
basilica of San
Clemente.

the conspirators of the Ides of March.[3] Here an axial apse curved behind and showcased the divine statue. Could the plan reflect influence from the Semitic world, where the traditional *adyton* of the sanctuary (the "holy of holies") was beginning to open wider, becoming a precedent for a niche sheltering an idol? Perhaps the recess was not so much a borrowed element as merely a parallel development wherein architecture translated into stone and concrete another parallel development, this one emerging between the sensibilities of Eastern religion (Semitic religion in particular) and those of the new Rome, which gave birth to and affirmed the cult of the prince.

Whatever the explanation, in Rome itself the conditions were in place as early as Caesar's victory, for places of worship to be designed like basilicas, no longer merely temples enclosing a statue but vaster spaces capable of receiving large congregations. It required only that the divine personality of the emperor be associated with that of the Lord, who, like the emperor, reigned over the Universe. In reality, the apse intended to house the imperial throne .was never, in Christian basilicas, to be filled with a divine image, the very notion of which would have been considered sacrilegious. Instead, the niche would house the seat of the bishop, the depository of the sacred. As for the altar, the site of divine mystery, it was placed in front of the apse and thus oriented toward the assembled faithful.

The basilican plan underwent further innovation. Three-quarters of the way along the main axis the divided nave gave way to a clear, free space for the clergy. Beginning with the Constantinian basilica at the Vatican, this space evolved into a transept, which conferred upon the whole the configuration of a Latin cross. The passage from the nave and aisles to the choir was marked by a great arch, the richly ornamented "triumphal arch." The barrier separating the faithful from the place where the rites of the Holy Eucharist were performed would be known as the *pergula,* meaning a "bower" or "arbor" (a "perfect" or semicircular arch in modern architectural parlance). Here unfolded the branches of the mystical vine symbolizing the spiritual life of the Church, for the Church was often compared to a vine whose grapes are the martyrs. Within this context the angels became harvesters and the wine the spirit animating the inner life of the Christian faithful. The Church was the site of a gradual progression toward Truth, from the forecourt or *atrium,* where the catecumens gathered, to the altar. The sequence survives at San Clemente, which dates from the fourth century.

The evolution of the basilica was not solely a Roman phenomenon. In Palestine, for example, a rather curious third-century monument, discovered at Emmaus, demonstrates the synthesis that developed and then transformed the basilica into *domus ecclesiae*. The Emmaus church had three naves, or nave and side aisles, separated by two rows of columns. Each of the longitudinal spaces terminated in an apse,[4] a plan that must surely be seen as a decisive stage in the development of the ecclesial place, the *dominicum*. The emergence of the Christian basilica, beginning in the third century, did not result from purely technical innovation, from the utilization of a structure formulated long before to provide a huge covered space in which a large urban population could freely circulate. It was, rather, a religious phenomenon that translated a precise ideology through the polarization and sacralization of a given space. The first Christian basilicas of Rome, like the one erected by Constantine, did not spring out of a void. Indeed, they fell within an established tradition. Like the religion they would serve, the Christian basilicas combined and integrated into a single entity both purely Roman elements and other features derived from the Middle East. The church, a sacred place, became a complex microcosm imbued with the divine spirit.

The Center of the World, a Place of Meditation

Persuaded that victory at the Milvian Bridge had been granted him by the Christians' God, Constantine decided to establish an official cult and began by constructing, on the immediate outskirts of Rome, a huge basilica dedicated to the greater glory of the new deity. The site he chose was the Palace of the Lateran, a villa formerly owned by the Plautii Laterani, which had been confiscated by Nero almost two centuries earlier, and thereafter appears to have come into the possession of Fausta, Constantine's wife. The emperor added adjacent terrain on which he installed *edquites singulares,* a cavalry corps under the direct command of the sovereign. The basilica was quite large, measuring 100 meters long and 65 meters wide, which made it even more vast than the Basilica of Maxentius. And herein lay an important symbol. Right away, Christianity declared itself to be a religion on a scale far more important than that of any cult committed to traditional divinities and, moreover, a religion legally open to everyone.

Next to the basilica came a baptistery, a circular-plan building with a steep roof. For this did Constantine, as many have assumed, utilize a hall belonging to an existing

The cloister of the basilica of San Giovanni in Laterano, built in 1223–30, is the work of the Vassalletti. Notice the careful treatment of profiles and moldings, the sculpture of the capitals and cornices mingled with ancient Eastern elements, and the great variety of the forms and incrustation of the colonnettes. The openings are framed by lions and sphinxes.

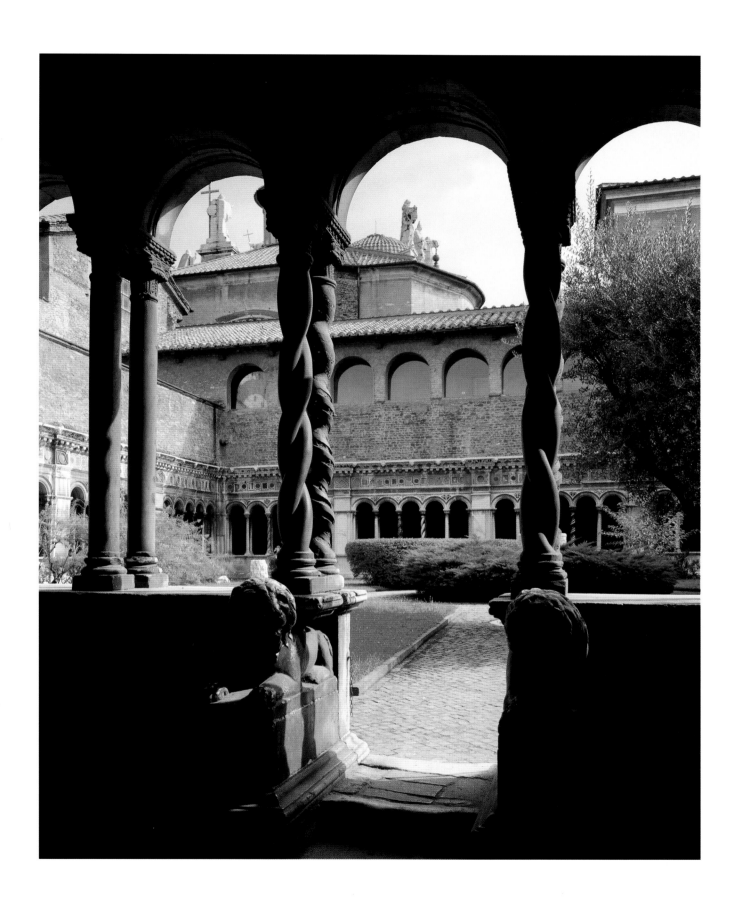

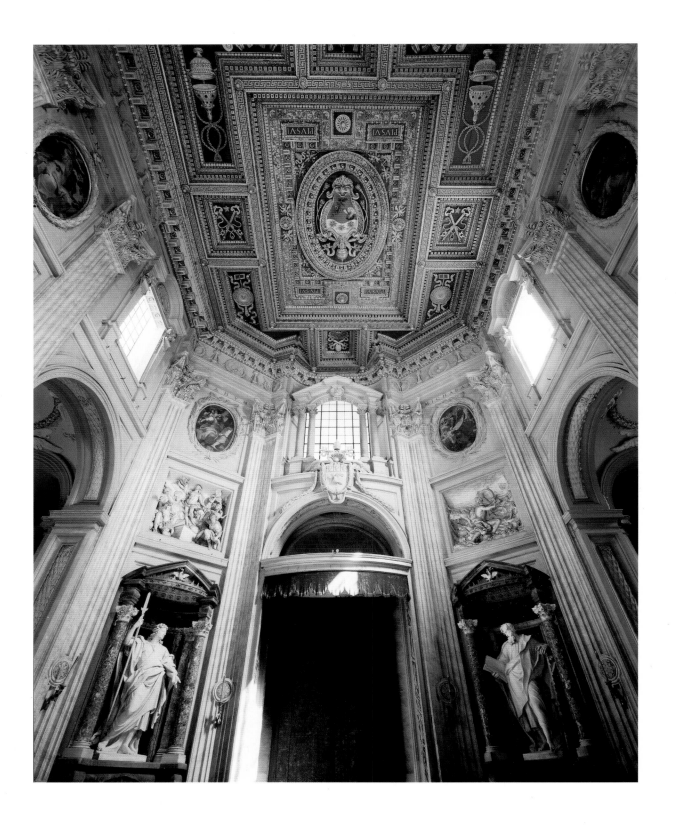

The ceiling of the nave of the basilica of San Giovanni in Laterano was executed by followers of Michelangelo, including Daniele da Volterra. At the center is the coat of arms of Pius IV, with that of Pius V facing the choir and that of Pius VI facing the entrance.

The left arm of the transept of San Giovanni in Laterano, decorated under the direction of Giacomo della Porta for Clement VIII. The lower part of the walls is faced with inlaid marble and decorated with sculptures of angels in half-relief. In the upper part are frescoes executed under the direction of Giuseppe Cesari (late sixteenth century).

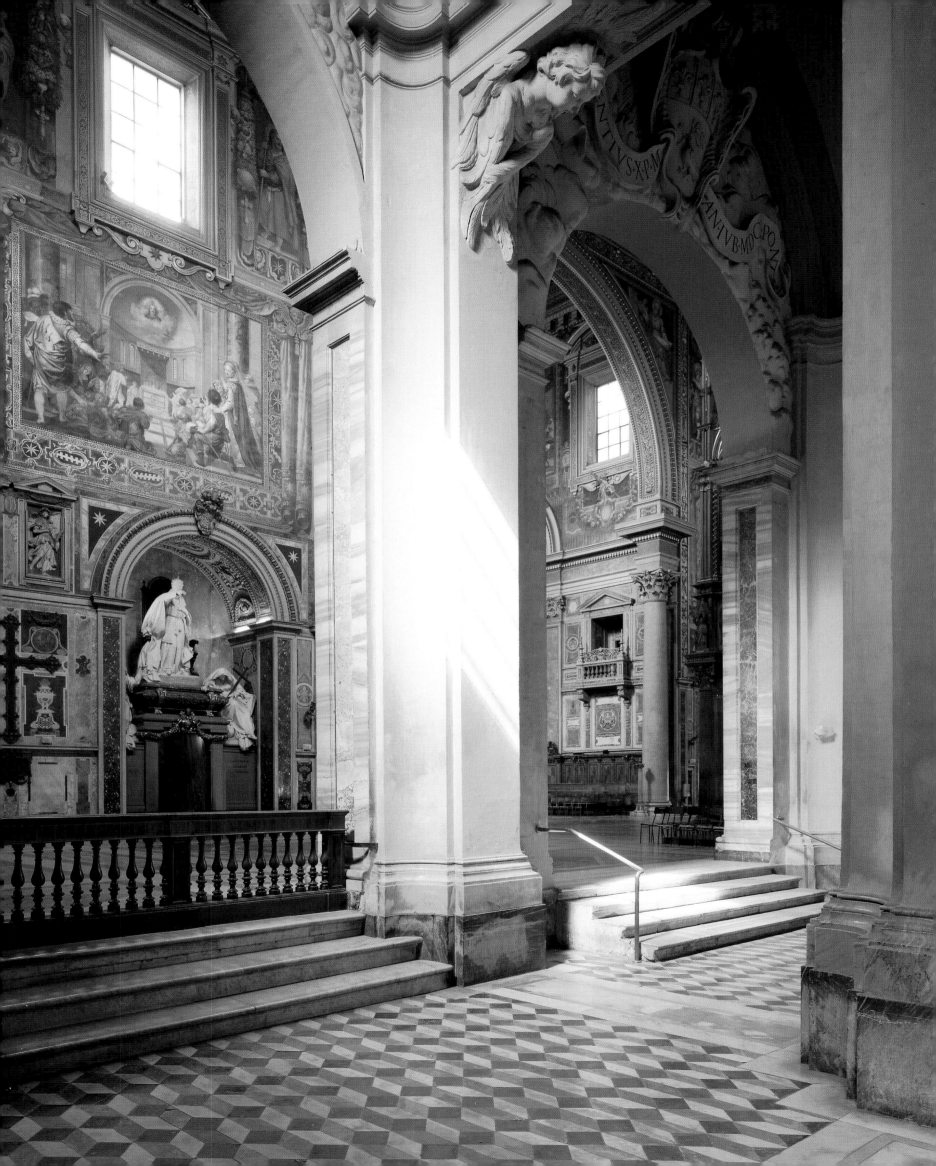

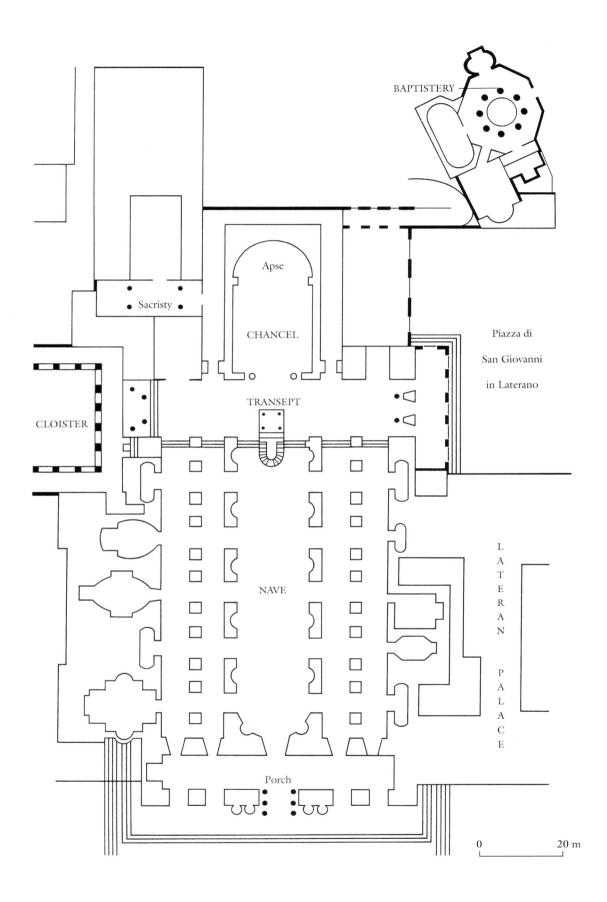

BAPTISTERY

Apse

Sacristy

CHANCEL

Piazza di
San Giovanni
in Laterano

TRANSEPT

CLOISTER

NAVE

L
A
T
E
R
A
N

P
A
L
A
C
E

Porch

Basilica of San Giovanni
in Laterano

0 20 m

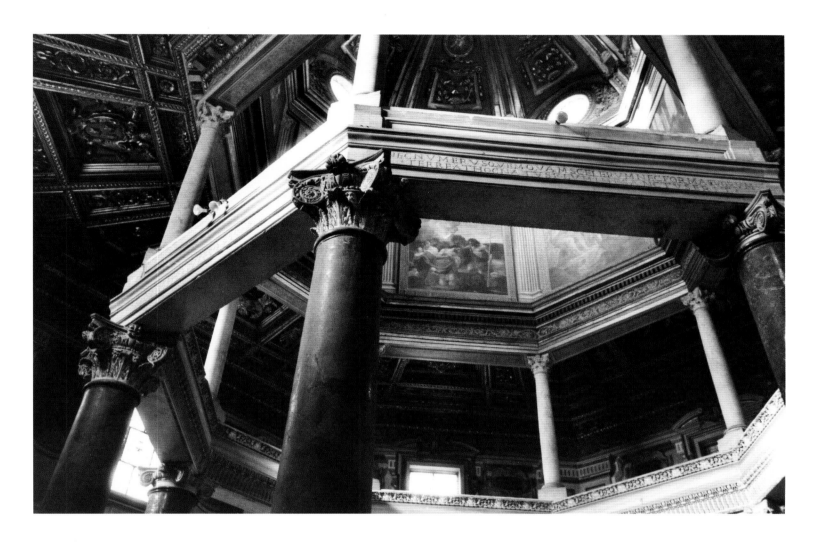

Baptistery of the ba-
silica of San Giovanni
in Laterano, founded
under Constantine,
rebuilt in the fifth
century by Sixtus III,
revised in 1637 and
then again by Borro-
mini. Octagonal plan
with central rotunda
with porphyry
columns (432–40),
which originally
supported a barrel
vault toward the out-
side and a cupola at
the center. The upper
colonnade and the
lantern date from the
seventeenth century.

thermal complex? This is not at all certain, although there can be little doubt about the emperor's intention, which was to create an ensemble of buildings wherein the essential moments of Christian life could unfold. It is known that Constantine himself accepted baptism shortly before his death, perhaps motivated by genuine piety—convinced of the unique, irrevocable character of this sacrament, with its promise to integrate the new Christian forever into the community of the faithful, both here and hereafter.

This original basilica, which later would be consecrated to Saint John the Baptist and Saint John the Evangelist and thus known as San Giovanni in Laterano (Saint John Lateran), long remained the Roman church par excellence. Nearby, meanwhile, in the palace of his mother, the Empress Helena, Constantine had a church erected for the imperial court. It is named Santa Croce in Gerusalemme, because legend holds that, from the time of Constantine, the church housed a fragment of the True Cross, although how the relic arrived in Rome is not known.

As an imperial edifice, the Lateran basilica marked that dependence by which the Christian religion was tethered to the power of the prince. Over time, this political and religious preeminence, though never challenged, receded in memory, no doubt on purpose, as the ties between the emperor and the Church loosened. The Lateran was to be supplanted by another Constantinian creation, the basilica of Saint Peter in the Vatican, which rose entirely outside the city on the right bank of the Tiber. Even larger than San Giovanni in Laterano (which has a total length of 122 meters), it was actually a martyrium, a place for prayer established over the site of the apostle's tomb. Saint Peter's was also one of a series of analogous buildings founded by Constantine all around Rome, among them San Lorenzo on the Via Tiburtina and San Paolo on the road to Ostia.

These martyria grew out of funerary architecture, their original forms foreign to the basilican tradition and dependent upon a great fortune. The archetypes can be found in two Constantinian monuments in the Holy Land: the Church of the Nativity in Bethlehem, and the Church of the Holy Sepulcher and the Church of the Resurrection in Jerusalem. All consisted of circular buildings joined to rectangular basilicas. On Golgotha, where Christ was crucified, there stood a cross of gold protected by a sort of ciborium—a dome-shaped baldachin—ornamented in gold and mosaic. A pilgrim named Theodosius who saw this monument in the seventh century recorded his impression: "The cross is of gold and embellished with precious stones, and above it is a gold heaven."[5] Here the

The nave of the basilica of Saint Peter, the largest in the Christian world (187 meters long). In the foreground, one of the two holy-water stoups, on which each cherub is taller than a man.

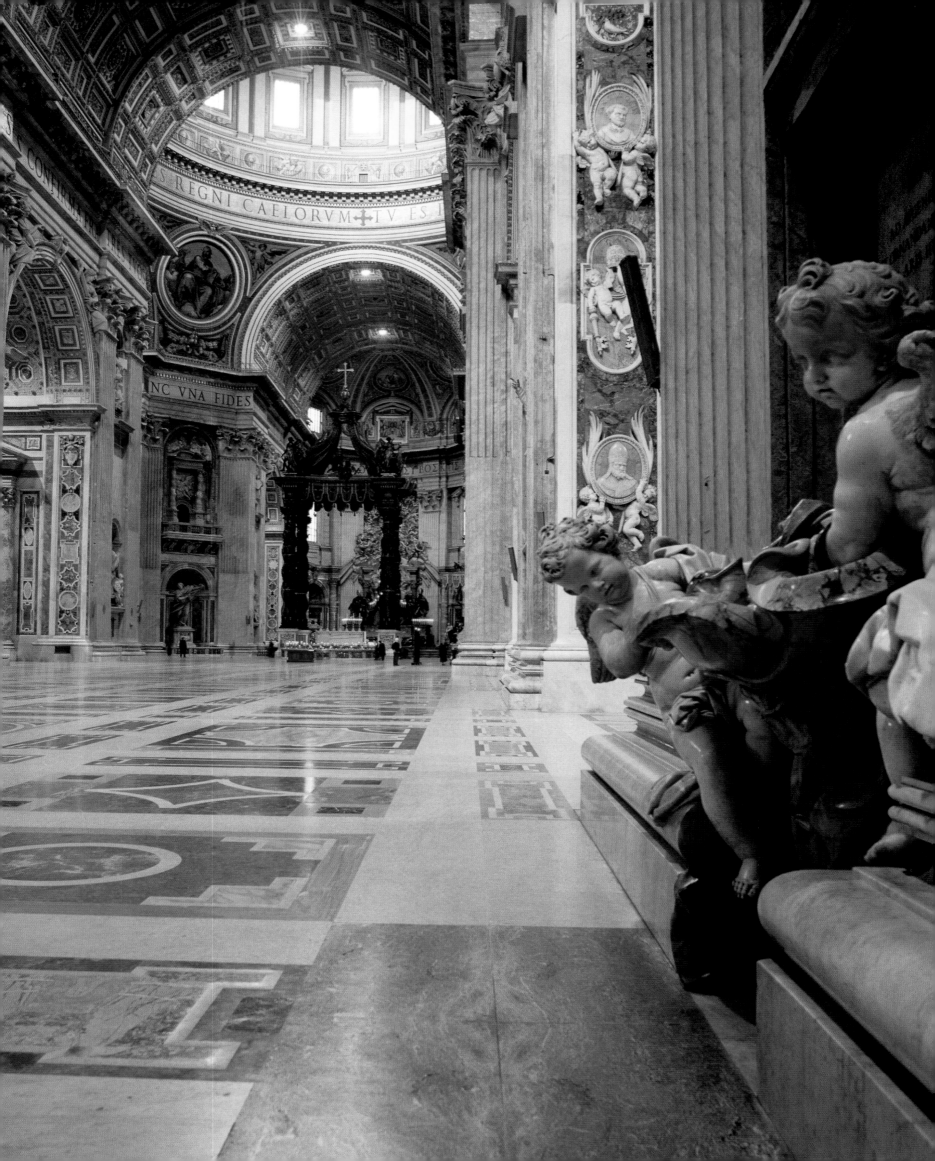

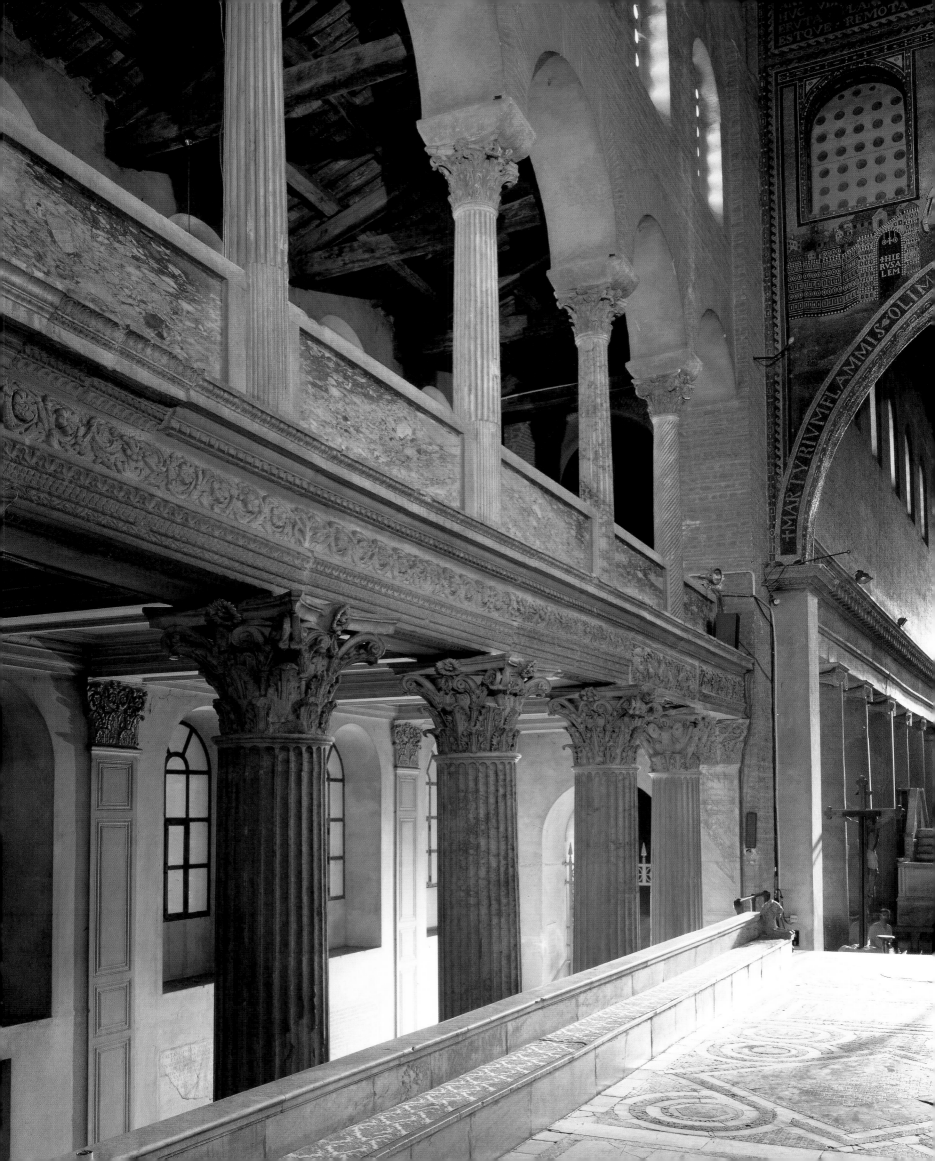

The basilica of San Lorenzo fuori le Mura, built over the martyr's tomb by order of Constantine, then rebuilt by Pope Pelagius II in 579–90. Its present appearance goes back to Honorius III (1216–27). The choir and the wide tribunes have elegant Corinthian columns, and the triumphal arch is decorated with a mosaic from the late sixth century, depicting Christ surrounded by saints.

word that draws our attention is "heaven" or "sky," serving as it does for "ciborium" or "baldachin." This cupola or "dome of Heaven" covered the sacred place par excellence, the site of the Redemption. Here, for the faithful, was the mystical center of the world, the place where everything began. The dome would therefore be repeated wherever the mystery was to be reenacted through the Eucharistic liturgy. Ideally, every cupola suspended above an altar constituted the same symbol, and every church it sheltered became a microcosm at the heart of which operated divine grace.

By erecting a dome over the cross, Constantine adhered to a very old tradition, a tradition dating back to the Persian kings. Henri Stierlin[6] reminds us, quite opportunely, that in the sixth century B.C. the Ephesians had offered Alcibiades, in celebration of his victories, a "Persian tent made in the image of the sky." It was a pavilion with a circular ceiling, under which the sovereign normally sat, thereby symbolizing the universal character of his power, as wide as the space covered by the dome of heaven. Alexander renewed the ceremony in the aftermath of his victory. One of his successors, Ptolemy Philadelphus, then continued it, at least on certain feast days. Several centuries later the practice could again be found, this time in Rome at Nero's Golden House, as well as in Spain at the palace of Granada.[7] In both places the cupola had cosmic significance, symbolizing the universality of power: material power whenever it hovered above kings and emperors, and spiritual when it rose above the altar of the Lord.

There was, however, another tradition, in Rome and elsewhere in the Latin world, which favored circular plans for tombs, albeit without implications of cosmic meaning. Etruscan tombs may have been the models for the drum-shaped tombs known today, such as the "tower" that became the tomb of Caecilia Metella on the Appian Way or the mausolea of Augustus on the ancient Campus Martius and Hadrian on the right bank of the Tiber, where it became a fortress defending the Vatican. In the Via Nomentana north of Rome a tomb of this kind, containing the remains of Princess Constantia, the daughter of Constantine, became the church of Santa Costanza. This concentric structure boasts a dome upon a drum rising above the central space, the annular vault over its encircling aisle supported by a double colonnade. The mosaics sheathing the vaults, among the oldest in Rome, display peacocks (the significance of which has already been noted), pomegranates, and birds perched on *canthari* (goblets), come to drink from the baptismal water of immortality. All the images were clearly borrowed from the traditional

The chancel of the basilica of San Lorenzo fuori le Mura, with a nave and two aisles, has kept its pavement of white marble, porphyry, and serpentine, with multiple motifs revealing the imagination of the Cosmati. The railing at the back of the chancel and the episcopal throne intended for the pope date from the midthirteenth century. The richness of the decoration and the chromatic effects evoke the sanctity and the theocratic ideas of Pope Innocent IV.

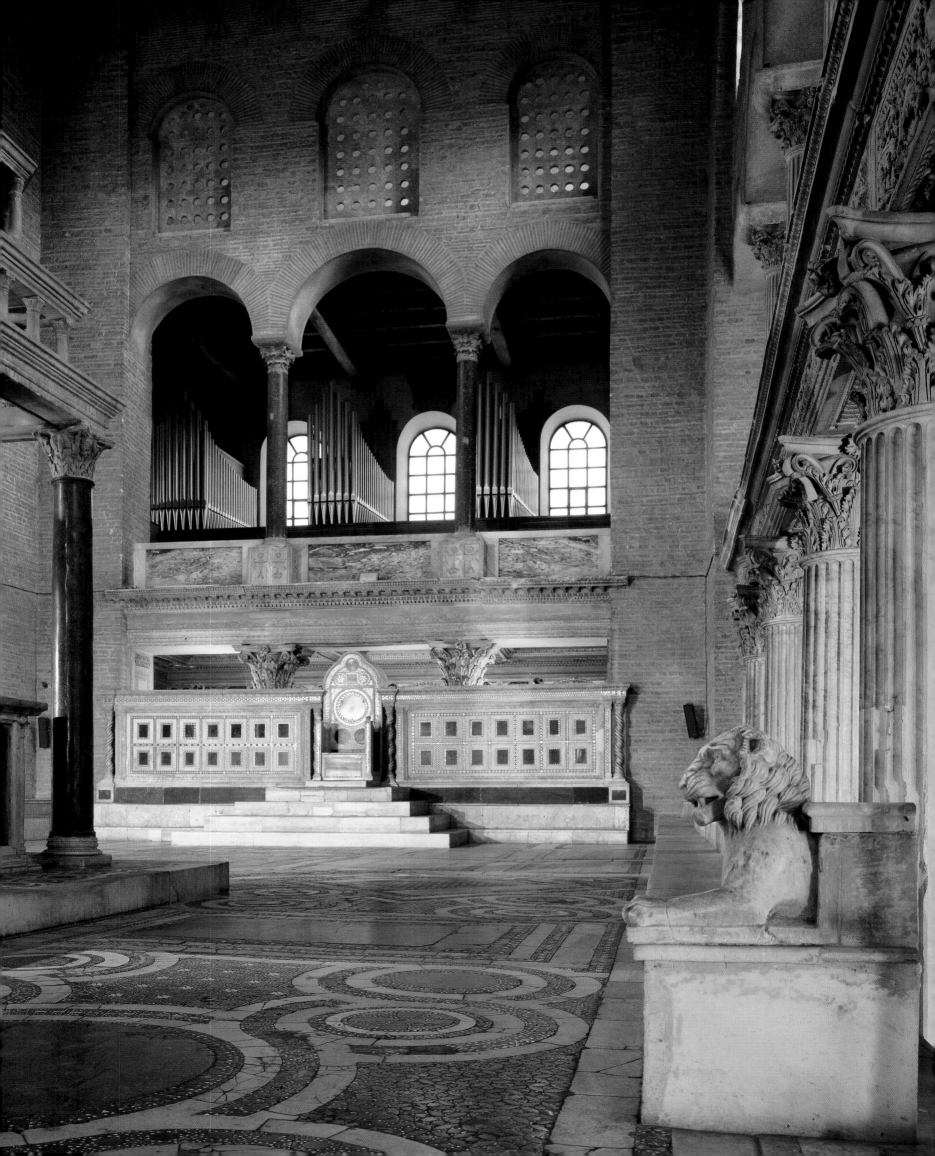

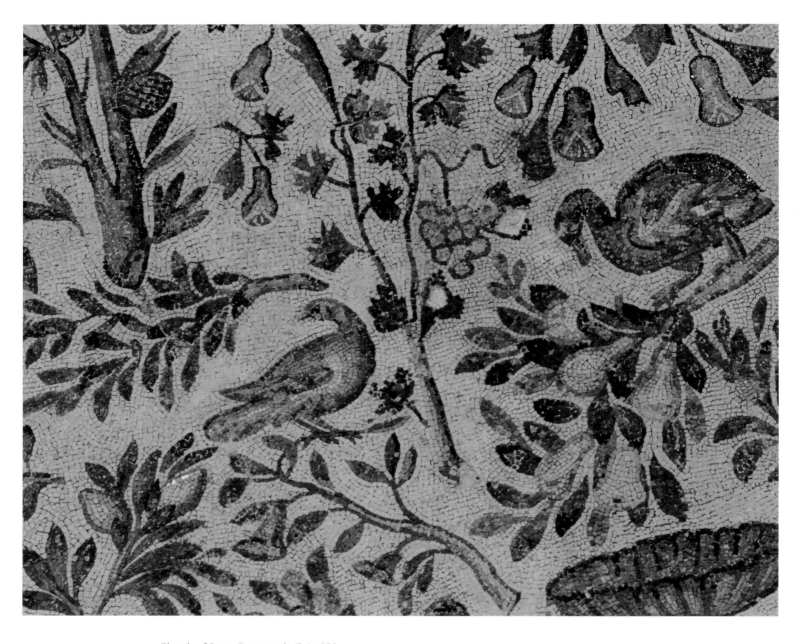

Church of Santa Costanza, built in 358
to house the sepulcher of Constantia.
On the barrel-vaulting of the ambulatory,
detail of a mosaic decorated with vine
tendrils and grapes, birds and pomegranates
(fourth century).

Church of Santa Costanza. The interior is
annular in plan, with a central tambour
and dome supported by twelve pairs of
columns with Corinthian capitals. A circular
gallery around it is decorated with fourth-
century mosaics.

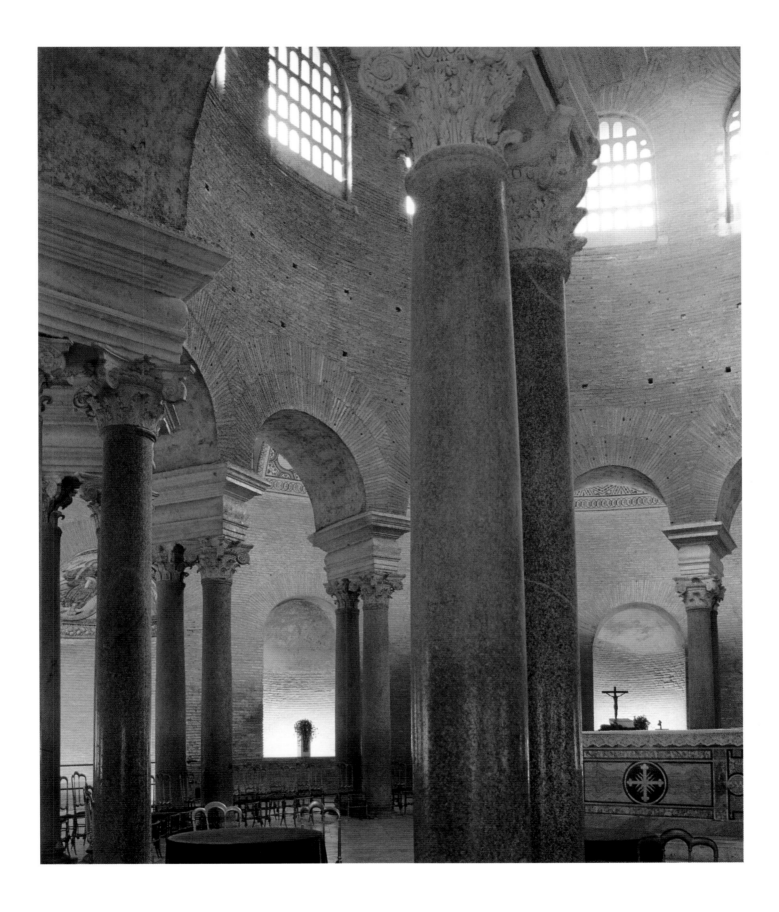

repertoire of funerary iconography; yet here they assume new significance, promising the deceased princess her rebirth in Christ. Also present in this tomb/church, with its vine and bird decorations, is the bust of a young woman, no doubt representing Constantia herself, presented as blessed in the bosom of the heavenly Jerusalem.

The church of Santa Costanza was planned as a simple annex to the adjacent basilica dedicated to Sant'Agnese, virgin and martyr, under whose protection Constantia wished to be buried. The place of assembly and prayer, where the liturgy unfolded, was evidently the basilica. In the tomb/church itself the living could come or gather to commune spiritually with the deceased, a person dear to them and one in whom they hoped to find an intercessor with the Lord.

In Rome a church with a circular plan, the famous Santo Stefano Rotondo, has long intrigued historians. Consecrated to the early Christian martyr Saint Stephen, it is located on the Caelian Hill, on what was long thought to be the site of an ancient market. In reality, its history is more complex and more instructive. Santo Stefano was not one of Constantine's constructions; rather, it dates from after the capture of Rome by Alaric (410), when the popes were trying to efface the traces of pillage. About fifty years ago it was observed that the dimensions approximate those of the Church of the Holy Sepulcher in Jerusalem.[8] There can be no doubt that the popes of the middle of the fifth century wanted to reestablish Christianity's most sacred sanctuary on Roman soil, at least symbolically. Is it possible they had a presentiment of the future divisions that would split the Christian world, some of which could already be felt? At that time, when the Western Empire had come to an end and the West was in the hands of barbarians, it may have seemed appropriate to assemble in Rome the monuments in which the drama giving rise to the Christian religion had been acted out. If this was really the intention, its implementation did not go beyond the construction of this circular church in a rather remote district on a largely deserted hill, once the site of villas but long abandoned to solitude.

By the end of the era of Constantine, therefore, two types of church had become established: large basilicas with a plan shaped like a Latin cross and, more sporadically, churches with a circular plan embodying two symbols inherited from the pagan world. One of these evoked the idea of a dominion embracing the whole universe, while the other commemorated a deceased person. Each of the building types reflected a different

Church of Sant'Agnese in Agone, with a centralized plan forming a Greek cross, built from 1652 to 1657. Marble altar of the right transept, surmounted by painted perspectives and a statue representing Saint Agnes.

The spacious cupola of
Sant'Agnese in Agone,
built by Borromini.
The brightly colored
paintings in the cupola
date from the late
seventeenth century.

ideology, although both were implied by the Christian religion. The basilica gives material form to the communion of the faithful and confirms the authority of the bishop. The circular church is a place of oration, in which prayer opens the way toward the invisible dimension of the Church. It was the basilica, however, that, for obvious reasons became predominant in the churches built in the late fourth and the fifth centuries. The hall form was necessary to provide places of assembly and worship for the Christian community, whose importance was growing steadily. The bishops of Rome set about building such places, but the churches associated with their names—with Popes Sylvester, Marcus, and Julius I—can no longer be clearly identified. They seem to have been scattered among districts as diverse as the Esquiline (near the market of Livia), the areas around the Forum of Trajan and the Via Lata (where it begins, at the foot of the Capitol), and at Trastevere, where texts refer to a Basilica Julii.

The churches founded under Pope Damasus I (366–384) are more easily identified. They include Sant'Anastasia, not far from the Circus Maximus, at the foot of the Palatine, which was once the imperial hill but had come down in the world by then. The church stands on the site of an ancient *insula,* or multiple dwelling. It is a basilica of modest size, 40 meters long by 23 wide. None of the modifications made to transform the *insula* into a place of worship indicates any use beyond that of an assembly hall. The vestiges of several other churches founded in the same period are difficult to discern, but they include the earliest state of San Lorenzo in Damaso, later covered by the Palazzo della Cancelleria and completely rebuilt by Bramante. Another church, erected by Damasus not far from the Baths of Caracalla, has left no trace beyond those in the texts.

Pope Siricius (384–399), Damasus's successor, began or completed two important churches. They have not survived without considerable modification and restoration, but Christian life continues in them even today. One is the church of Santa Pudenziana, dedicated to a saint born of the popular imagination, but with a name derived from that of a certain Pudens, who may have been a real person, perhaps the donor who provided the land and the building that was converted into a church (a situation repeated at Santa Prassede). Built next to the Piazza Esquilino, and over one of the many "baths" available to private citizens in all parts of the city, Santa Pudenziana has a nave, side aisles, and three apses. Its dimensions are comparable to those of Sant'Anastasia (30 meters by 17).

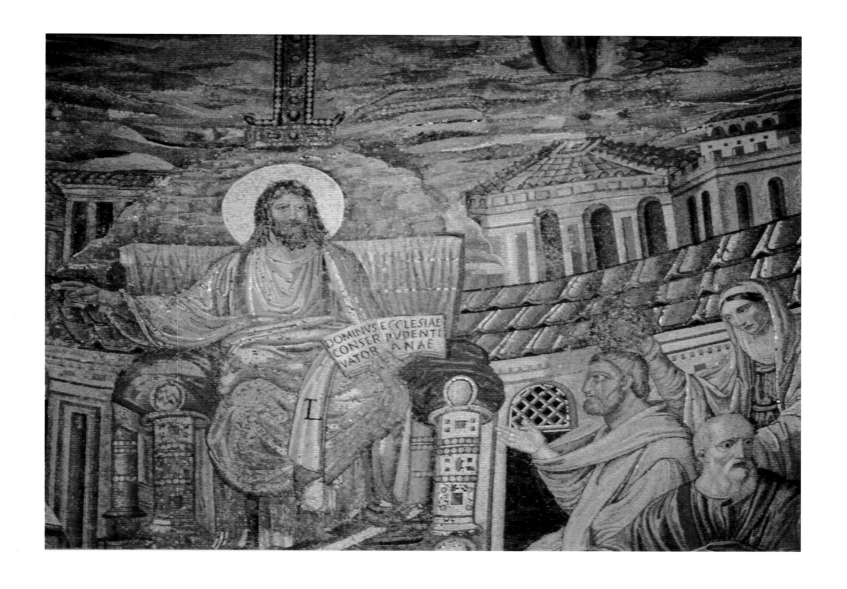

Detail of the apse mosaic in Santa Pudenziana produced ca. 400 and depicting Christ enthroned amid the apostles. Behind him are the cross on Calvary and the town of Jerusalem. The Christ, dressed in gold, with bearded face and a peaceful, humane expression, is not of the Eastern type. The use of marble cubes adds a range of shades and gradations to the bright colors of the mosaic.

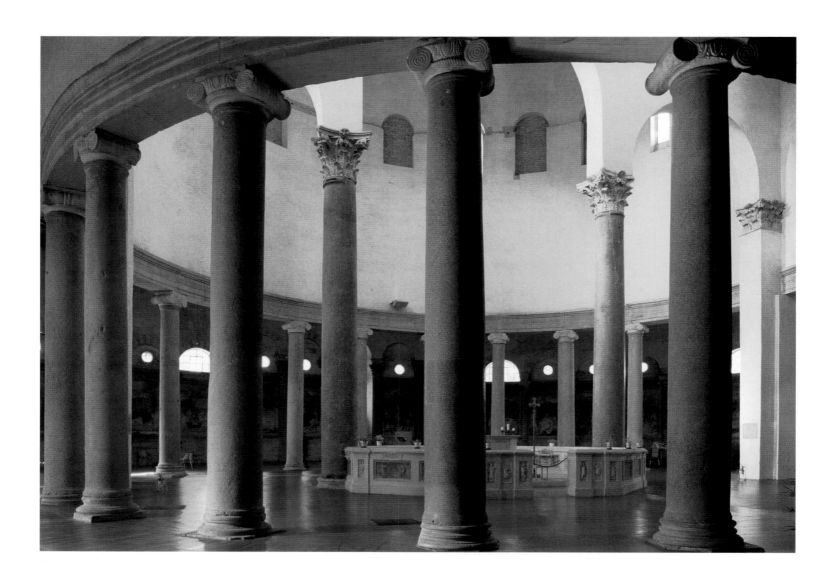

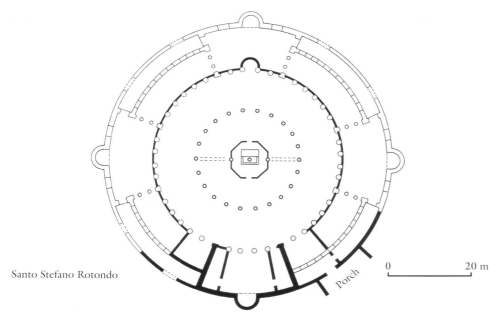

Santo Stefano Rotondo

Santo Stefano Rotondo, built by Pope Saint Simplicius between 468 and 483, is a large circular church with a double inner colonnade in imitation of the Church of the Holy Sepulcher in Jerusalem, which is of the same dimensions. The aisles have trussed roofing and the columns are taken from ancient monuments, while the capitals decorated with crosses have a cushion above the abacus, an indication of the Eastern influence in Roman architecture.

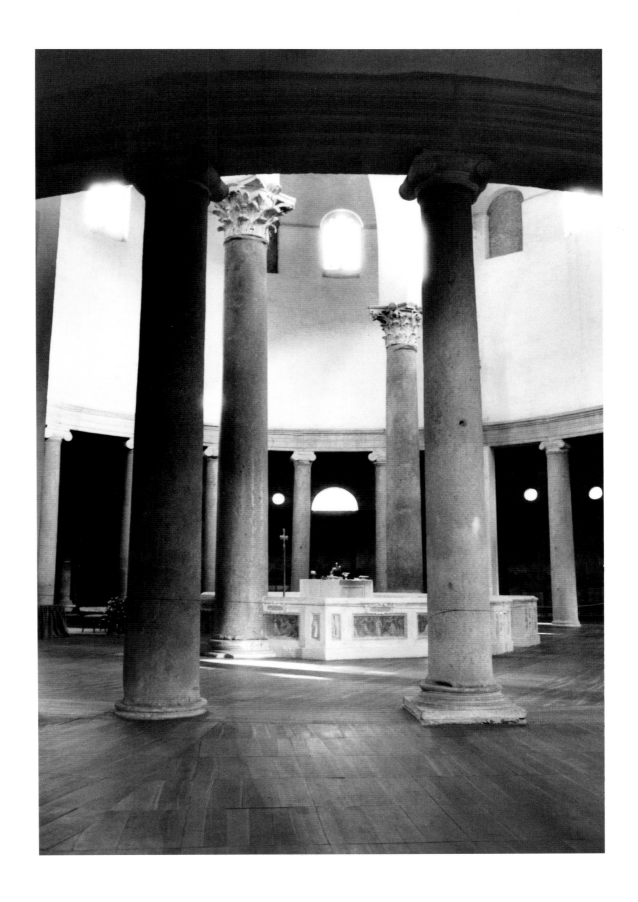

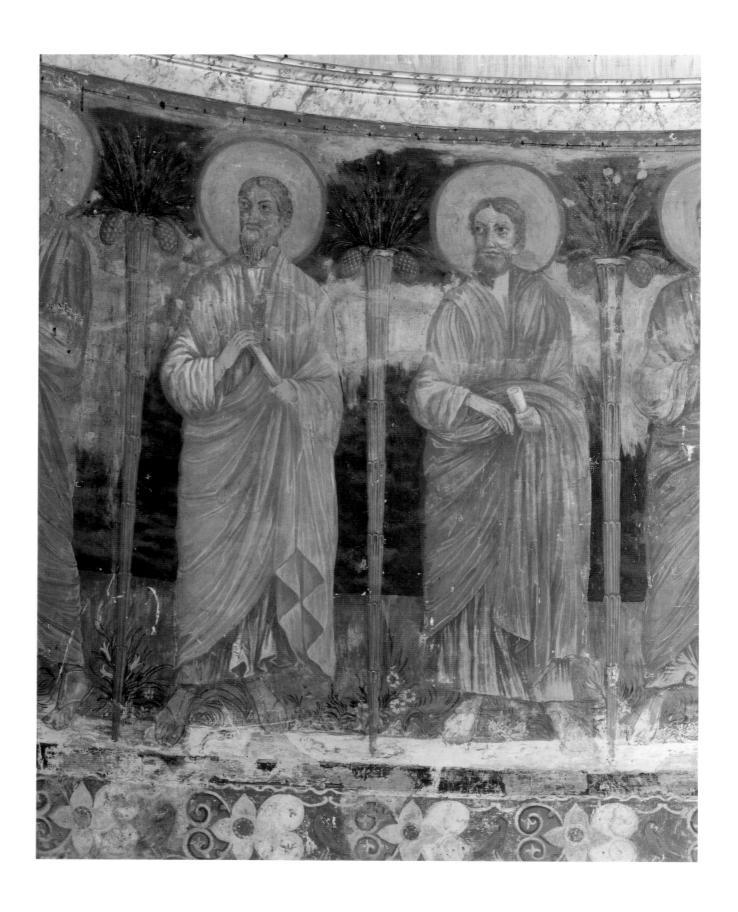

The central apse is decorated with a mosaic depicting Christ seated on a throne and surrounded by the apostles. In the background lie Golgotha and an urban landscape, perhaps representing Jerusalem. Consistent with the iconography of the day, Jesus is shown in glory, displaying omnipotence over the universe. He brings the New Law to the world.

The very beautiful and moving basilica of San Clemente, another church from the pontificate of Damasus, survives today, halfway between the Coliseum and San Giovanni in Laterano. Here the continuity of Christianity, since its victory over the pagan divinities, can be seen more clearly than anywhere else in Rome. Beneath the church, at a lower level, we find ourselves in an alley from pagan Rome, where a complex of rooms around a central courtyard, perhaps a market, dating from the reign of Augustus, stood next to a *mithraeum*, the altar of which has survived. Over these remnants rose the first Christian basilica, today only partially visible in the surviving structure. All that can be made out are a nave, aisles, and an apse. Very likely an atrium lay in front of the church, but this has not been uncovered. Some important elements of the decorative program within have come down to us. The second basilica, superimposed on the first in the eleventh century, provided the occasion for new embellishments, including an apse mosaic with subject matter based upon earlier models. Every figure is surrounded by ornamental foliage forming a kind of medallion, a motif with a mystical meaning taken from the Psalms and often used to illustrate sacred texts. At a higher level an atrium resembling a cloister provides San Clemente with a Baroque upper façade, whose triangular pediment and volutes date from the pontificate of Sixtus V at the end of the sixteenth century. But this front too often goes unnoticed, inasmuch as services are held in the upper basilica, reached directly from the Via di San Giovanni in Laterano.

Also on the Caelian Hill, but close to the site of the former temple of the deified Emperor Claudius, the church of Santi Giovanni e Paolo rests on the vestiges of earlier structures, in a manner similar to that seen at San Clemente. Its dedication is not to the Apostles John and Paul but, rather, to a pair of eunuchs martyred during the reign of Julian the Apostate (361–363). According to tradition, their house stood right here. The basilican church itself was probably built at the end of the fifth century, superimposed on a Christian establishment decorated with imagery featuring motifs found in catacomb paintings—peacocks, doves, and small figures amid flowers and vines. Was Santi Giovanni e Paolo a private oratory, a chapel that antedated the basilica by more than a

Paschal candelabrum with Cosmatesque decoration in the basilica of San Clemente, twelfth century.

45

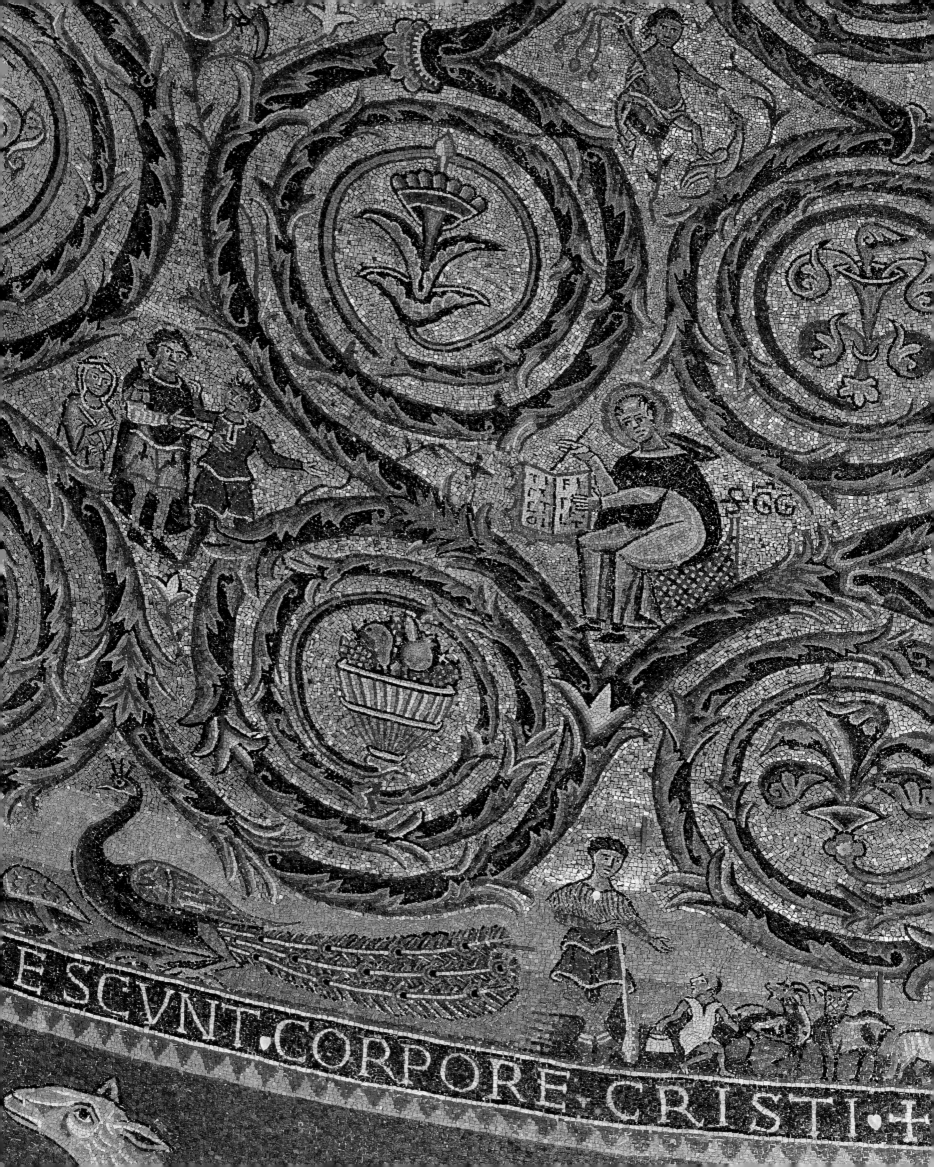

...ESCVNT·CORPORE·CRISTI·...

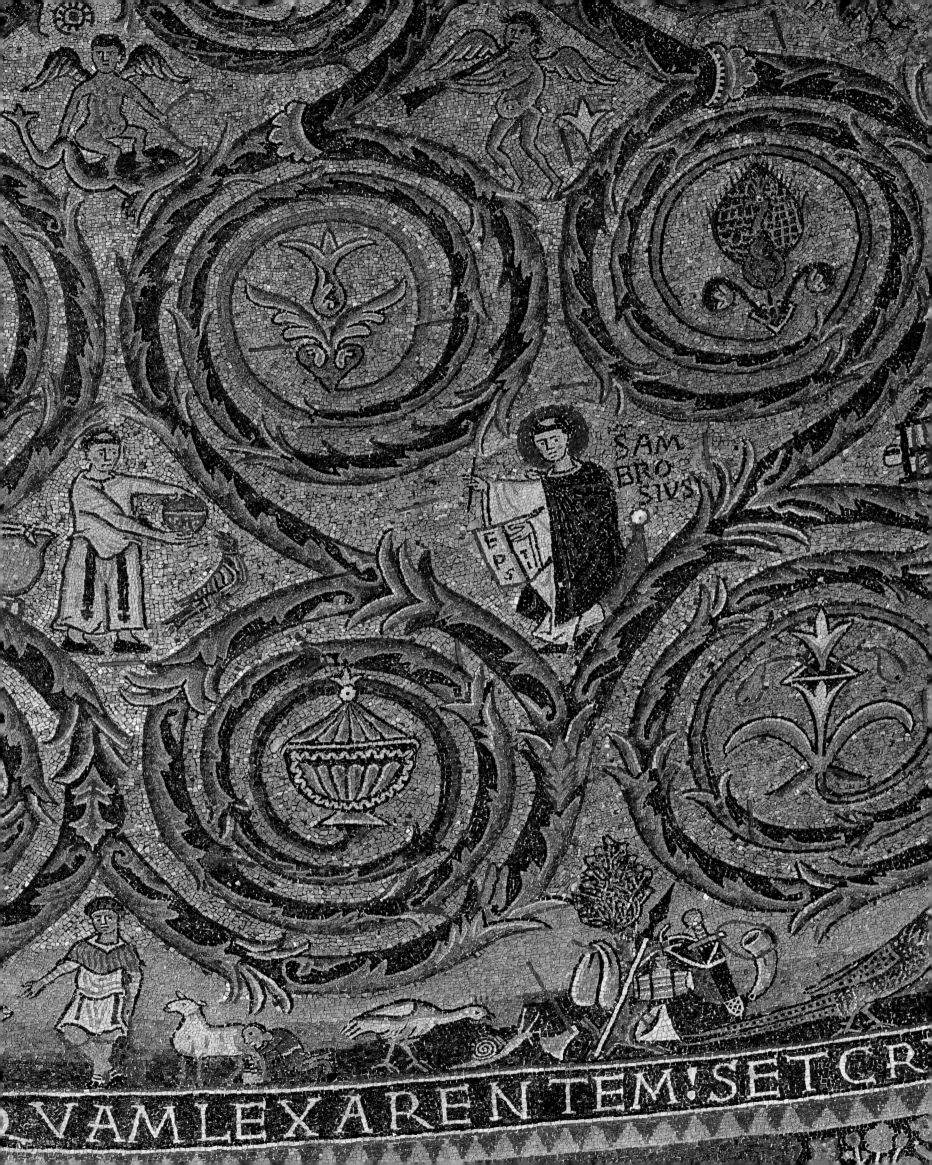

SAM
BRO
SIVS

VAM LEX ARENTEM! SET CR

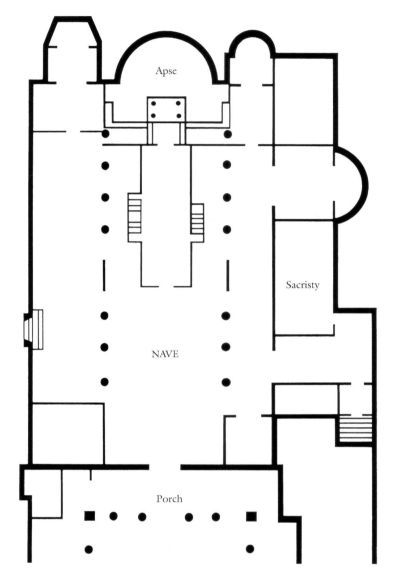

Apse

Sacristy

NAVE

Porch

Upper basilica

Mithraeum

Apse

NAVE

NARTHEX

0 10 m

Lower basilica
Parts of the building dating from the
fourth century

Basilica of San Clemente

PREVIOUS PAGES: Detail of the apse mosaic of San Clemente (1120). This composition with foliage scrolls and small figures surrounds the cross, Mary, and Saint John. The subjects between the scrolls represent the gestures and faculties of man. In the lower part of the mosaic: work on the soil and from pastoral life; in the middle: doctors of the Church and laity; in the top row: small spirits, Psyches, and birds.

Detail of the fresco depicting the apostles, painted below the apse mosaic of San Clemente.

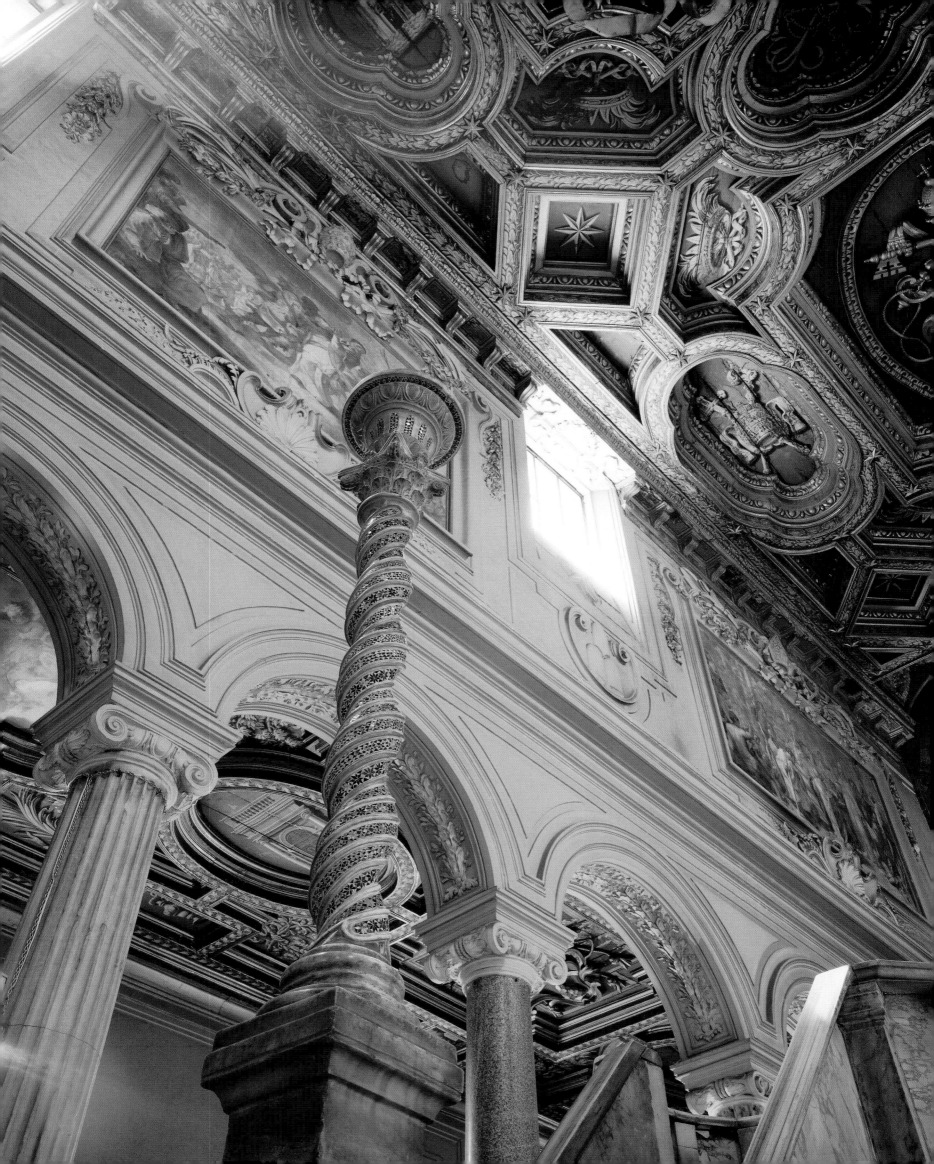

The church of Santi
Quattro Coronati,
founded in the fourth
century, was rebuilt in
the seventh century.
It was restored in
the twelfth century,
when the nave was
decorated with a
rich Cosmatesque
pavement.

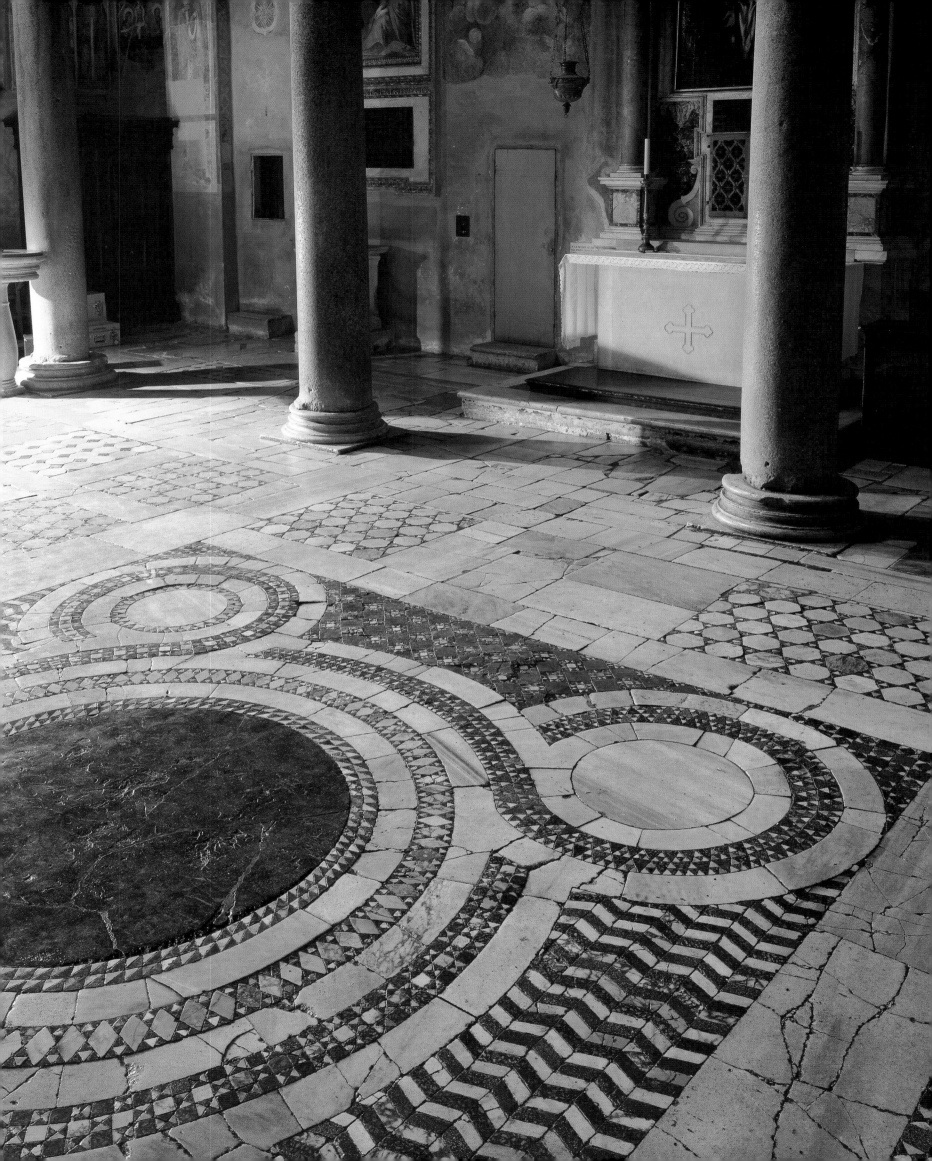

century? We do not know. However, rooms embellished with paintings of undeniably pagan inspiration have been found to have existed on the same site. Did these serve merely an ornamental purpose? There is reason to doubt it, given that they represent, rather curiously, scenes evoking legends connected to the life beyond the grave. Did the oldest Christian building replace one used by a mystical pagan sect? It is difficult to determine.

Not far away, and also close to San Clemente, is a church that now resembles a fortress, as if it had to defend the street leading to the Lateran. Santi Quattro Coronati claims the patronage of the Four Crowned Saints—soldiers who were said to have suffered martyrdom at Sirmium in Pannonia. Built in the fourth century, the church underwent reconstruction first in the seventh century and then in the ninth. It was partly destroyed by fire in 1084, when Robert Guiscard and his Normans came from Southern Italy to release Pope Gregory VII, held prisoner by Emperor Henry IV and the Roman populace. Pope Paschal II rebuilt the quarter about 1110, so extensively that the original structures are now difficult to identify. A chapel consecrated to Saint Sylvester located under the portico of the first courtyard reminds us that for a long time this church kept alive the memory of the struggles of the popes against the emperors. The frescoes painted there in 1246 narrate the legend of Constantine as it had been elaborated in the popular imagination, telling how the emperor had been cured of leprosy by Pope Sylvester, whose reward was sovereignty over the city of Rome. This edifying tale, intended to justify papal authority to the emperors, was depicted in the chapel of Saint Sylvester at a time when Emperor Frederick II had just been deposed by the Council of Lyons. The peaceful cloister seen today, with its flowers, its double columns, and its central fountain, came into being at the outset of the thirteenth century.

In Honor of the Virgin

Political events were not the only factors affecting the location or the decoration of churches. It was no accident that the great basilica on the Esquiline, Santa Maria Maggiore, became one of the most famous sanctuaries in Rome, thanks to Pope Sixtus III. Since the time of Pope Liberius (352–366) the site had been host to a church of modest size, erected following a vision. The Virgin Mary had appeared to the pope during the night of 4–5 August 352 and had asked him to have a church built in her honor at the place

The cloister of the church of Santi Quattro Coronati shows the work of marble masons of the early thirteenth century: twin columns with plain capitals and slight polychromy on the frieze. At the center is a fountain with a large basin for ablutions.

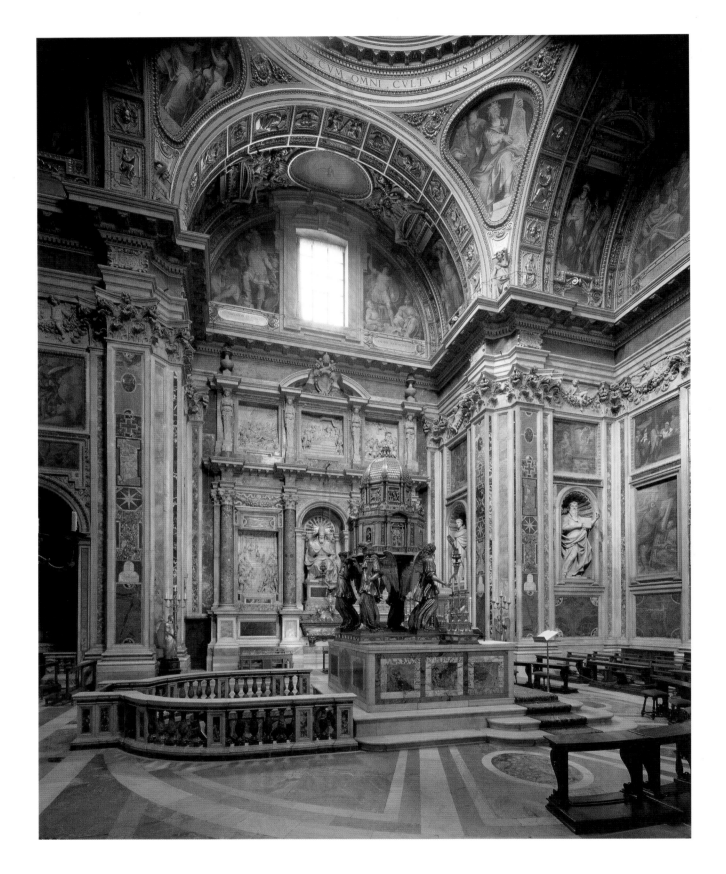

Basilica of Santa Maria Maggiore, founded in the fifth century. Its Sistine Chapel and its dome were built by Domenico Fontana in 1586 by order of Sixtus V. The chapel, revetted with marble from the Septizodium on the Palatine and decorated with frescoes, contains the monumental tombs of Sixtus V and Pius V.

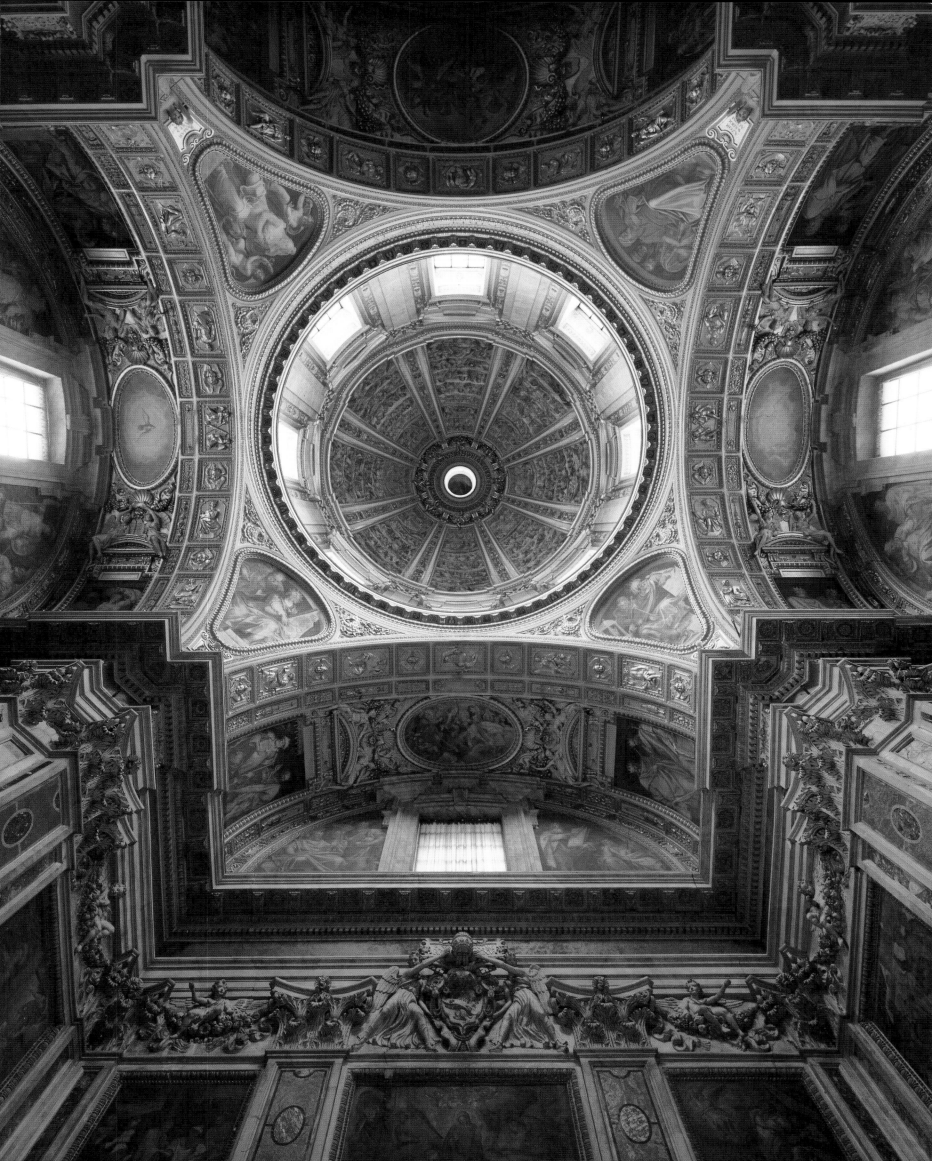

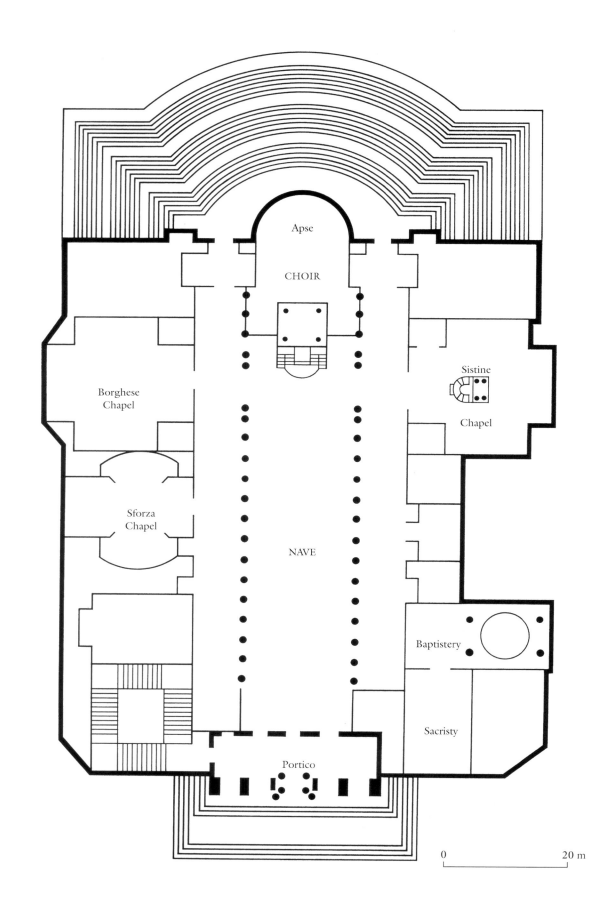

Apse

CHOIR

Sistine

Chapel

Borghese
Chapel

Sforza
Chapel

NAVE

Baptistery

Sacristy

Portico

Basilica of
Santa Maria Maggiore

0 20 m

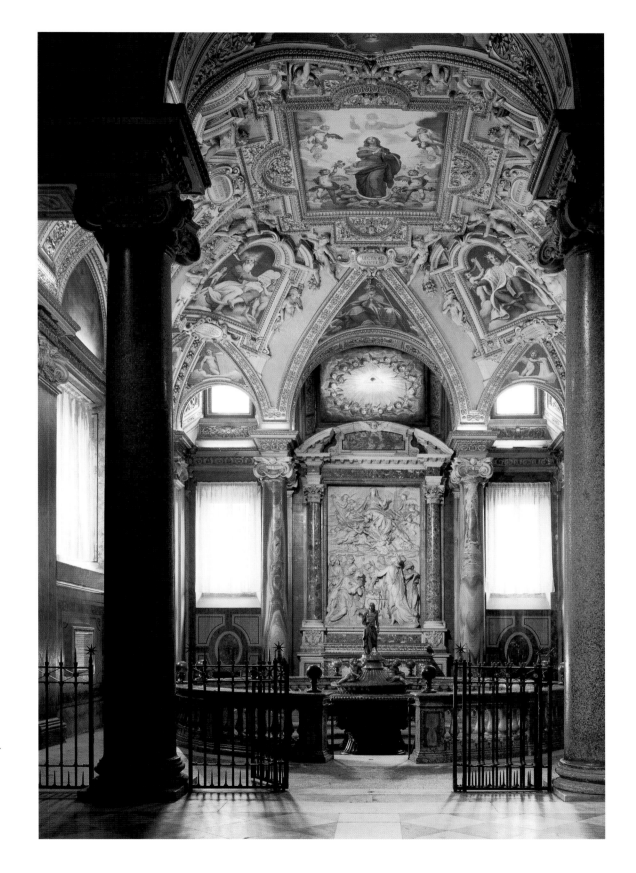

Baptistery of the basilica of Santa Maria Maggiore. The porphyry font basin was decorated by Giuseppe Valadier in the nineteenth century; the altar is embellished with a high relief of the Assumption by Gian Lorenzo Bernini.

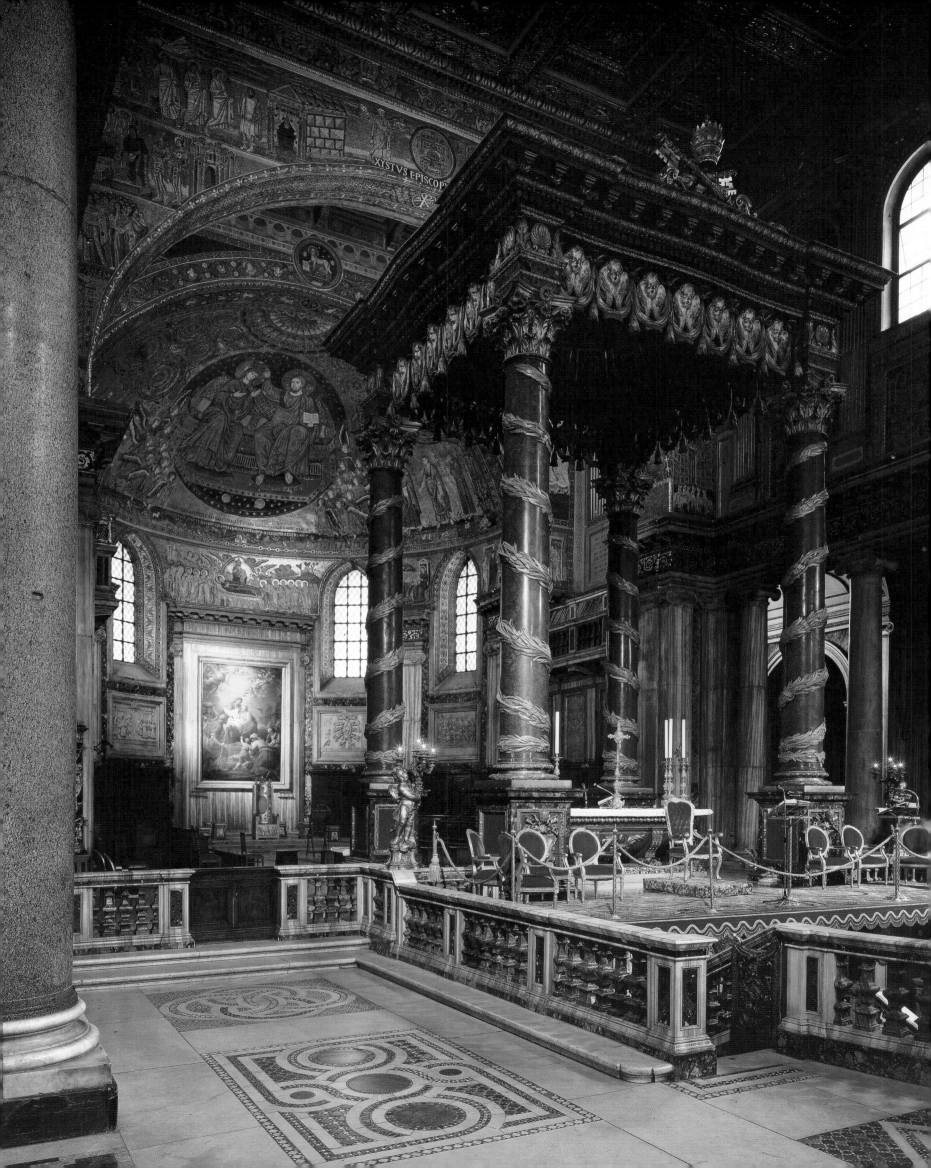

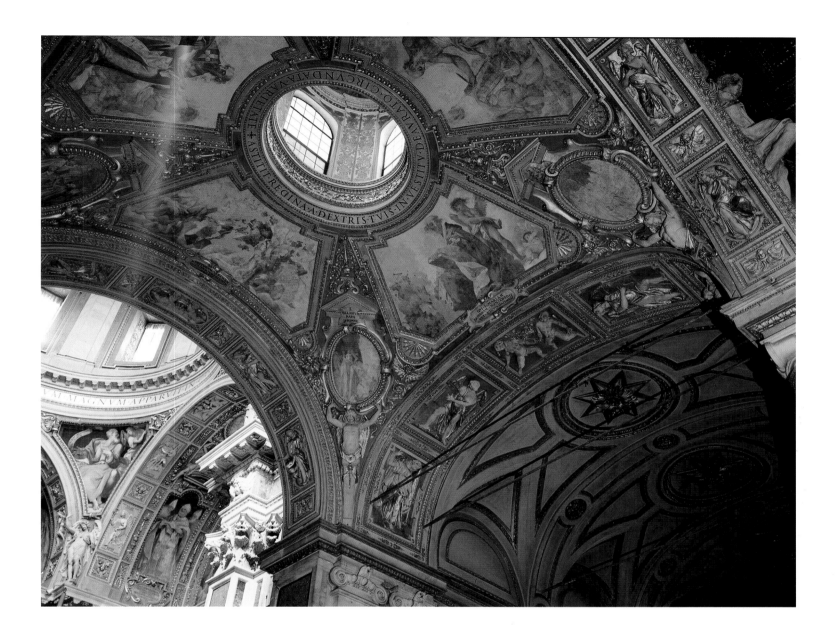

OPPOSITE: Apse, triumphal arch, and baldachin of the basilica of Santa Maria Maggiore. The apse mosaic by Jacopo Torriti dates from 1295 and depicts the Coronation of the Virgin surrounded by two large acanthus scrolls and a representation of the River Jordan.

At the base of the calotte, a series of scenes from the life of Christ dating from the fifth century. The baldachin with porphyry columns is the work of Fuga.

The vault of the crossing of the left aisle and transept in Santa Maria Maggiore.

where, the following day, a patch of snow would be found. This place turned out to be on the Esquiline, on the highest part of the plateau. Pope Liberius obeyed the Virgin's command and built the church requested, thereby establishing a place of worship destined to become an obligatory stopping point on any pilgrimage to Rome.

Heretofore only one church, recently built during the pontificate of Julius I, had been consecrated to the Mother of Christ, the Basilica Julia in Trastevere, now covered by Santa Maria in Trastevere. The dedication to Mary, which appears to have emerged suddenly with the almost simultaneous construction of the Esquiline and Trastevere basilicas, may be explained by the resolution of old disputes, carried on since the beginning of Christianity, concerning the nature of Jesus and thus the carnal or spiritual nature of his conception. We should not forget that a large Jewish community lived in Trastevere, and that its members were inclined to think of Jesus as a man, born in the same way as all humans. To assert the sanctity of Mary in this district was to pit orthodoxy against doctrines inspired by Judaism. And sure enough, it was not long before the assertion was confirmed by Pope Liberius's vision and the construction of his basilica on the Esquiline.

Nevertheless, arguments over the nature of Christ, and consequently that of the Virgin, did not vanish. Dispute broke out anew with the preaching of Nestorius, patriarch of Constantinople since 428. According to Nestorius, Mary was not the "mother of God"; rather, she had merely brought into the world a man in whom a divine nature had subsequently emerged and evolved. A council held at Ephesus in 431 condemned Nestorius's doctrine and proclaimed that Mary had indeed given birth to a divine being. This declaration, which caused much upheaval, especially in the Eastern Church, was accepted by the bishop of Rome, Pope Sixtus III, who thereupon decided to erect a large basilica not far from that of Liberius, which had suffered in the sack of Rome led by Alaric. From now on the basilica on the Esquiline would serve as the center of the cult of the Virgin.

The decoration of Santa Maria Maggiore, a program that undoubtedly conformed to the wishes of Sixtus III, tells the story of Jesus and his Mother in a series of mosaics, displaying the continuity of biblical times and laying out the whole genealogy of Christ. The Gospels concerning the Savior's childhood appear on the triumphal arch. As for the life of the Virgin herself, it unfolds in the apse mosaic, which dates only from the thirteenth century and embraces subjects already treated at Santa Maria in Trastevere,

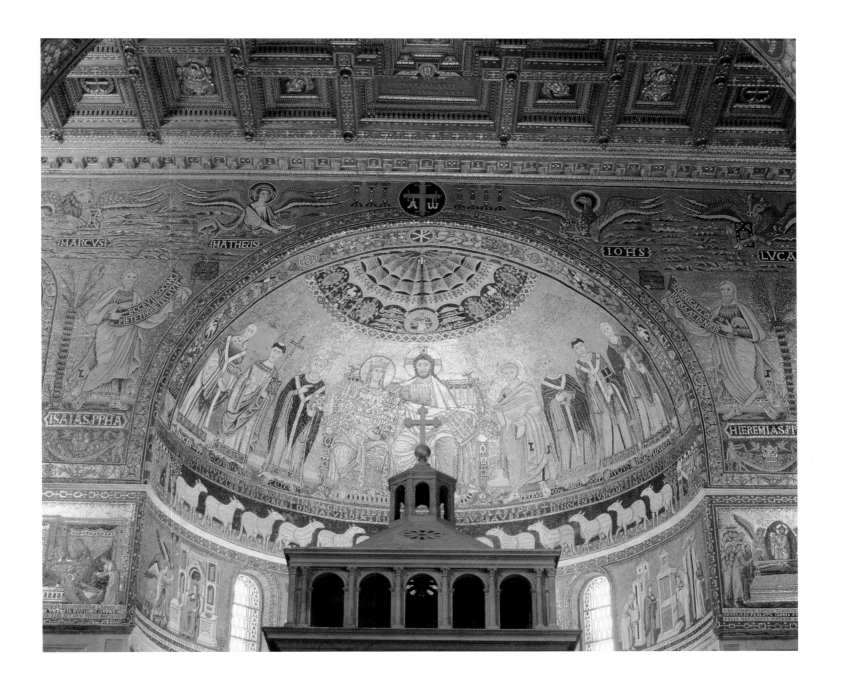

Basilica of Santa Maria in Trastevere. The mosaics of
the triumphal arch and of the apse calotte date from the
twelfth century. On the arch: Isaiah and Jeremiah and
the symbols of the four Evangelists. On the calotte:
Christ with the Virgin dressed as empress on a throne
and surrounded by popes and saints. On the base: two
files of sheep leaving Bethlehem and Jerusalem to join
the Lamb of God.

61

where the mosaic decorating the apse sets forth the triumph of Jesus and Mary. The Virgin is dressed as an empress, a Byzantine one, but Jesus has placed his arm round her shoulders, a tender gesture that humanizes them both. The mosaic may have been influenced by Saint Bernard, who happened to be in Rome at the time of its creation. Also on the triumphal arch is a curious symbol, an inhabited bird cage located near the figures of Jeremiah and Isaiah. Two banderoles worn by the prophets reveal the meaning of the image: they read "Our Lord Christ was taken prisoner by our sins" (Jeremiah) and "Behold a virgin who will conceive and bear a son" (Isaiah). According to the doctrine of Ephesus, Jesus, who is God, existed before the Incarnation; the body of Mary was a prison imposed on the Lord by human sin, but the Savior liberated Himself through the Incarnation. Two other banderoles recount the dialogue between Son and Mother. The first announces: "Come, you whom I have chosen, and I shall place you on my throne," to which the Virgin replies: "His left hand shall be under my head and his right hand shall embrace me." It has been shown[9] that the terms of this dialogue are those of two antiphons from the Assumption liturgy, both endowed with the spirit, if not quite the letter, of the Song of Songs. We can therefore conclude that while devotion to Mary had not been expressed in church construction for six or seven centuries, it was present nevertheless. It had also become increasingly human, the Virgin appearing more and more as a mother and less as a princess. This evolution of sensibility occurred not merely in Rome but also throughout Western Christianity.

Santa Maria Antiqua, an eighth-century church built somewhat haphazardly in an outbuilding of the old Imperial Palace in the Forum, boasts decorations revealed by excavations carried out early in the twentieth century. When the church acquired its name is not known, but construction began during the first years of the eighth century, under Pope John VII (705–707). Still, what survives very likely dates from the pontificates of Zacharias (741–752) and Paul I (757–767), who reigned during the period when iconoclasm erupted in the Eastern Church. The sheer number and magnificence of the images constitute a protest against the Byzantine ban on the portrayal of sacred figures. Because the representational style used at Santa Maria Antiqua is Eastern and thus foreign to Roman art, it seems clear that the decorative program was meant to affirm the unity of Christianity. Hence the saints of the Roman Church appear on one side of the enthroned Christ and those of the Eastern Church on the other.

Left aisle of the church of Santa Maria in Cosmedin, with three aisles and three apses, founded in the sixth century and enlarged in the eighth, when it became the church of the Greek community.

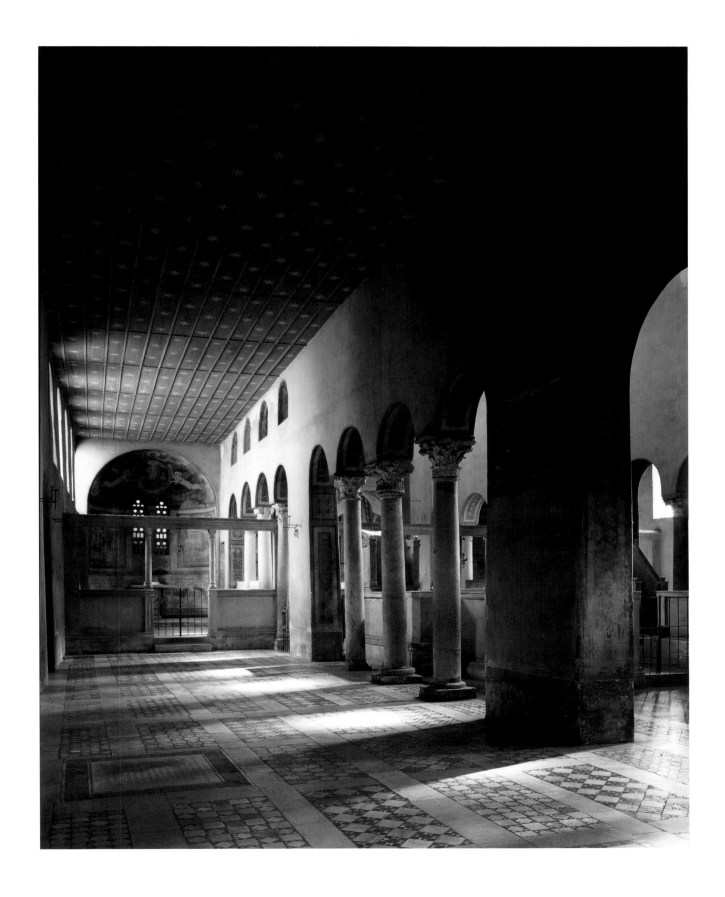

The nave of the church of Santa Maria in Cosmedin. The sumptuous pavement is the work of the Roman Cosmati. In the center, the *scuola cantorum* and presbytery were restored in the nineteenth century. This is a unique example of a *pergula* erected over a presbytery enclosure and intended to be fitted with curtains.

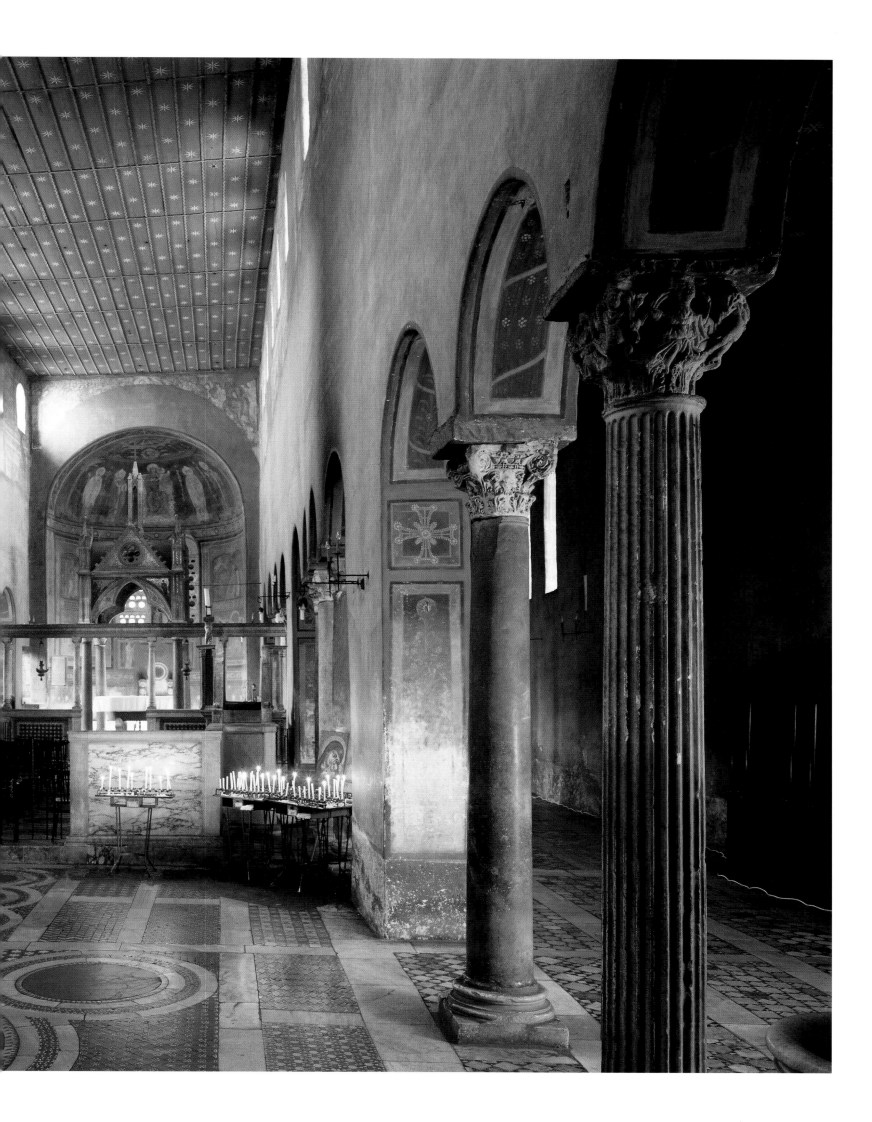

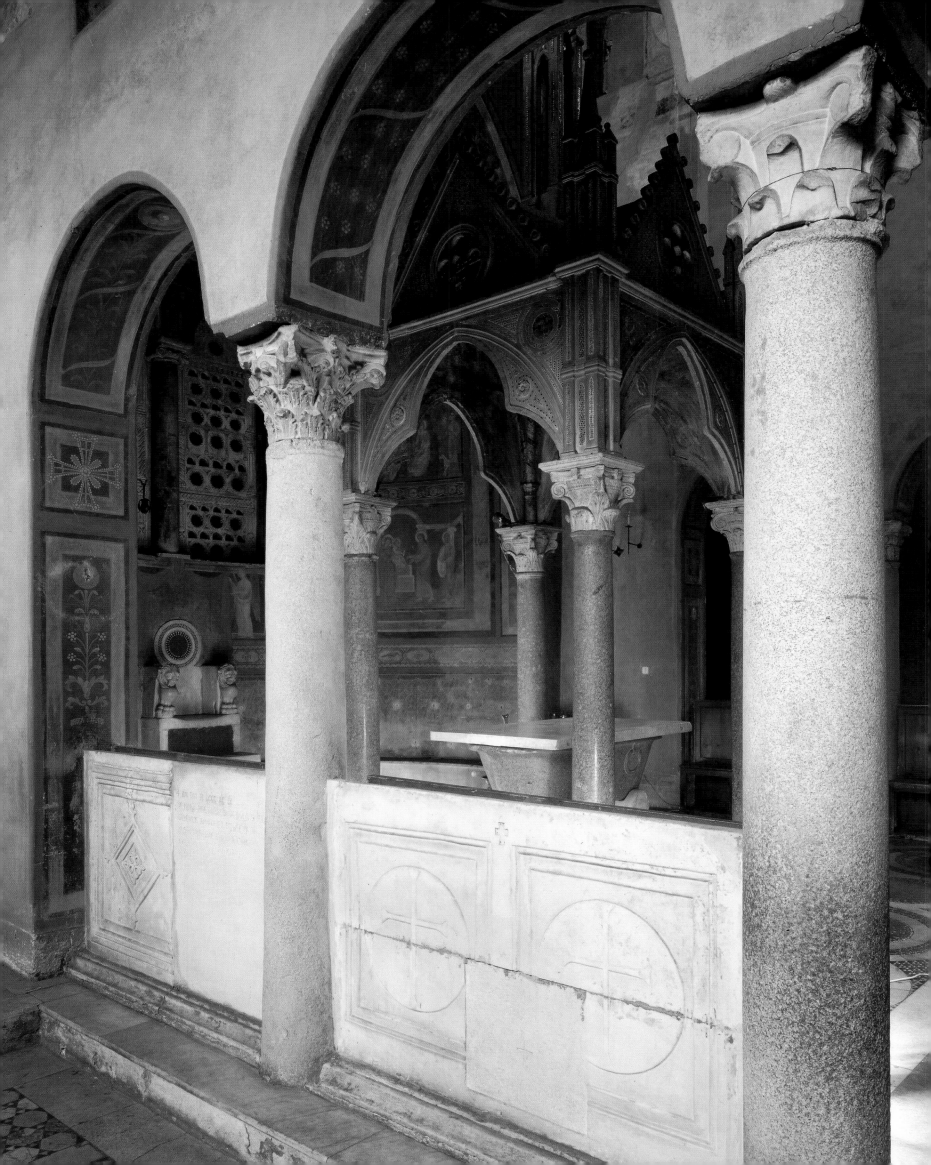

Antique columns and reused capitals and episcopal throne in the church of Santa Maria in Cosmedin. The altar is made of an antique bath and still bears the table consecrated in the twelfth century.

ABOVE: Candelabrum for the Paschal candle with encrusted decoration.

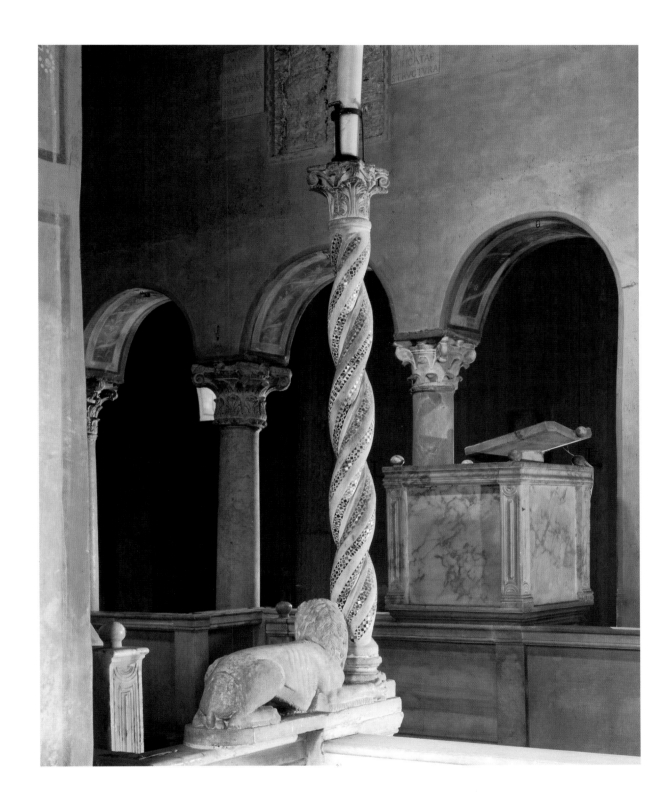

Santa Maria in Dominica, another Marian church dating from the iconoclastic era, was built by Pope Paschal I (about 820) on the Caelian Hill. In this basilica with nave and aisles the apse mosaic depicts Mary between two angels, while the triumphal arch presents the image of Christ, again with flanking angels. By ceding the place of honor to the image of the Virgin, Rome appears to have been eager to refute the heretical arguments of the iconoclasts and to reaffirm the divine nature of the woman who bore the Savior.

The church of Santa Maria in Cosmedin, also consecrated to the Virgin and perhaps for the same reasons, is located in Rome's Greek quarter, near the old port where ships loaded with grain arrived from overseas. It was also the port of entry for many strangers, among them that eternal voyager Hercules, who, according to legend, triumphed here over the abominable brigand Cacus. Nearby was an altar, the *ara maxima,* dedicated to the powerful Greek hero. It is therefore not surprising that Pope Adrian I gave Santa Maria in Cosmedin to Greeks who had sought refuge in Rome at the end of the eighth century, after the iconoclasts had begun ravaging the Eastern Church. It was an old basilica, apparently erected in the sixth century and invested with such archaic traits as a *pergula,* an example of which we saw earlier. Pope Adrian had the church enlarged, but not unduly modernized, and his preeminence asserted in a magnificent pontifical throne.

Santa Maria in Cosmedin is flanked by a campanile, one of those bell towers that, together with the multitudinous domes, make up the Roman skyline. These shafts with perforated tops had no place in the older churches and did not figure in their plans. Were they added later, beginning with the pontificate of Gregory VII (1073–1085), in order to meet the needs of liturgy? We do not know. One could readily imagine that the campanile once present alongside the basilica of Constantine in the Vatican rose in the eighth century, when Pope Stephen II celebrated the coronation of Pepin the Short in Saint Peter's. Was this campanile the model for all those that still punctuate the Roman skyline? Here, too, we have little information. The great bell tower in the Vatican was demolished in the fifteenth century to make way for the new Saint Peter's. Many of those that survive are situated on the right bank of the Tiber, while others signal the world from almost deserted areas, like the campanile of Santa Francesca Romana in the old Forum, where sheep used to graze. Still others, such as the one at Sant'Eustachio, are on

the Campus Martius. In a medieval Rome too large for its diminished population, the campaniles marked the positions of shrines, rallying points amid the ruins and the solitude. Elsewhere, they provided centers around which the frightened inhabitants of a city without defenses could gather for protection. Under Pope Gregory XIII, toward the end of the sixteenth century, a tower much like a campanile was added to the Palazzo Senatorio on the Capitol.

The Transfiguration of Pagan Motifs

Santa Sabina, built high on the Aventine Hill overlooking the Tiber, marks an important moment in the history of Christian Rome. The basilica was erected by a priest from Dalmatia, Peter of Illyria, a few years after the sack of Rome by Alaric, while Saint Augustine spent his last years as bishop of Hippo in North Africa. It was built, with a nave and aisles but no transept, over existing structures, including an old *domus ecclesiae,* in this case a *titulus Sabinae.* Santa Sabina was long thought to have replaced the Temple of Juno, the temple for the goddess brought here as an honored prisoner so that the Romans could use her power for their own purposes. We now know better; even so, the site commands interest. Thanks to Alaric, pagan temples as well as Christian churches had been ransacked and destroyed. This was viewed as a providential sign. Upon the ruins of the world from before the Revelation, why not build a new temple, one that would glorify the Lord? Given this attitude, it may have mattered little that the church's foundation stones were those of the old temple; the important thing was that the new basilica would reveal the path of Truth. The teachings of Saint Augustine in these same years bore the same message.

Notwithstanding, the actual layout of Santa Sabina suggests influence from the old pagan world then being negated. For the most visible evidence of this, one has only to consider the superb Corinthian columns, obviously carved at the height of the Empire, when Roman architects were developing formulae elaborated in the Hellenistic East for pagan worship. It is inconceivable that craftsmen in the first quarter of the fifth century could have created such capitals and such delicately fluted columns from their own resources. We have also noted that the basilican plan itself had been taken from civil and imperial architecture. Further, we know that the parallel arcades separating the nave from the side aisles follow an Italian architectural tradition. At Pompeii, moreover, there are

peristyles with springing arches in place of flat or trabeated architraves, confirming that such a solution to the problem of the colonnade had been utilized in Campania no later than the beginning of the Christian era. Also in pagan times, at the end of the Republic or the beginning of the Empire, the fashion of making pavements and revetments of polychrome marble had already begun to emerge, notably on the Palatine. Just as the bishop's seat had replaced the emperor's throne or the statue of the prince in the apses of churches, all imaginable splendor, including the splendor of Rome, would be placed in the service of the God who was now recognized as master of the world.

One of the most notable features of Santa Sabina is the light streaming into the apse, nave, and aisles from the large windows. This was not always the case, owing to the wave of austerity that swept through Roman Catholicism following the Council of Trent, which judged such abundant illumination to be too stimulating and thus not conducive to meditation. As a consequence, many of the windows at Santa Sabina were bricked up, leaving only six of the twenty-six openings free. Today, the original fenestration has been restored, allowing the ancient church to dispel the terrors of darkness. Santa Sabina has become more or less the basilica Peter of Illyria wanted it to be—a palace worthy of the Lord.

Unfortunately, the interior decoration is no more than a distant memory of what it may once have been. The mosaic covering the apse gave way in the sixteenth century to a painting, which may actually reproduce the old motifs—a spring gushing from a rock and sheep symbolizing the faithful come to drink there. The original cypress doors, on the other hand, retain their beautiful reliefs, carved with scenes from the Old and New Testaments: the Crucifixion, the Appearance of Jesus before Pilate, the Miracles of Moses, the Adoration of the Magi, and the Crossing of the Red Sea. Eastern influence may be present in the choice and composition of the images, which recall scenes carved on sarcophagi, but the structure of the church derives from Roman monuments rather than from Eastern models. Also, the marble slabs marking out the different areas intended for worship may have been designed by Roman marble masons, without reference to Byzantine models.

The fluidity of these images, in which plant motifs are combined with purely geometric forms, recalls draperies found on third- and, particularly, fourth-century Roman monuments and mosaics. Marble masons and mosaicists had at their disposal an

Detail of the main doors of Santa Sabina in cypress wood, dating from the fifth century. The carved bas-reliefs on the panels depict scenes from the Old and New Testaments, formerly placed in parallel. Here, a church framed by two towers, as in the Antioch region, may represent the annunciation of the birth of John the Baptist to Zacharias by an angel.

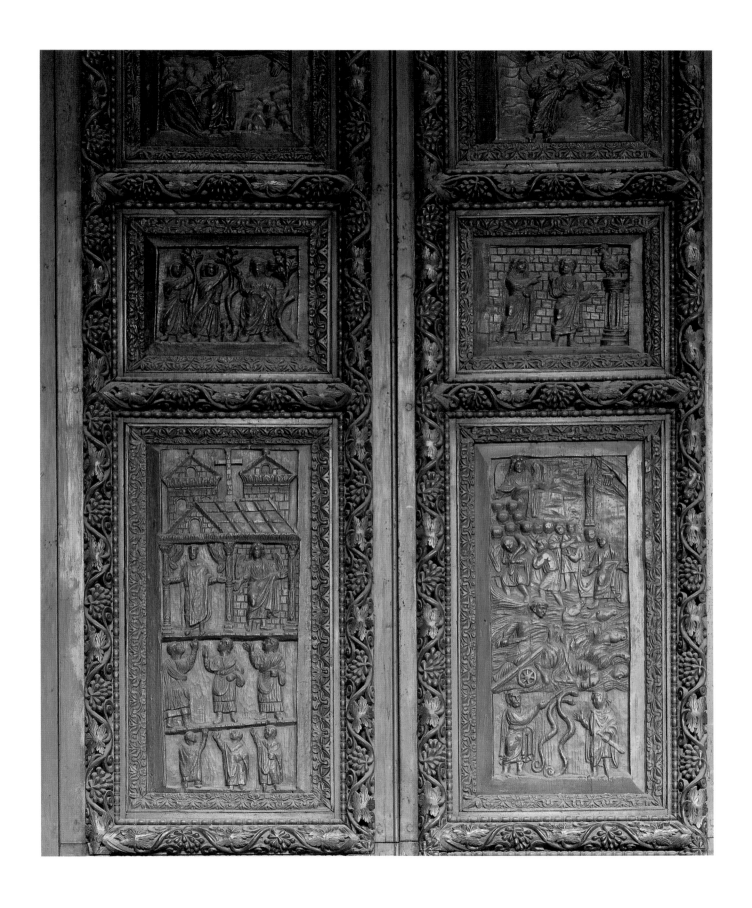

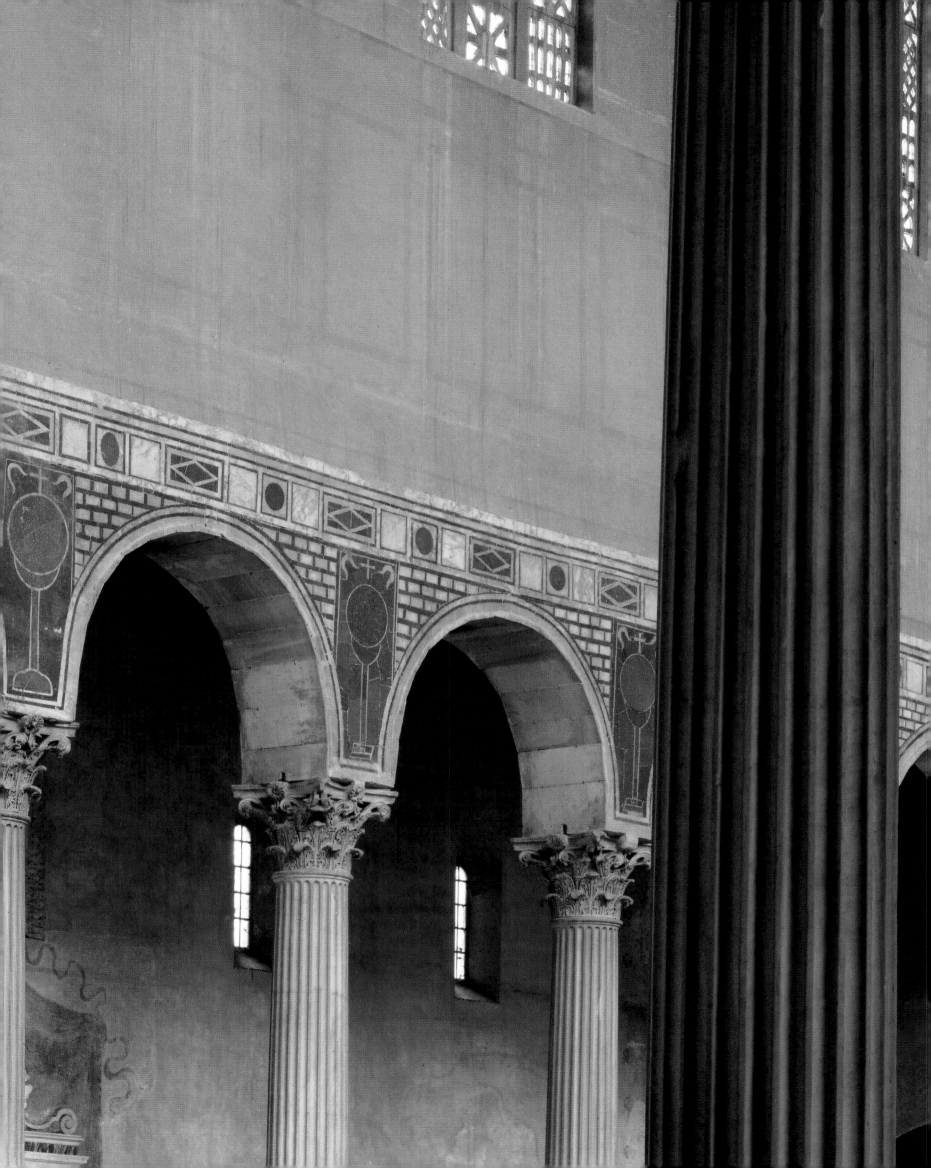

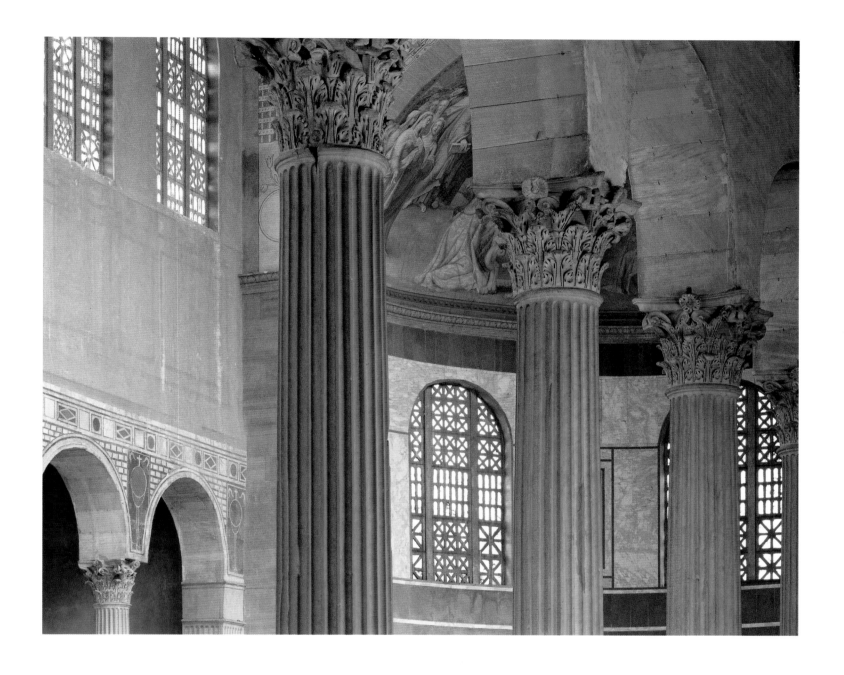

The columns of
the basilica of Santa
Sabina support
arcades decorated
with porphyry and
serpentine inlays
representing chalices
and crosses, perhaps
imitating an orna-
mentation procedure
used in palaces in
the imperial era.

Detail of the choir enclosure, divided into a *scuola cantorum* and a presbytery. The tracery decoration, sometimes a transposition of ancient motifs and scrolls, is Carolingian.

OPPOSITE: Left aisle facing toward the entrance of the nave of Santa Sabina.

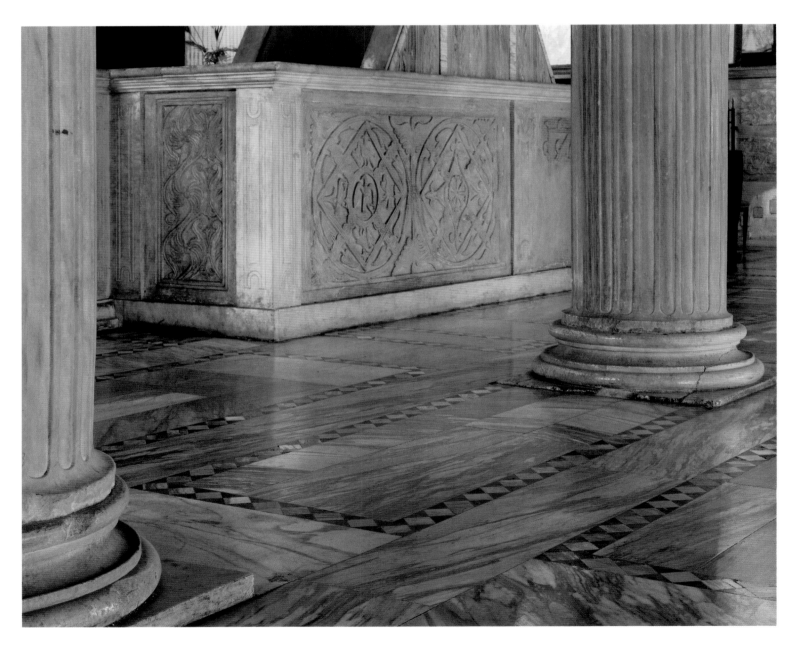

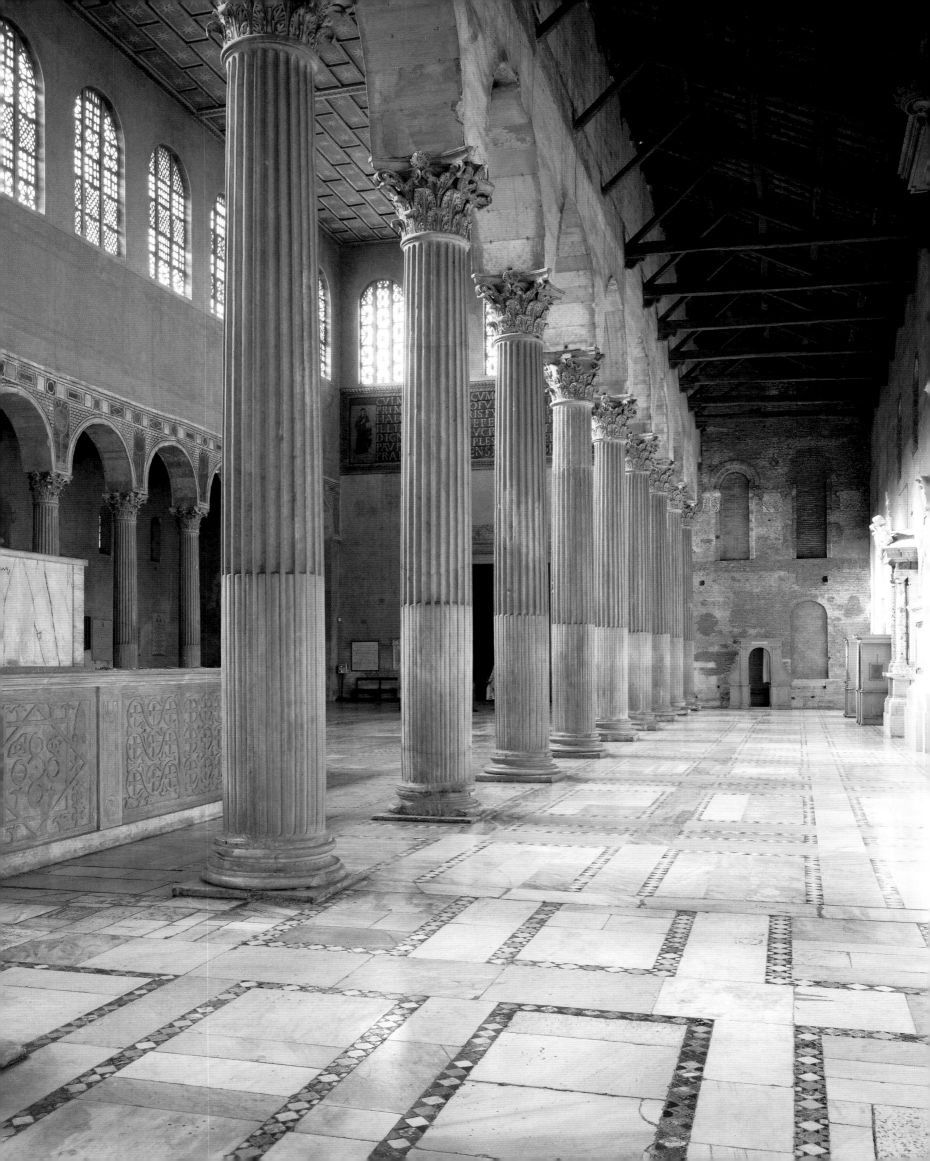

The basilica of Santa
Sabina, with three
aisles and a single
apse, has twenty-four
fluted and cabled
Corinthian columns
of Paros marble. Their
proportions, based on
Vitruvius, introduce
a note of classical per-
fection. Abundant
light enters through
the twenty-six win-
dows of the nave and
apse, passing through
slabs of selenite
mounted in frames
made of super-
imposed circles,
lozenges, and squares.
These windows
probably date from
the ninth century.

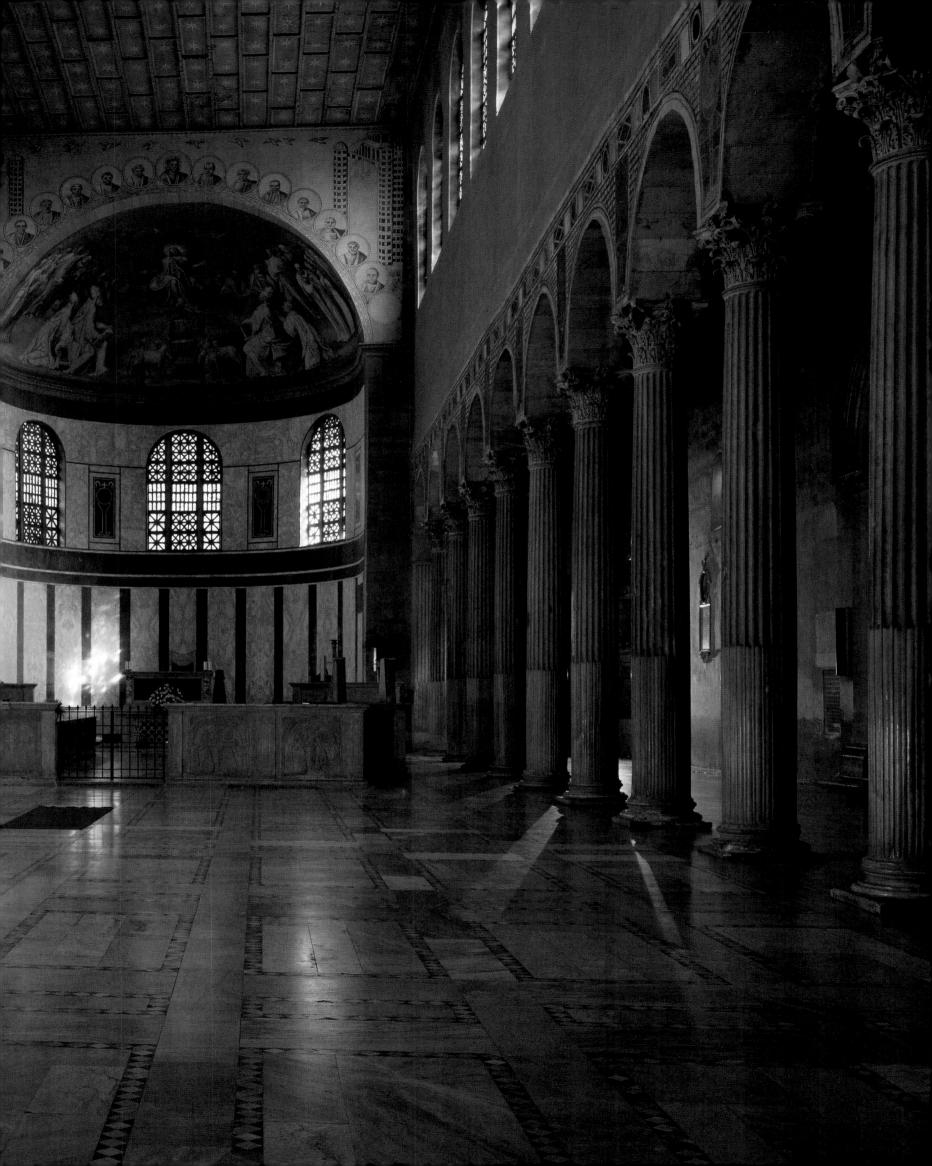

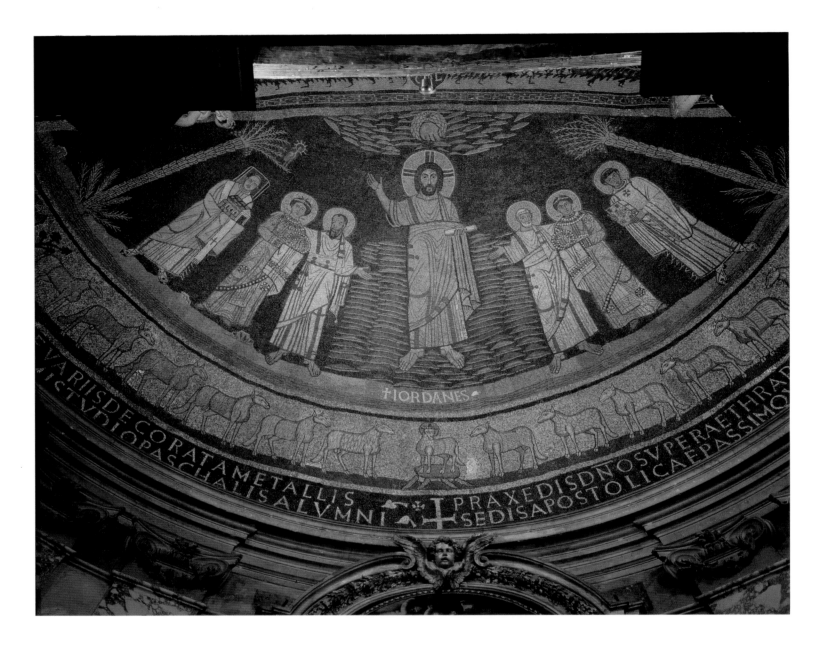

Carolingian mosaic in the apse of the church of Santa Prassede (817–24). Saint Praxedes and her sister Saint Pudentiana are received into heaven by Saint Peter and Saint Paul, who have put their arms around their shoulders. They present them to a Christ dressed in gold who is descending from heaven on a purple cloud. Saint Zeno on the right and Pope Paschal with a square nimbus and carrying the Church are introduced into eternity at the same time, shaded by two palms under a deep sky; the phoenix, a symbol of resurrection, is perched on the left palm. At the bottom, twelve sheep are converging toward the mystical Lamb.

inexhaustible stock of prototypes, drawn according to the dictates of inspiration and fantasy from sources as far away as Sicily, North Africa, Egypt, and Syria. But Classical motifs also found a place in this art, which flourished in Rome especially between the eighth and tenth centuries. Evidence of its popularity and quality abounds not only in the revetment and the *plutei* (breastwork) of Santa Sabina, but also in similar decorative programs within a whole series of churches, among them Santa Maria in Cosmedin, Santa Maria in Trastevere, and Santa Prassede. Here we discover motifs such as peacocks perched on an arm of the cross and drinking from the bowl of life, or vine scrolls coiling about flowers of various kinds. On every side appear allusions to anything that blossoms, develops, enhances our earthly existence, and promises us bliss in afterlife. The old Roman "naturalism" has been submerged, and the human visage is notable primarily for its absence here. When a face does appear, it stands outside the limits traced by the marble slabs. Only the faces of Christ, the apostles, and the various participants in the life of Jesus have the privilege of being admitted into this garden, the delights of which the faithful can only glimpse. Otherwise, why at Santa Sabina should the cross be placed under the great arch, which is so like a gate, and why should the palmettes be aligned as if they were an avenue of trees?

In Response to the Iconoclasts

Not far from Santa Maria Maggiore lies Santa Prassede, a basilica commemorating one of the two daughters of Pudens (the other being Saint Pudentiana), the mythical senator said to have welcomed Saint Peter into his house during the reign of Nero. A *titulus Praxedis* was established early, perhaps by the end of the fourth century (no evidence exists for the preceding period). A first basilica certainly stood on the site of the *titulus,* only to be replaced by the present structure during the reign of the Carolingian pope Paschal I (817–824). The new Santa Prassede, like Santa Maria Antiqua and other churches, came in response to the challenge of the iconoclasts, which explains the increased number of images within these basilicas. At Santa Maria Antiqua, alongside the files of saints and martyrs, we find portraits of purely Eastern inspiration, such as the face with elongated features and a gaze recalling the faces found at al-Fayum.

In Santa Prassede the apse and the two triumphal arches celebrate the victory of Christ and the joy of the heavenly Jerusalem, peopled by a throng of the elect, each

Ninth-century mosaic
on the first triumphal
arch of Santa Prassede,
representing the heav-
enly Jerusalem of the
Apocalypse, the city of
the Elect built of pre-
cious stones. At the
center, Christ between
two angels; beside Him
the Virgin, Saint John
the Baptist, Saint
Praxedes, and eleven
apostles. At the gates
of the stone wall angels
receive the saints wear-
ing crowns of gold.

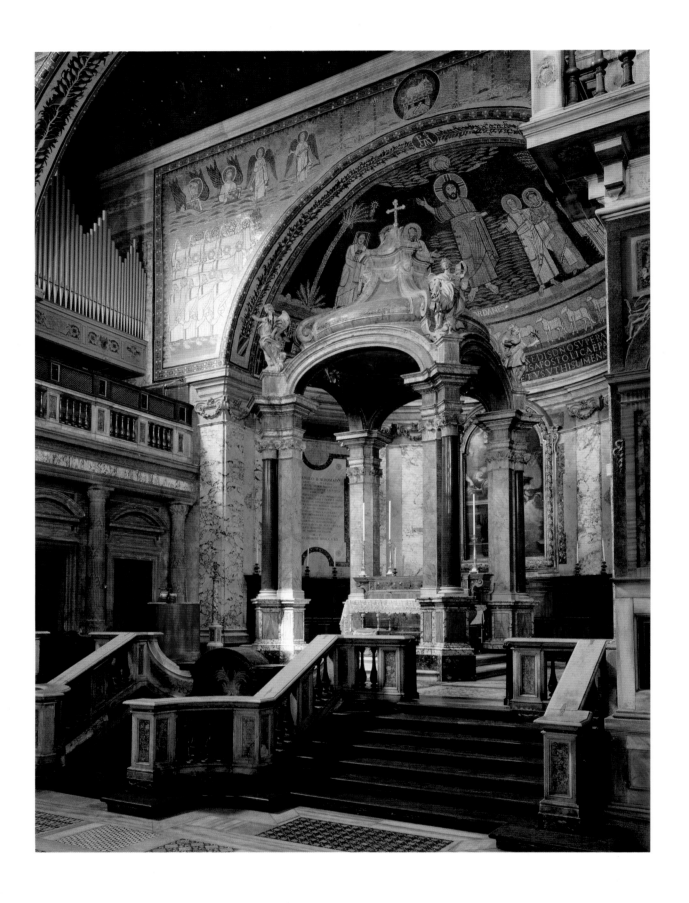

The choir and the baldachin of the high altar (seventeenth century) of Santa Prassede.

OPPOSITE: Loggia added to the pier of the triumphal arch in the seventeenth century.

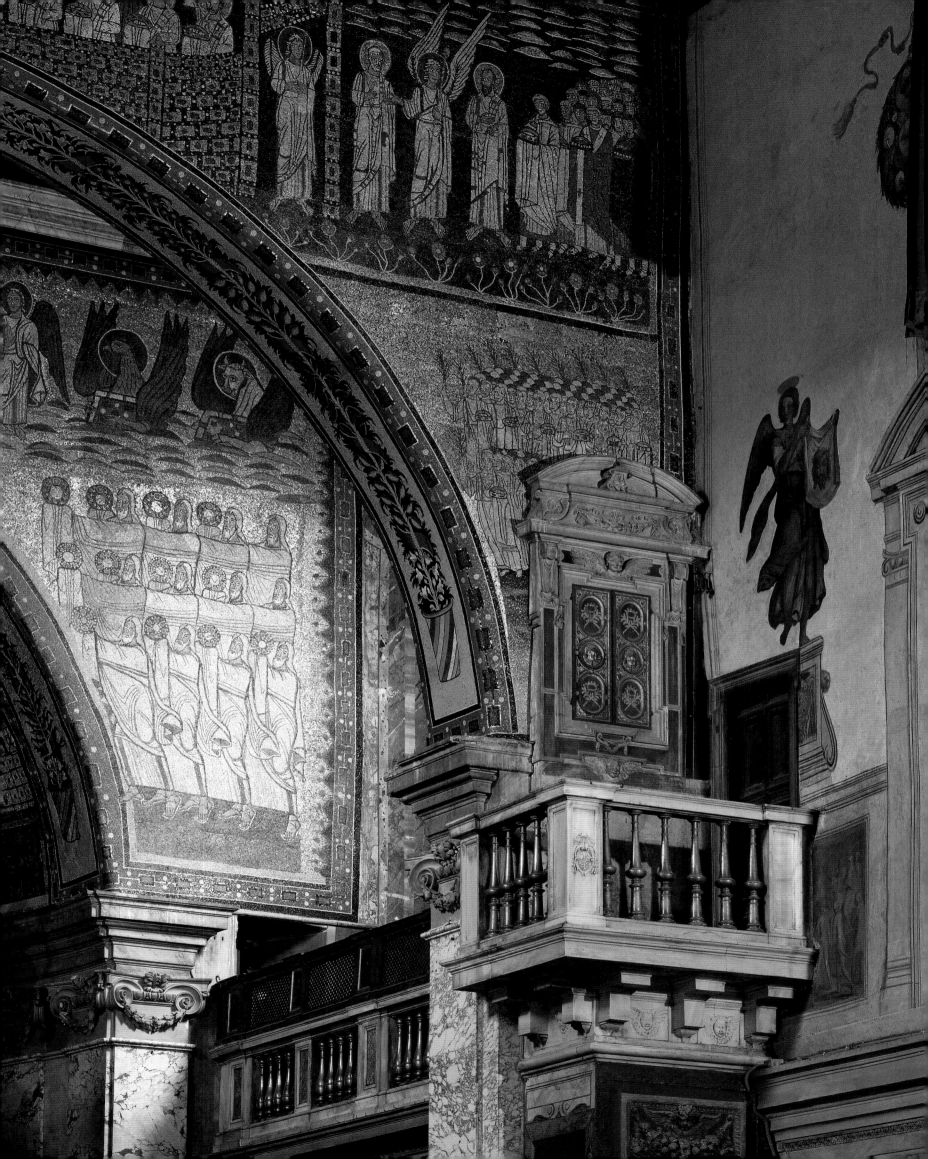

holding a palm, as if for an Easter procession. The mosaicists responsible for the decoration drew inspiration from the church of Santi Cosma e Damiano, by then already two centuries old.

Paschal I's intention at Santa Prassede was not only to assert the value of images; he also wanted to counter the iconoclasts' hostility to the cult of martyrs by heaping new honors on the sacred bodies. The church was thus provided with a crypt into which the relics of numerous martyrs were solemnly conveyed, many of them from the catacombs.

Opening onto one of the aisles at San Prassede is a chapel so marvelously embellished that it was long called the "Garden of Paradise." The name aptly expressed the purpose embodied in the church as a whole, since everything there evoked the rapture awaiting the faithful in the world beyond. The soul whose salvation the chapel proclaims belongs to Theodora, Paschal I's mother. The intercessor is Saint Zeno, one-time bishop of Verona (where his memory was especially cherished), whose actions had helped to sustain orthodoxy. The chapel of Saint Zeno constitutes an oratory in itself, where the vault, with its culminating figure of Christ surrounded by four angels, shows the path to heaven.

The Triumph of the Cupola

San Zeno, as the chapel was planned by Pope Paschal early in the ninth century and as it stands today at San Prassede, reveals why domes began to appear on the Roman skyline only in the last years of the fifteenth century. Since the reign of Constantine, meanwhile, Eastern churches had been endowed with cupolas, making them a form justly viewed up to our time as characteristic of Byzantine architecture.[10] Given that the architects who built Ravenna in the sixth century favored this type of roof, one might well ask why the builders of Roman churches seem to have been reluctant to adopt it, at least for important buildings, prior to the pontificate of Sixtus IV (1471–1484). And then, out of the blue, several large churches—Santa Maria del Popolo, Santa Maria della Pace, and Sant'Agostino—received dome vaults, all within a few years. The triumph of the cupola was soon complete, its progress traceable from Bramante's sketchlike Tempietto to Michelangelo's monumental achievement at the new Saint Peter's. Why did this form surge up so suddenly in Rome, and why is it inseparable from images associated with the flowering of the Renaissance?

From antiquity, Rome had inherited one building capped with a dome vault: the second-century Pantheon, donated in 609 by the Byzantine emperor Phocas, to Pope Boniface IV, who turned it into a church, Santa Maria ad Martyres. An immense building with a flattened cupola, the Pantheon is only distantly related to the domed churches that would come into being some eight centuries later. If subsequent architects failed to imitate it, it may be because they thought a Hadrianic temple originally dedicated to all the pagan deities lacked suitability as a model for Christian places of worship, despite its having been hastily adapted to the new religion. The few circular-plan churches that existed—Santo Stefano Rotondo, Santa Costanza—were little more than tombs and thus not particularly imposing. In such churches a more monumental form would perhaps have seemed a breach of taste. There was San Vitale in Ravenna, of course, but the Ravenna churches radiated an aura of the exotic. In other words, they bore the imprint of Byzantium, which could not but offend the Romans, proud of their own Western traditions and eager to remain distinct from the East. The Romans, as already noted, understood the symbolic and mystical import of the cupola, albeit without the conviction that an image of heaven offered to the faithful inside the church ought to be expanded into a dome on the exterior. Another factor may have been the slight awkwardness of the Byzantine domes in Ravenna. Moreover, they lacked the technical perfection of ancient vaults, and would never have fitted well into the Roman skyline.

Banished from the world without, the cupola found a place within churches, as at the San Zeno chapel. Here, according to Émile Mâle,[11] the motif of four angels with a medallion surrounding the Christ like a triumphal crown was Byzantine. The whole decoration of San Zeno reflects Eastern influence. Very likely, Greek artists were involved, even if their influence did not extend to the general plan of the building.

For centuries the only cupolas in Rome were those crowning the small circular churches already mentioned. It is possible that the Great Schism that divided Christianity into East and West—first in 863 and then, definitively, in 1044—contributed to the long veto on monumental domes. Before such structures could reappear in Rome, architects had to reinvent them, using new techniques, so that the domes would be neither too flat nor too slender but, instead, triumphantly rounded and harmonious. The new Roman cupolas owe nothing to the domes of San Marco in Venice, which antedate them by four centuries and derive from Byzantine prototypes. Their prehistory is to be found,

Vault of the chapel of San Zeno added to the right aisle of Santa Prassede by Pope Paschal I in honor of his mother Theodora (817–24). In the vault, mosaics of Byzantine inspiration show four standing angels lifting a bust of Christ in a triumphal crown above their heads.

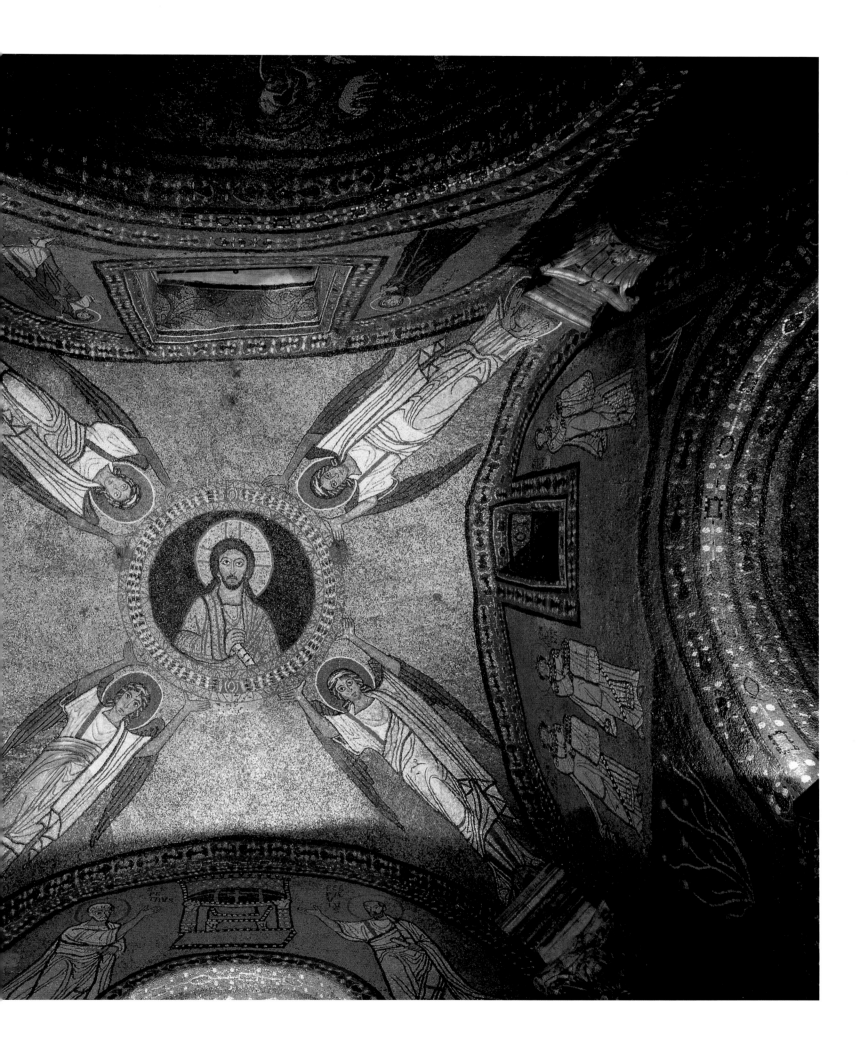

rather, in Florence, at the baptistery of San Giovanni, generally dated to the fifth century, and, more convincingly, at the cathedral of Santa Maria del Fiore, built by Brunelleschi in 1420 to solve a formidable problem created by his Gothic predecessors: how to vault the vast space of the transept, which required a dome measuring an unprecedented 45 meters in diameter. The great Florentine cupola very quickly became the paradigm. Indebted neither to Byzantium nor to Ravenna or Venice, it may echo the cupola of San Michele in Pavia, erected in the twelfth century, although in a manner more like Gothic vaults with intersecting ribs.

The cupolas of Rome have their source in the Florentine architecture that came to fruition during the Early Renaissance. Not surprisingly, this happened thanks to a pope, Sixtus IV, from the Della Rovere family of Savona, who had contacts with Brunelleschi. After the end of the schism with Avignon in the early fifteenth century (1417), the popes, starting with Martin V (1417–1431), set about to endow Rome with its ancient splendor. Throughout the century there was intense architectural activity in the city, which accelerated in anticipation of the jubilee year, fixed for 1475. All the building projects benefited from the Florentine experience, for in this period the first Roman cupolas were erected, at Santa Maria del Popolo (1479), Santa Maria della Pace (1483), and Sant'Agostino (1483). By this time, almost forty years after the death of Brunelleschi, domes no longer had quite the same shape or appearance as those of Florence, but it is to Tuscany that Rome owes its ultimate skyline. The antique precedent had a real if subliminal effect, contributing to the formulation of a Roman style, in contrast to the idiom of Northern Italy. Inevitably, the architecture of Roman churches embodied religious feeling and a conception of the divine proper to the capital of Western Christianity.

Santa Maria della Pace rose on a site where a miracle had occurred, involving a dice player who, annoyed at losing despite his prayers to a nearby Madonna, had stabbed the image with a knife, whereupon a few drops of blood flowed from the wound. News of the miracle spread, and Sixtus IV decided to build a church on the spot dedicated to the Virgin. These were troubled times: the king of Naples attacked the Papal States, Romans feared invasion by the Turks, and there were riots in Florence and rumors of conspiracy on every side. Intervention by the Blessed Virgin appeared to have the effect of restoring peace, at least for a time. In its first state, the church had an octagonal ground plan, to

The octagonal cupola above the crossing of the transept of the church of Santa Maria del Popolo was probably the first cupola built in Rome during the Renaissance.

The church of
Sant'Andrea della
Valle was begun in
1591 but the cupola
by Maderno dates
from 1622. The tall
cupola is the second
largest in Rome,
and the fresco by
Lanfranco (1621–25),
the Glory of Paradise,
is the first in Rome
designed for this type
of surface. The pen-
dentives, executed by
Domenichino between
1624 and 1628, show
the Evangelists sur-
rounded by their
attributes.

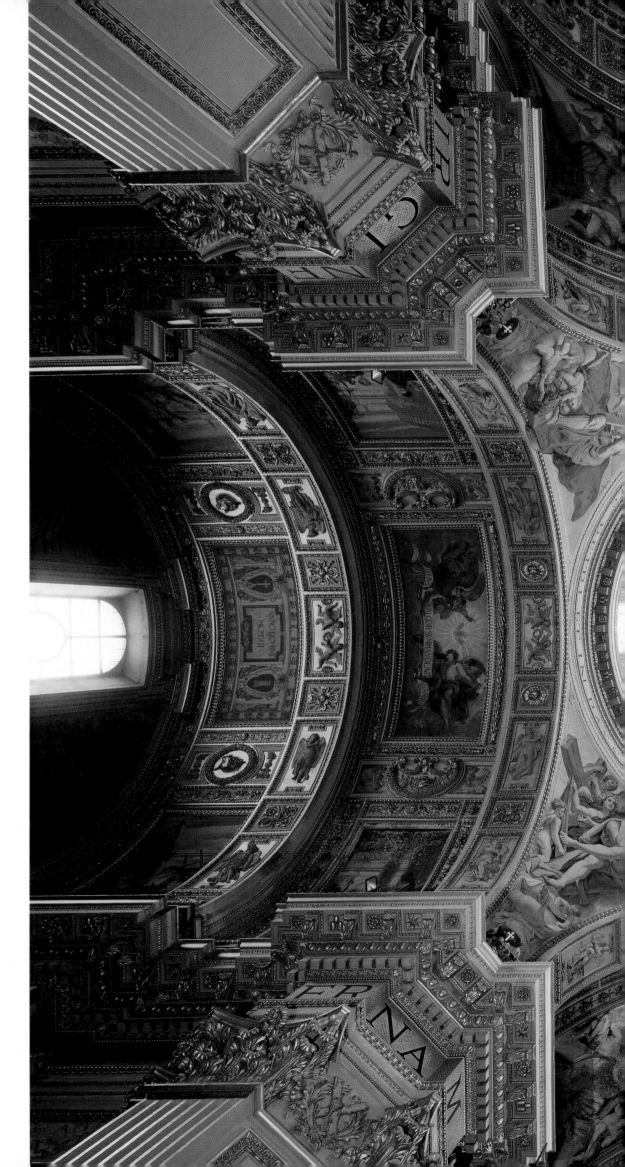

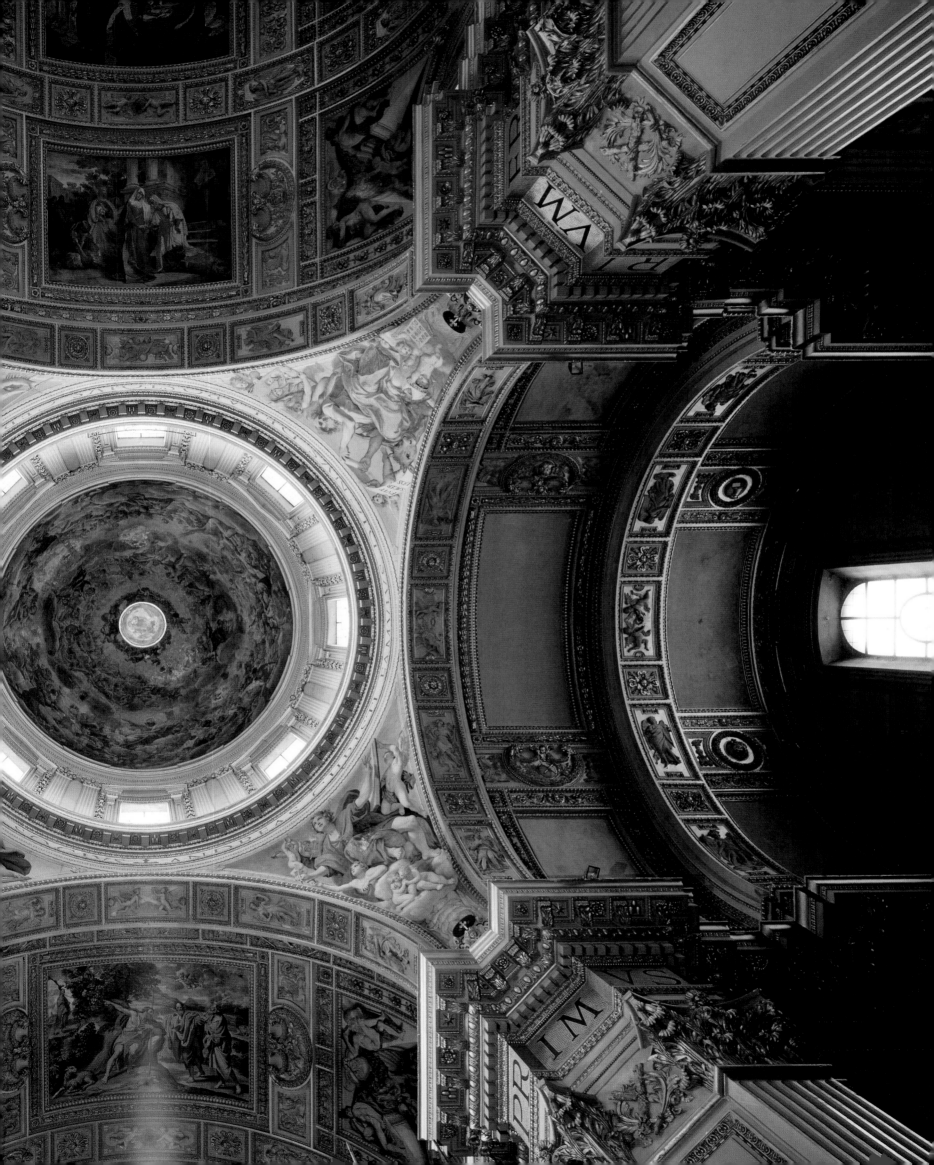

which the front part, now forming an embryonic nave, was later added. More a votive oratory in the Constantinian style than a church—a *domus ecclesiae* where believers could assemble—the octagon opened on each of its sides into a chapel generally housing funerary monuments, such as that of the Cesi, a work of 1525 by Simone Mosca. The tradition represented by Santa Costanza had not been forgotten; indeed, it was continued and further developed by the addition of a cupola taller and bolder than anything imaginable in the fourth century.

Something quite different obtains at Santa Maria del Popolo. Here the cupola, which hovers above the crossing of the nave and transept, serves another purpose altogether. The *popolo* in question was in fact a village, a cluster of dwellings that had formed around the Porta Flaminia in the Aurelian Wall. Up to the time of Sixtus IV the village was served only by a small church dating, apparently, to the early eleventh century. It stood on the site where witches formerly met to invoke the accursed name of Nero, whose tomb, as everyone knew, was located nearby. The church was meant to exorcise these practices, which had fallen into disuse by the fifteenth century—or so, at least, we may suppose. The pope, with his gift of a larger place of assembly, was now extending the Church's domain to the boundaries of the city, while also exorcising both the ghost of Nero and the specter of the Roman communes, set up by Cola di Rienzo in the mid-fourteenth century. The dome of Santa Maria del Popolo therefore did not merely cover an oratory or a holy place consecrated to a martyr; it also functioned as a boundary stone signaling territory claimed by the papacy. Simultaneously, domes were beginning to supplant campaniles, the latter increasingly regarded as legacies from times past.

Sixtus IV saw the erection of a third dome-vaulted church. This was Sant'Agostino, located in the Campus Martius and donated to the Augustinian order by Cardinal d'Estouteville, who had assumed the cost of construction. Off the long nave opened two side chapels where the monks could say their daily masses. Here too the cupola, raised above the crossing, functioned as a signal rather than as a symbol.

A different case altogether was the cupola erected by Bramante during the pontificate of Alexander VI (1492–1503), to crown the so-called Tempietto at the side of San Pietro in Montorio on the Aventine. The Franciscans had just rebuilt San Pietro, an old, half-ruined sanctuary said to mark the spot where the Apostle Peter had been

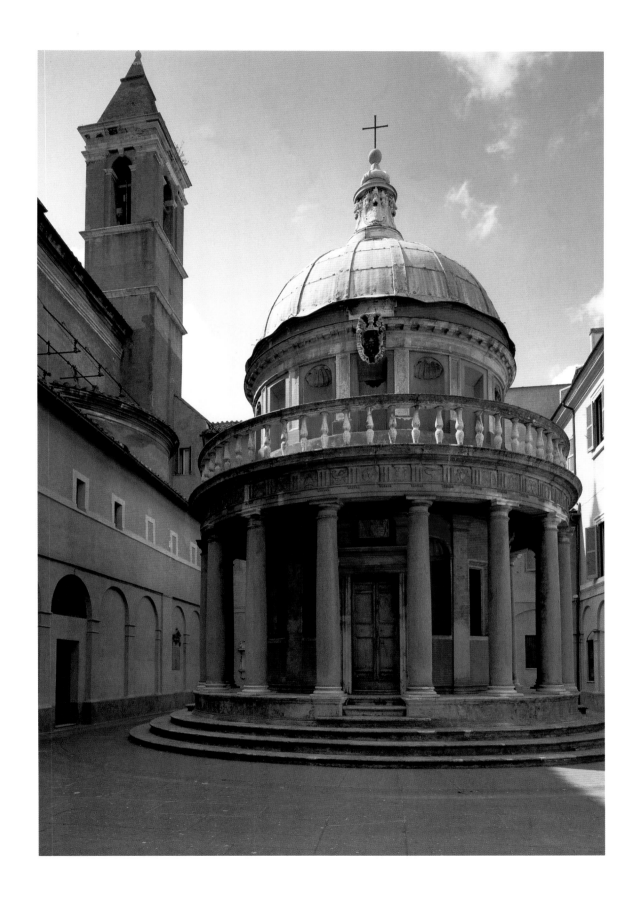

The Tempietto, Bramante's masterpiece, built in 1502 in the courtyard of the convent of the church of San Pietro in Montorio. The building, with a circular plan surrounded by a portico of Doric columns, has the proportions and elegance of a work of antiquity.

Cupola of the
underground chapel
of the Tempietto, the
stucco decoration of
which was added
under Paul III
(1534–49).

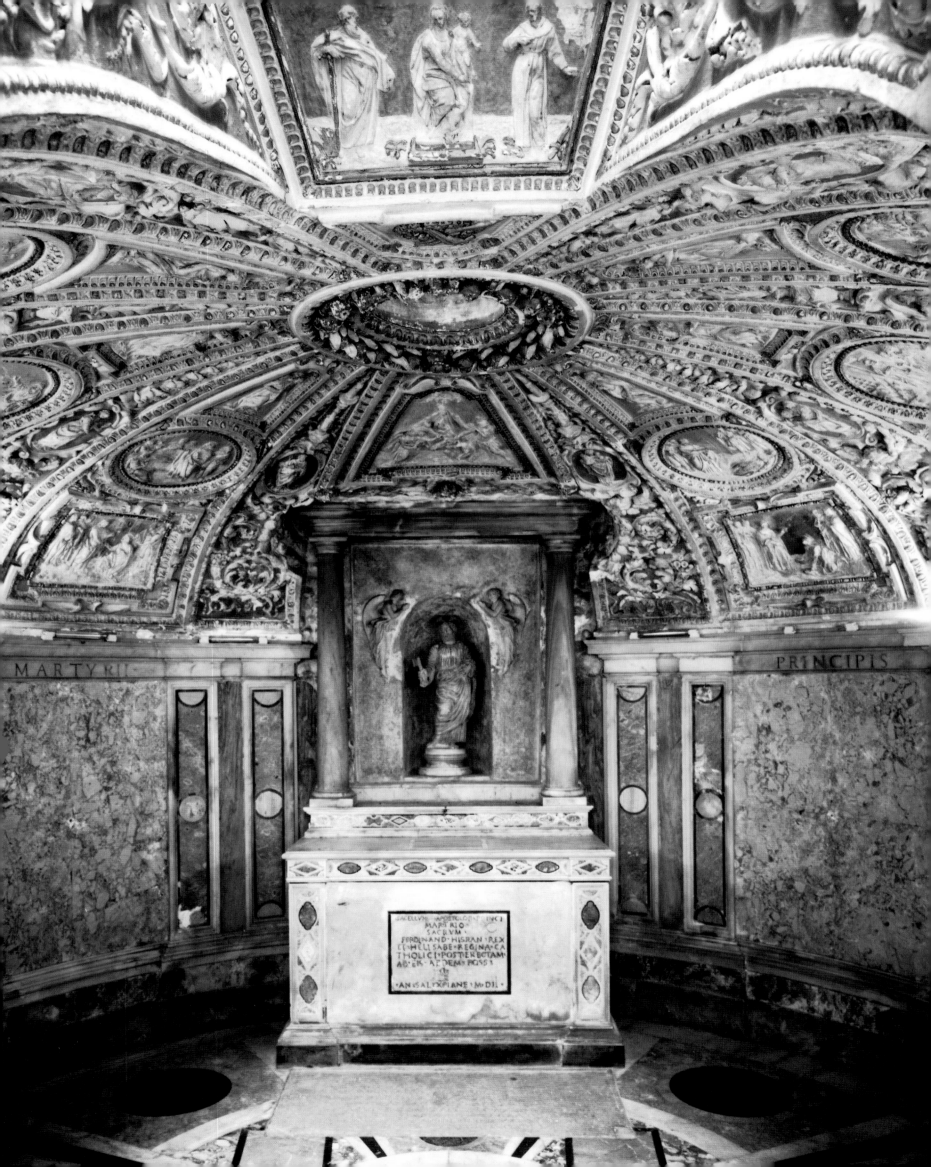

MARTYRII PRINCIPIS

executed. Dedicated to poverty, the monks had few resources, which may explain why they did not embellish their new church with a cupola. In lieu of a monumental dome, however, they resorted to a sort of architectural trompe l'oeil. When Bramante arrived in Rome, having been forced out of Milan by the French occupation, he placed himself in service to Alexander VI. With the pope's support, he was able to erect next to San Pietro in Montorio the circular oratory that was to be a shrine worthy of the apostle. In the Tempietto, regarded by many art historians as the touchstone masterpiece of the Roman Renaissance, Bramante did not so much create new forms as revive the Constantinian tradition of votive churches. This legacy, as already noted, had never been entirely forgotten, even though the need to spread the gospel and, more generally, the need to worship demanded different architectural forms. Certainly the Tempietto was intended to evoke the chapel on Golgotha. The formal vocabulary may not have been the same, but the dome of heaven still rose above the sacred image, this time of Saint Peter. Around the Tempietto Bramante had planned to erect a cloister, also composed of columns arranged in a circle. It would have allowed the gaze to explore the central monument gradually and made it appear somewhat less strange. All we know of the overall project is a drawing, which Bramante did not have time to realize in stone on a grand scale.

From such "daydreams" as the drawing, Bramante had formulated several ideas for the restoration, or rather the reconstruction, of Saint Peter's in the Vatican. He would never see them completed. The rebuilding continued for almost a century, with various architects succeeding one other on the site, from Bramante to Michelangelo and beyond. The main problem—apart from purely technical difficulties—centered upon the issue of whether, and how far, the new basilica should incorporate elements from a centralized plan at the expense of the basilican layout fundamental to the Constantinian church. It was thought (no doubt correctly) that the tomb of Saint Peter lay beneath the chancel of old Saint Peter's. The new Saint Peter's would therefore have to be a shrine; at the same time, however, the papal liturgy, developed in the course of centuries, required large areas, which the Latin-cross basilican plan provided more readily. This double requirement gave rise to much research as well as modification, traces of which survive today. In addition to Bramante's original project, for example, we have the plans of Raphael, Antonio da Sangallo, and Michelangelo. All vacillated between the two

The cupola and lantern of the church of Sant'Eligio degli Orefici, attributed to Baldassare Peruzzi (1481–1536). The church, built in 1509 to plans by Raphael, is an example of the Renaissance architects' research into formal proportions and geometry.

97

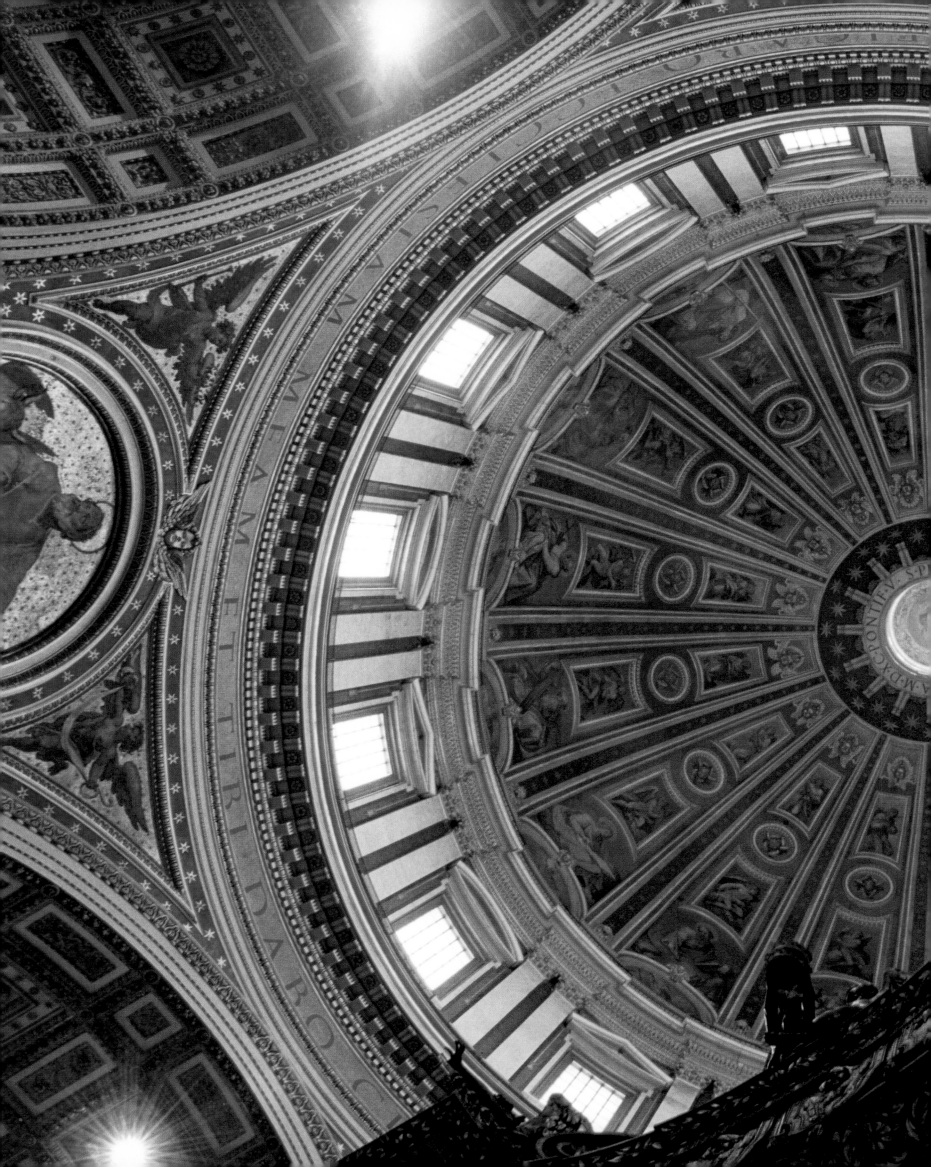

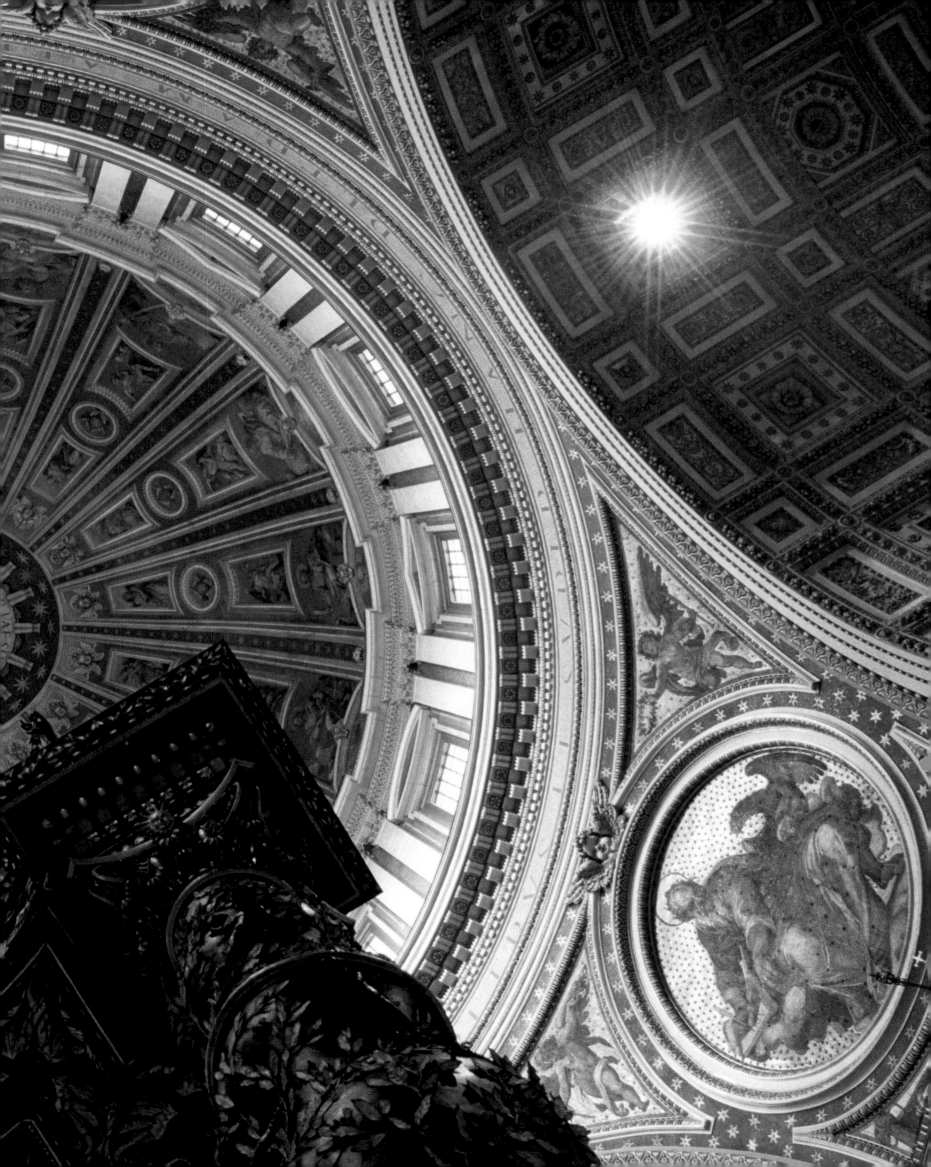

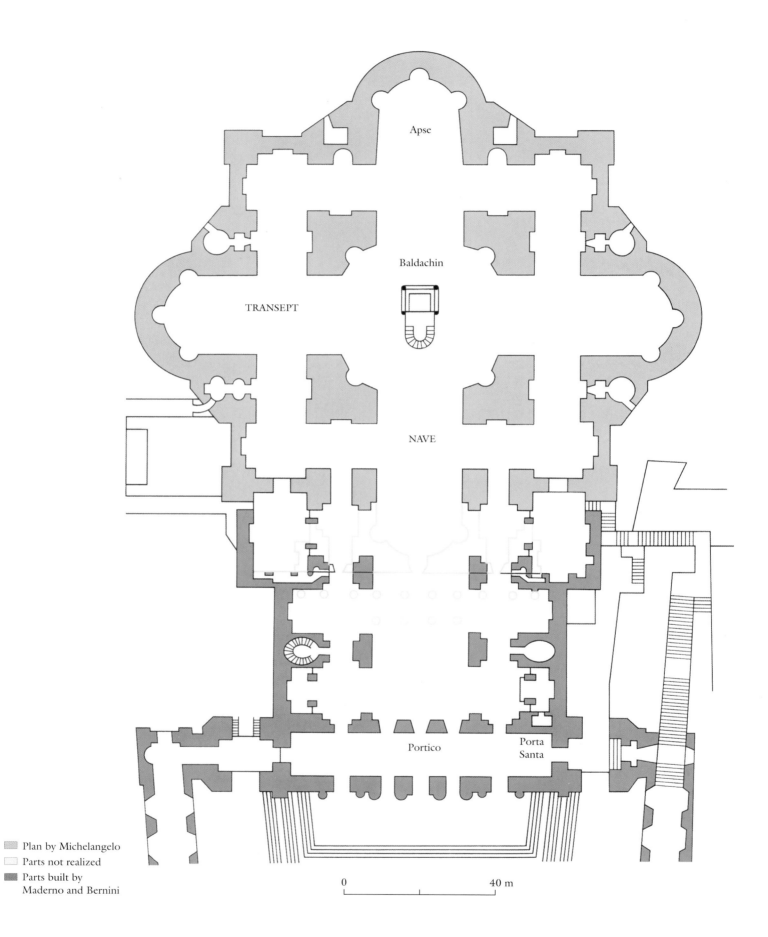

Apse

Baldachin

TRANSEPT

NAVE

Basilica of
Saint Peter

Portico

Porta
Santa

Plan by Michelangelo

Parts not realized

Parts built by
Maderno and Bernini

0 40 m

solutions. Finally, the Latin cross prevailed, but the part vaulted by the colossal dome remains dominant, so that the whole church seems to have been designed to showcase an enormous funerary "chapel."

The first years of the sixteenth century saw the triumph of central-plan churches. These were not shrines but oratories, designed to accommodate a limited number of worshipers, such as the members of a corporation. In 1509, for example, Pope Julius II authorized the goldsmiths' guild to select a site for a chapel alongside the recently constructed Via Giulia. This church, consecrated to the goldsmiths' patron, Saint Eligius (Sant'Eligio), needed not to shelter large congregations but rather to offer a place for prayer and meditation. A cupola would suit it perfectly, and by 1526 the vault was in place, one year before the sack of Rome. Meanwhile, the "Tuscan confraternity of bakers" had a similar church erected near the Forum of Trajan. Unlike the situation at Sant'Eligio, construction on the bakers' chapel, consecrated to Our Lady of Loreto, would remain under way for almost the entire century, with the cupola not completely built until after 1592.

The proliferation of such intimate sanctuaries, each designed for small, clearly defined groups and surmounted by a cupola, reconfigured the panorama of Rome as viewed from the heights of the Janiculum or the Vatican. Bernini likened the cupola to a human head, a concept he made clear in a sketch showing a pair of arms added to Michelangelo's great dome atop Saint Peter's. So many cupolas, so many heads, so many souls surging up in prayer to God. Perhaps the new architecture had indeed met the challenge of the Council of Trent, inasmuch as it had, for the last half-century, become the expression of an assertive spirituality, so different from the sweetness and measure of the Renaissance.

Roman Façade Decoration

While raising more and more cupolas over basilicas as well as over oratories and votive chapels, architects were also busy designing and disseminating a new style of façade destined to achieve widespread success. For a long time churches had been preceded by a portico, the descendant of the ancient Roman atrium, whose middle side it formed. The portico, like the one found today at Santa Maria in Cosmedin, masked the lower part of the façade, which therefore remained bare or perhaps ornamented in a simple manner closely related to the wall's function. On the upper part there might also be a circular

PREVIOUS PAGES:
The dome of Saint Peter's, designed by Michelangelo, is taller and wider than the one conceived by Bramante. It is 132.5 meters high and 42 meters in diameter, and was completed in 1593.

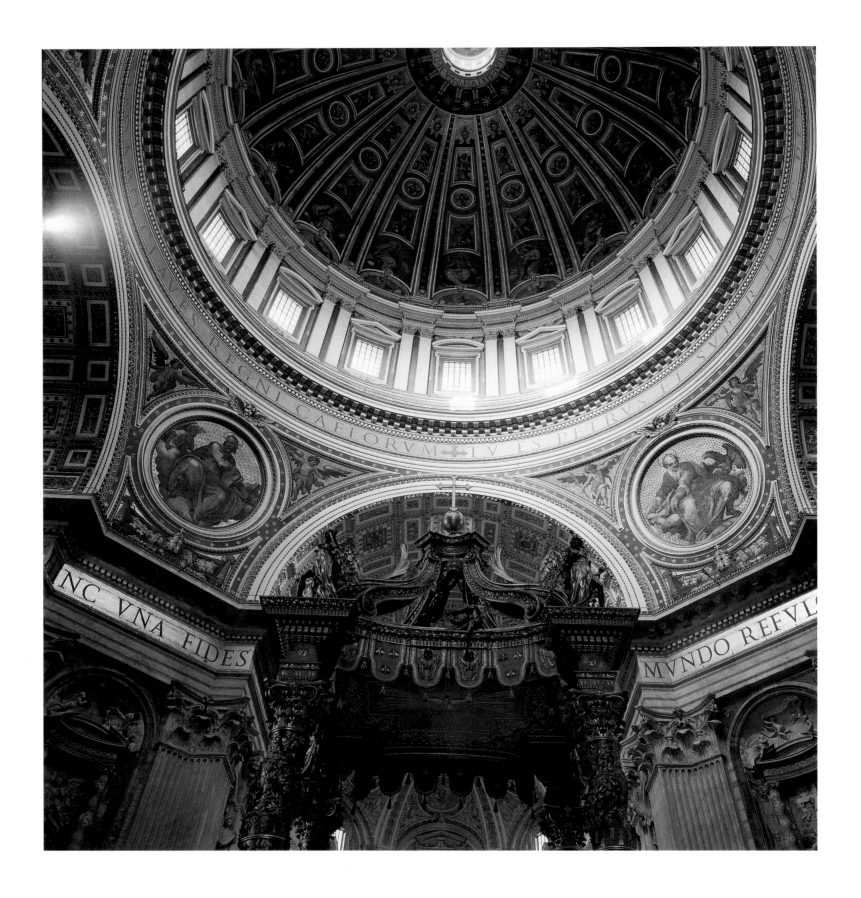

A baldachin erected below the dome and rising above the high altar dominates the nave of Saint Peter's. Commissioned by Urban VIII from Bernini in 1624, it is 29 meters high and its wreathed columns are cast of bronze taken from the Pantheon.

Mosaic medallion representing an evangelist on a pendentive of the dome.

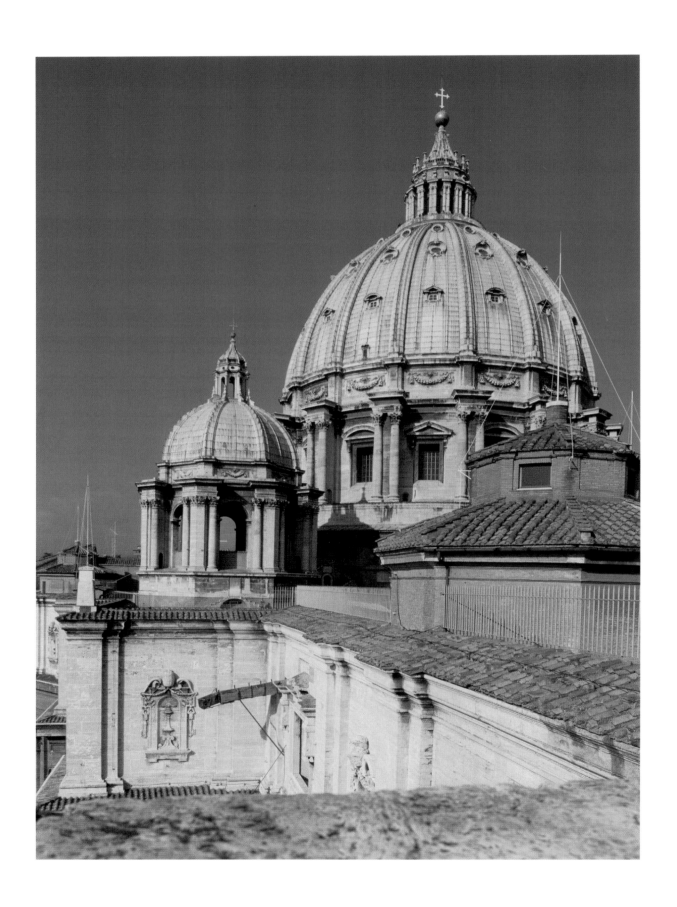

window, forming a kind of tympanum. Yet, even in the absence of a portico, itself a decorative element, the façade was sometimes left virtually bare. A case in point is San Pietro in Montorio, which shared the simplicity and the poverty of the Franciscans.

In the course of the sixteenth century, however, the façade grew ever more complex, as architects explored its intrinsic nature and rhythm. They divided the surface into two stories of unequal width, roughly corresponding to the volumes of the nave, aisles, and roof. The rhythm of the lower story, pierced by the entrance door, would be set by a row of pilasters, their number depending upon the width of the façade. On either side of the door at Santa Caterina dei Funari (1560–1564) unfolds a series of three pilasters with Corinthian capitals linked by a running garland. Inserted between each pair of pilasters is a deep niche, surmounted by a sort of blind dormer window, rectangular in shape. The door culminates in a triangular pediment, borne upon two engaged columns. The whole arrangement—pilasters, garlands, niches, and gable windows—is repeated in the much narrower upper story. On either side of the central "tympanum"—a circular window whose diameter matches the the width of the door below—there is room for just two pilasters, with only one niche and one blind dormer window on each side. A double-sloped roof caps the upper story, forming a pediment, which echoes the one above the door but on a larger scale. The overall impression produced by this ordered assembly of architectural elements is that of a pavilion placed on top of a hall, with a large volute or scrolled gable—in reality an inverted buttress—on either side of the upper story, so placed as to fill the void caused by the different widths of the two stories. The widespread use of such volutes is said to have been initiated by Leon Battista Alberti, one of the greatest innovators of the Early Renaissance. His patron was Martin V, the pope whose election launched the rehabilitation of Rome, long abandoned during the popes' "Babylonian captivity" in Avignon.

But what were the origins and meaning of this new style of façade, which, halfway through the sixteenth century, triumphed in churches built by the architect Giacomo Barozzi da Vignola? Rather curiously, it bears a certain similarity to the *frontes scaenae* of ancient Roman theaters—the permanent stage set designed to look like a palace façade. This usually included three doors, used for the action on stage, and an upper loggia reserved for the *deus ex machina,* the deity whose intervention untangled the plot and resolved the drama. Did ancient stage décor influence the design of church façades in

The dome of Saint Peter's, surmounted by a lantern, rests on a drum that has windows topped with triangular or arched pediments separated by paired columns.

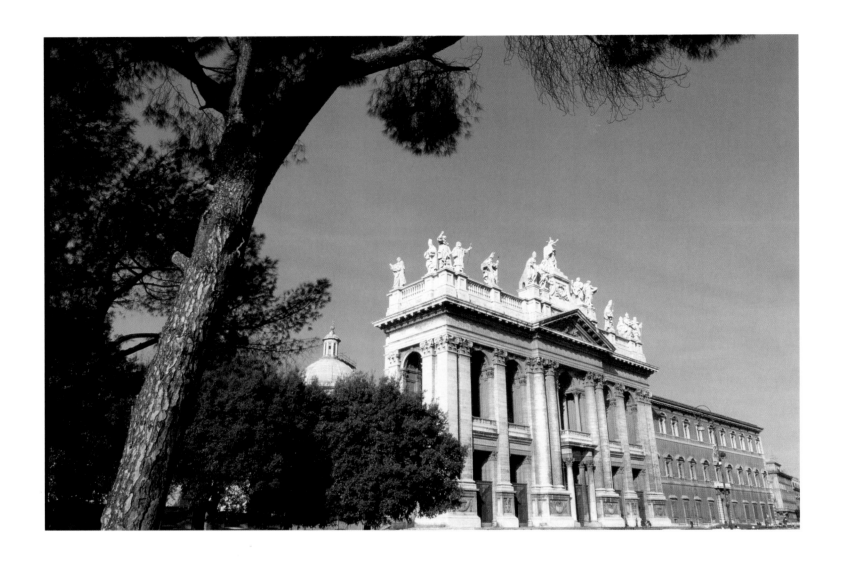

The basilica of San
Giovanni in Laterano
has been ruined and
burned several times
and repaired in
various epochs. The
main façade with its
portico and loggia
surmounted by fifteen
colossal statues is the
work of Alessandro
Galilei, dating from
1735. The palace of
Sixtus V, joined to
the façade, was the
residence of the popes
from the fifth century
until their departure
for Avignon.

OPPOSITE: Detail of
the portico and loggia
of San Giovanni in
Laterano.

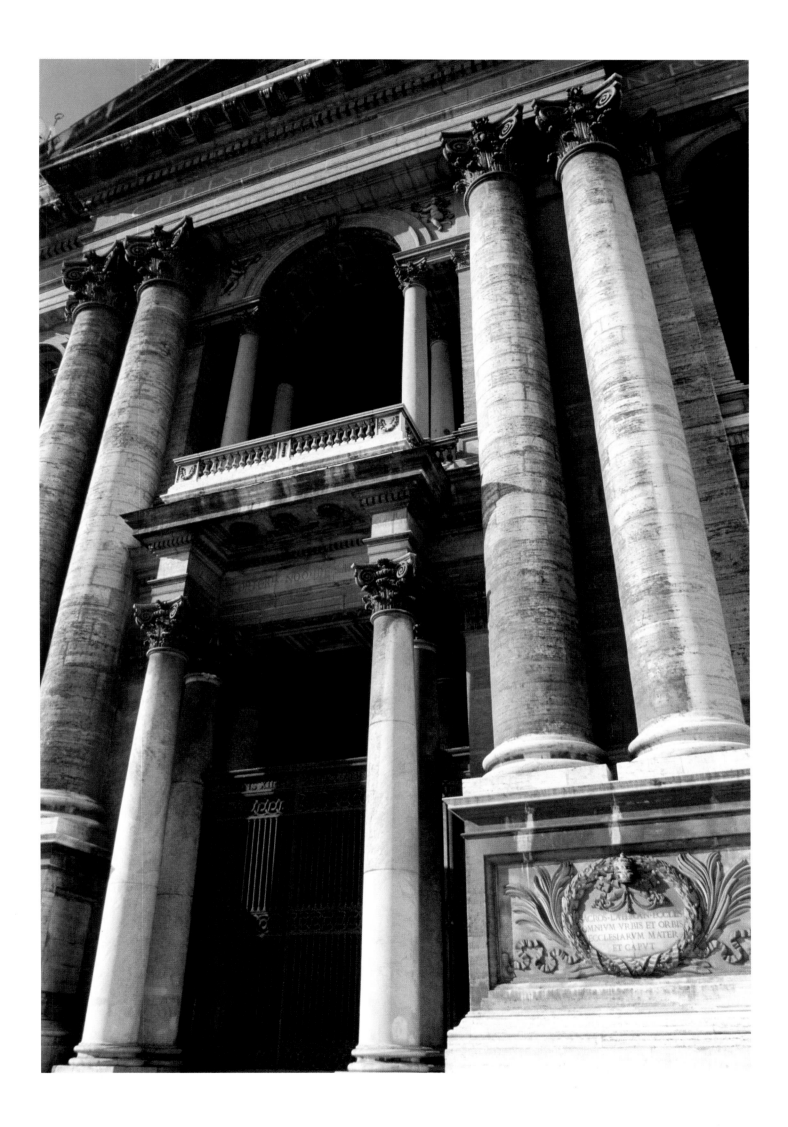

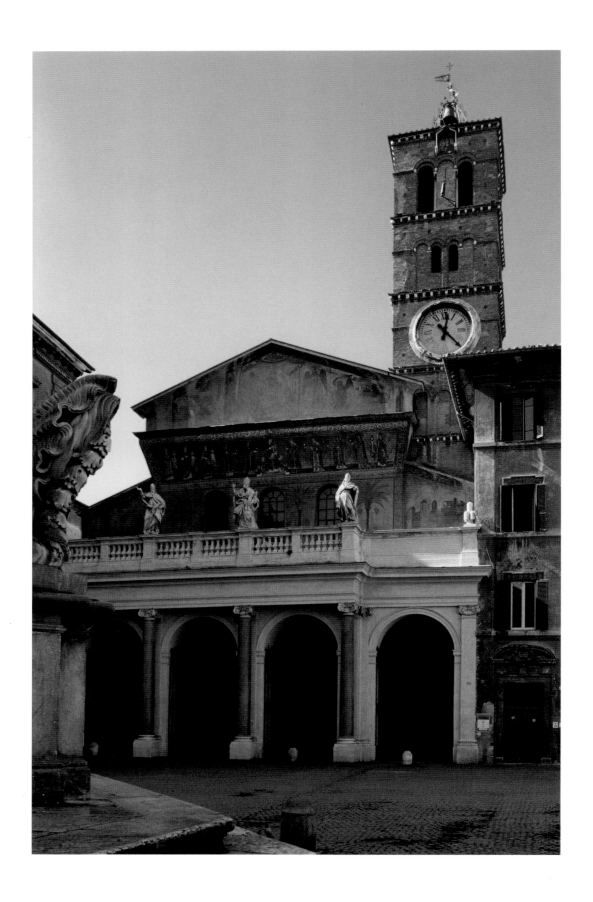

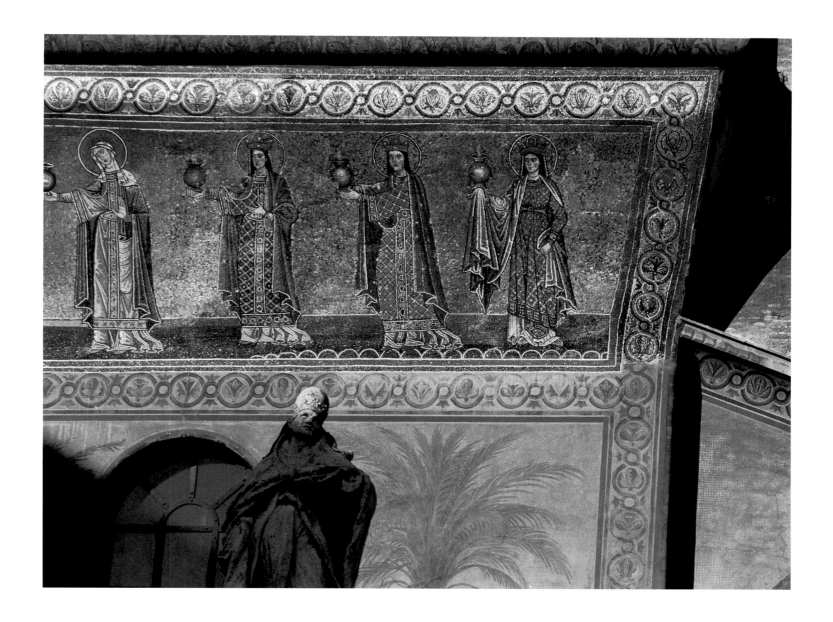

Façade of the church of Santa Maria in Trastevere. The campanile dates from the twelfth century and is decorated at the top by a small mosaic showing the Virgin and Child. The corbelled strip at the base of the gable is decorated with mosaics showing the Virgin suckling the infant Christ, surrounded by ten female saints carrying lamps, the symbol of virginity. Some of them, badly restored as "foolish" virgins *(above)*, no longer have crowns, and their lamps have gone out. The portico added by Carlo Fontana in 1702 is surmounted by four statues of popes.

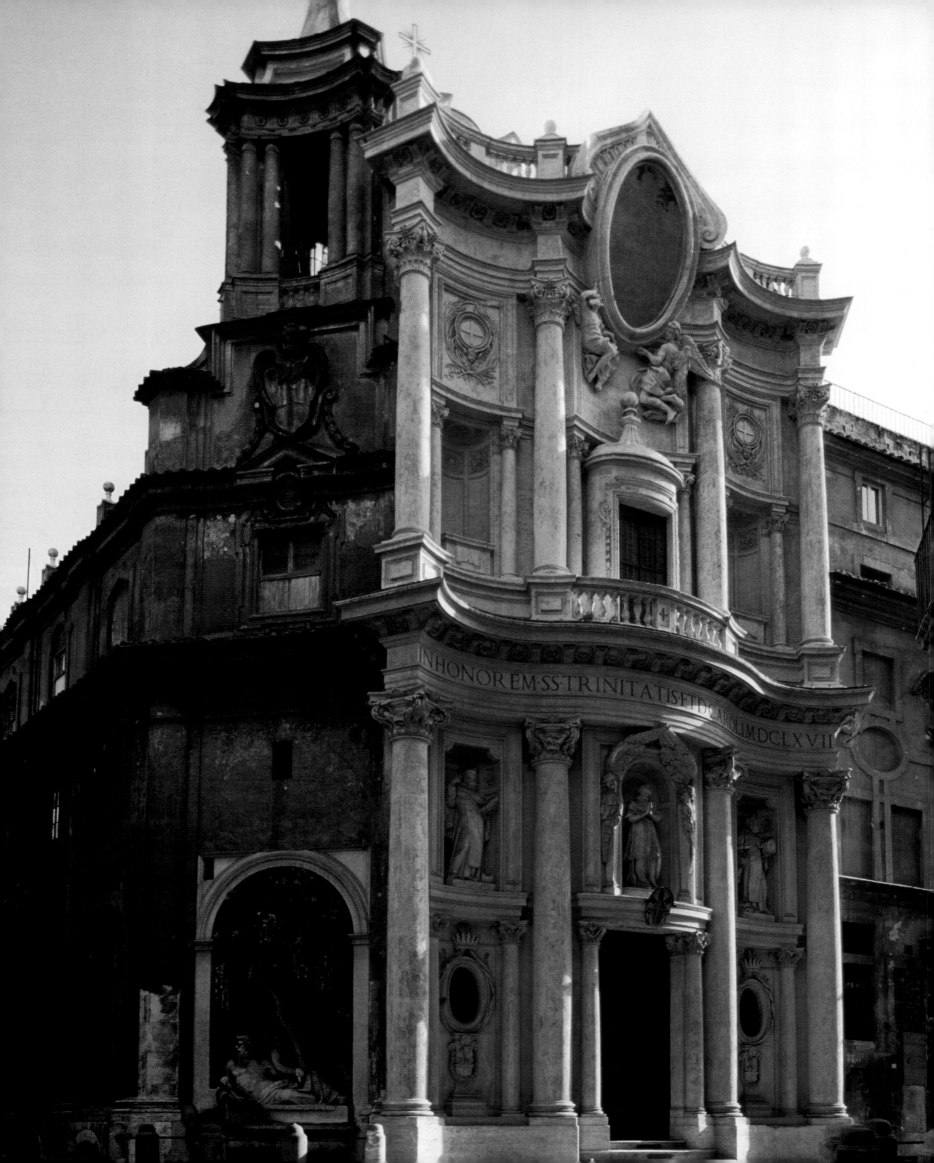

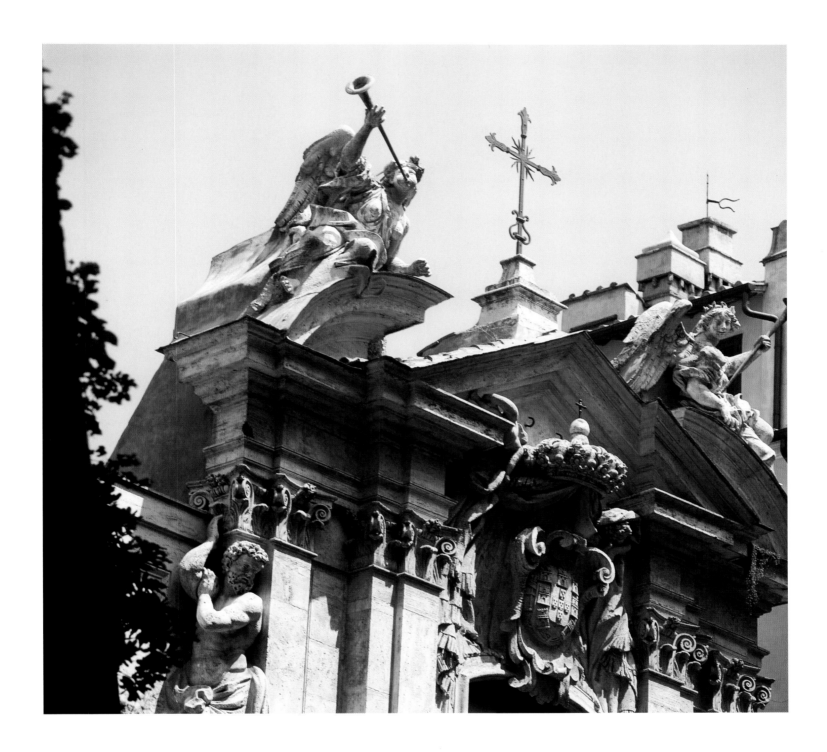

The façade of the church of San Carlo alle Quattro Fontane, constructed by Borromini thirty years after the church was built, is the architect's last work (1667). The convex and concave lines are inverted from one bay to the next, and the whole is crowned by a large concave medallion supported by two angels.

ABOVE: Detail of the pediment of the façade of the church of Sant'Antonio dei Portoghesi, designed by Martino Longhi the Younger about 1631.

Rear façade of the basilica of Santa Maria Maggiore. The exterior architecture of the apse, built by Carlo Rainaldi about 1674, integrates the Sistine Chapel and the Borghese Chapel (or Cappella Paolina) into the style of the basilica while modifying the apse.

OPPOSITE: Baroque façade of Santa Maria della Pace by Pietro da Cortona, dating from 1656. The Corinthian columns and pilasters of the upper part contrast with the Doric columns of the semicircular porch and the concave wings.

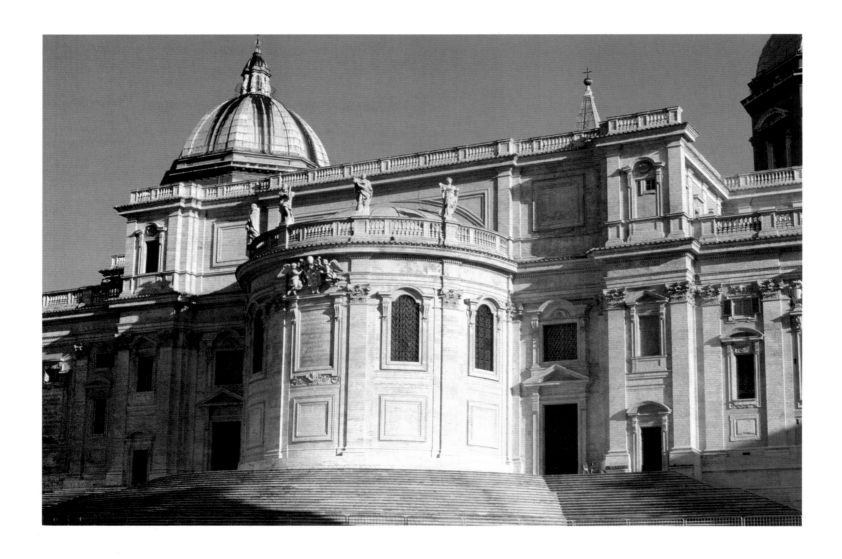

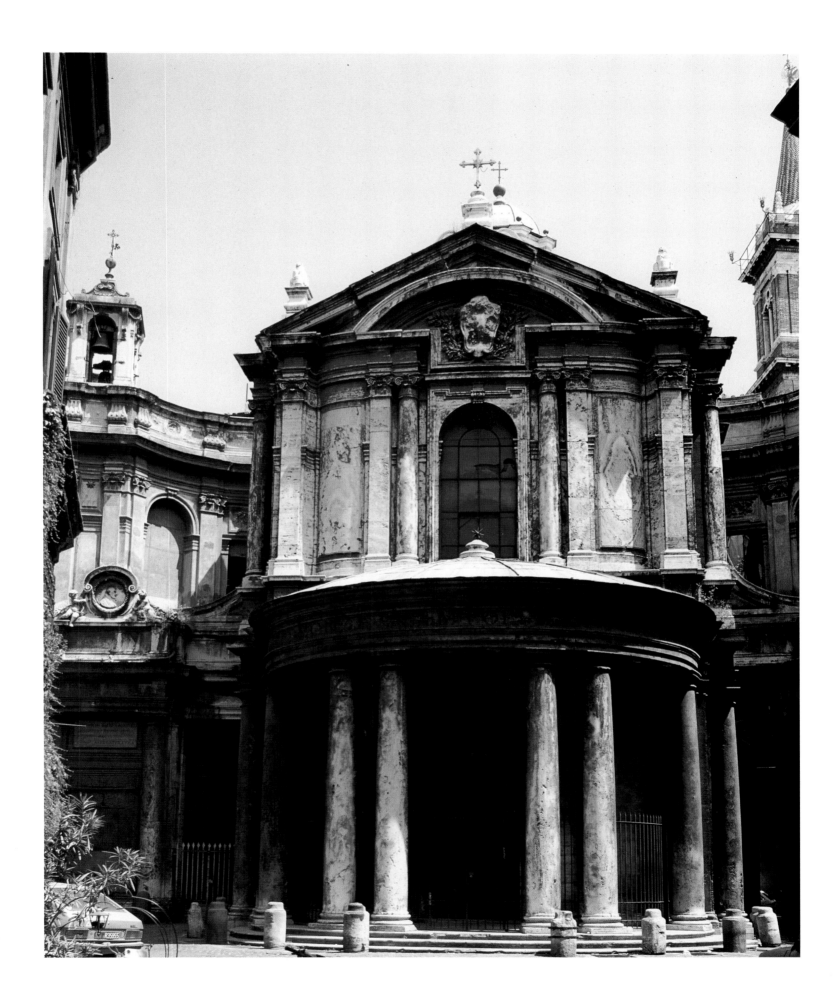

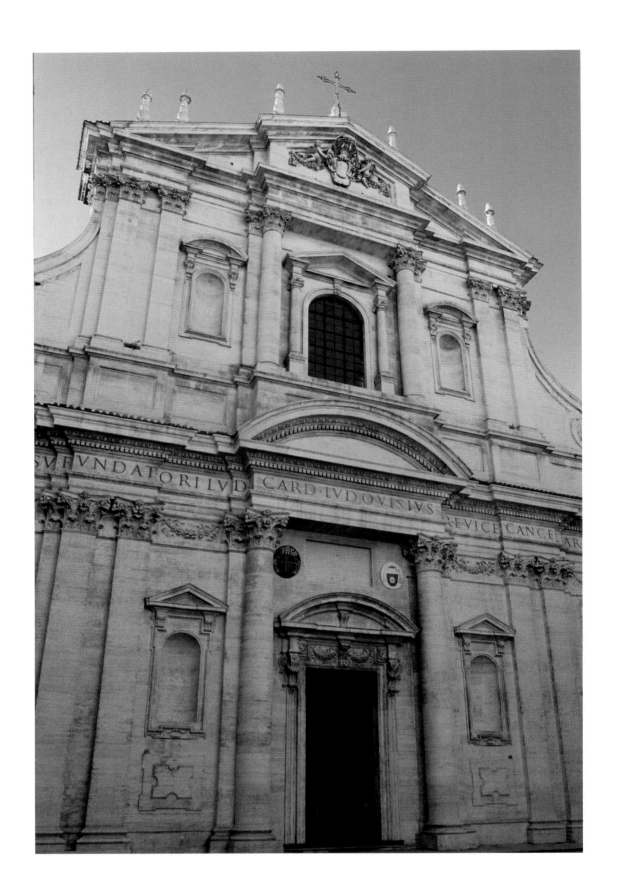

The façade of
Sant'Ignazio dates
from 1685. Its impos-
ing appearance and
dimensions and the
interplay of set-back
planes and columns
are very representative
of the aesthetic of the
Counter-Reformation.

OPPOSITE: Façade of
Sant'Andrea della
Valle by Carlo
Rainaldi, dating from
1665, which exploits
the effects of relief
and setting back
different parts of the
plan. The upper order
is framed by large
statues of angels, each
with one wing raised.

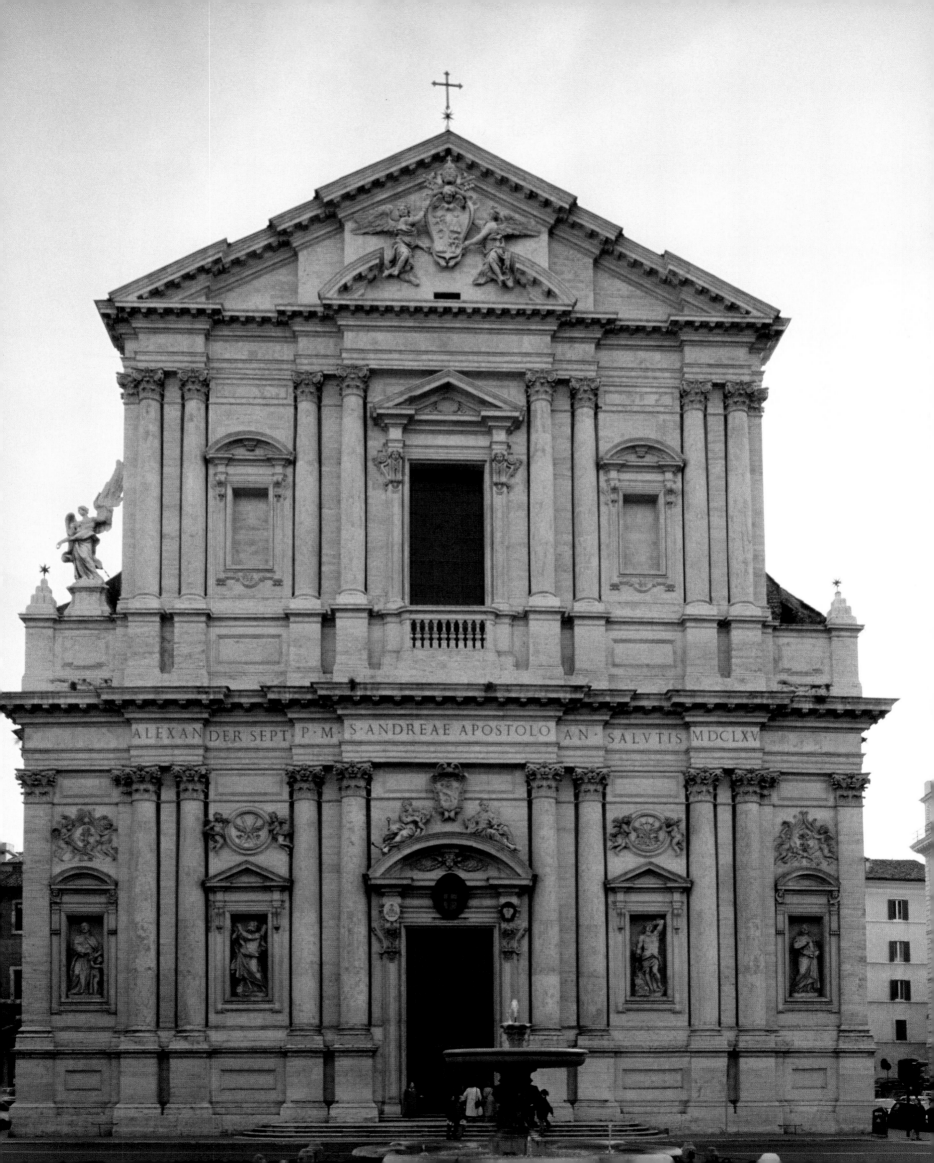

ALEXANDER SEPT · P · M · S · ANDREAE APOSTOLO AN · SALVTIS MDCLXV

mid-sixteenth-century Rome? By this date, certainly, no Classical theaters could have been found intact, with the possible exception of the Septizonium, which Sixtus V would not demolish until the end of the century. But Vignola practiced during the period that witnessed the discovery of the frescoes decorating the Golden House of Nero. Apart from the famous "grotesques" adopted by Raphael, these included decorations realized in a style often analogous to that of stage scenery.

It therefore seems conceivable that the church façades of architects like Vignola and Giacomo della Porta connect more or less directly to that period of ancient art. Another influence may also have played a part in suggesting the use of columns or pilasters to give rhythm and animation to façades: the sight of the *tabularium* that dominated the view from the Forum. A further influence may have been the façade of the Theater of Marcellus, the arcature of which was being remodeled at precisely that time to convert the building into a palace. The Porta Maggiore in the Aurelian Wall, or, more simply, the triumphal arches to be seen at the Forum, may also have served as models. It is tempting to suppose that the church architecture of the Counter-Reformation drew part of its inspiration from antiquity, seeking in the tradition still visible in the fabric of the city some means of expressing the continuity of Rome that had been called into question by a new spirit.

In medieval churches the roof of the portico that formed the lower story of the façade was used as a platform and for the giving of blessings. A loggia at San Saba, for example, was used for this purpose. Boniface VIII had had one added to San Giovanni in Laterano at the beginning of the fourteenth century. This structure (no longer extant) was no more than a rather narrow balcony projecting above the porch. Under Nicholas V (1447–1455) a "benediction tribune" far larger than that of the Lateran had been begun at Saint Peter's. It had three stories, each of which comprised an arcade of four arches. The whole structure formed a separate edifice attached to the façade, with which it had no organic link. It was demolished when the new basilica was constructed. Once the new style had become established and more and more domes appeared, it became impossible to retain such projections, which acted as a screen obstructing a view of the whole. The benediction loggia required by ritual was then integrated into the façade, as is seen in Saint Peter's or the Lateran. In other churches the tympanum (inherited from the Gothic style) was replaced by a rectangular window in the position of the upper

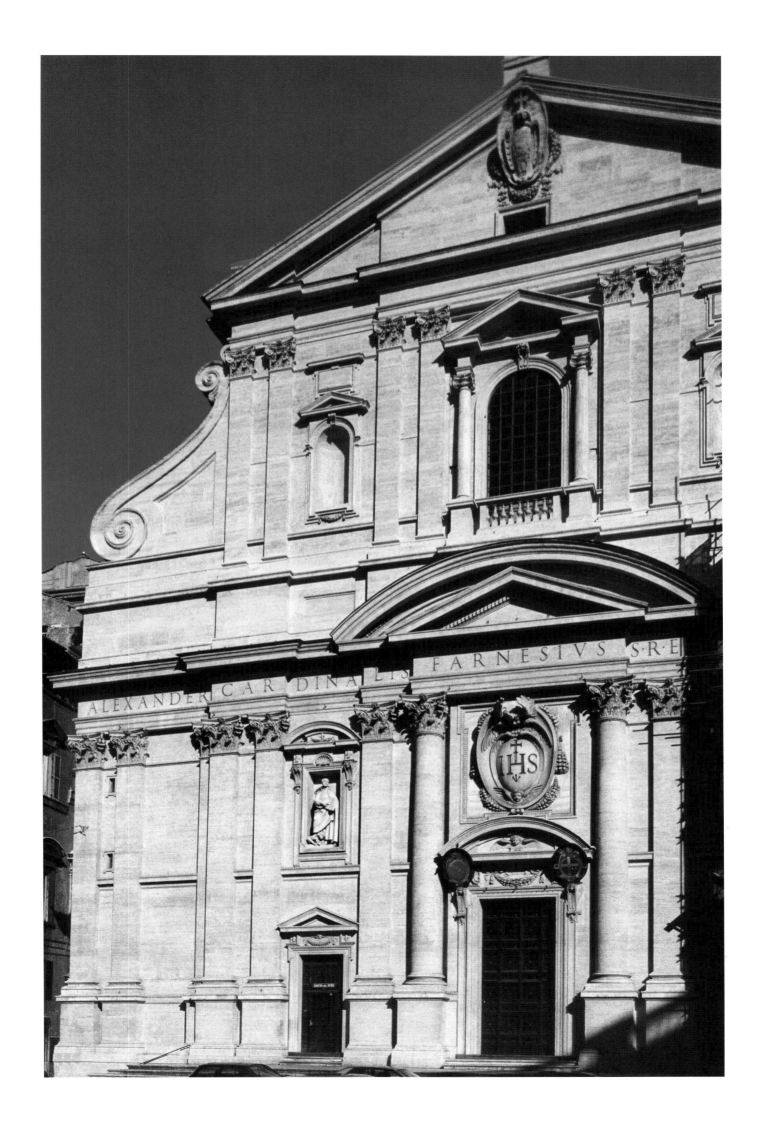

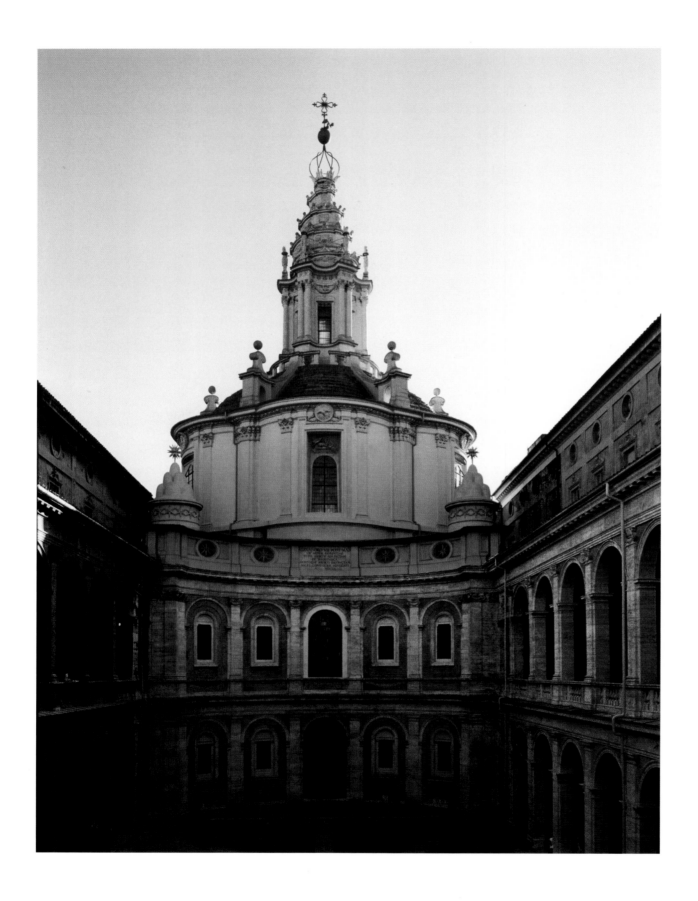

The façade of the
chapel of Sant'Ivo
della Sapienza closes
the courtyard, with
two levels of arcature,
of the palace of
La Sapienza, the
headquarters of the
old pontifical univer-
sity. It is the work of
Borromini, who had it
built between 1642
and 1660. The undu-
lations of the drum
and cupola contrast
with the severe lines
of the lower part and
the fanciful spiral
lantern evoking the
Tower of Babel.

loggia. This was used by Vignola in the design for the Gesù, and in the realization of the façade of Santa Maria dell'Orto, a small church built in Trastevere to celebrate the abundance of the Roman markets, and of the gardens whose protector the Virgin was. More often the benediction loggia was incorporated in an attic story of relatively modest proportions, as in Saint Peter's. In this way aesthetic requirements were reconciled with a sense of measure.

The Contraction of the Centralized Plan

Façades in the "Vignola style" were particularly suited to churches with a basilican plan, but they could also be adapted to buildings with a centralized plan, whether circular or polygonal. The tradition for such buildings had survived, for several reasons, some of which have been given. A building like Santo Stefano Rotondo, on the Caelian Hill, reminds us that at least some churches, here or there in the city, had been built to symbolize the transition from mortality to eternal life. The circular plan of Santa Costanza, for example, had been chosen to recall the church at Golgotha, and the same is probably true of Santo Stefano Rotondo. When the centralized plan was taken up again in the sixteenth century, first by Vignola and then by others, especially Borromini, it had not entirely lost this meaning. An indication of this can be seen in a humble chapel still visible on Via Flaminia, a curious monument constructed by Vignola and commissioned by Julius III to commemorate the happy outcome of a misadventure that had befallen him there during the sack of Rome in 1527. While still a cardinal, he had been taken prisoner by soldiers of Charles V as he made his way to the Villa Giulia, but thanks to the intercession of Saint Andrew, the brother of Saint Peter, he had been set free without harm. This chapel dedicated to Saint Andrew was situated at the roadside—that is, in the position of a tomb, according to the custom of antiquity. It had a rectangular, almost square ground plan and was covered by a very shallow elliptical cupola, strongly reminiscent of the Pantheon. As in Jerusalem, an image of heaven marked the point where the divinity had intervened—there for the salvation of mankind and here for a man whom Providence had intended to become pope.

Should we attribute a similar symbolism to the plan adopted by Borromini for Sant'Ivo, the church of the Università della Sapienza? This plan has been interpreted as a hexagon formed by two superimposed equilateral triangles, which, we are told, are

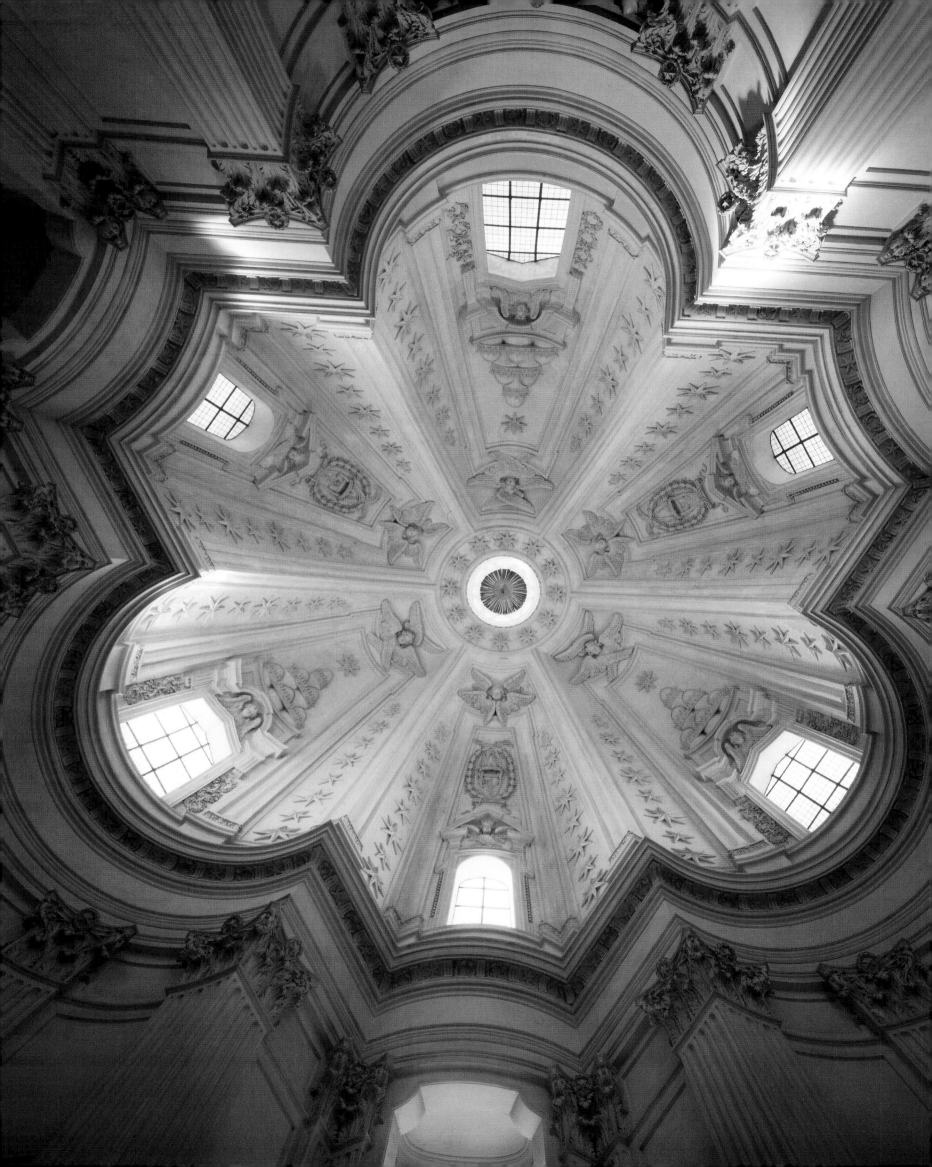

images of wisdom. According to one book of the Old Testament, wisdom is also a gift of God. Sant'Ivo has a cupola surmounted by a lantern window, itself topped by a spiral ramp that seems to symbolize the ascent of the spirit that has attained to *sapienza,* a term implying knowledge still more than wisdom.

Other, more material considerations may have induced the architects to adopt the centralized plan here—for example, the narrowness of the space available to them between two galleries of a cloister. As we shall see, that argument applies to other buildings. There are, however, some churches in which the circular, centralized plan was adopted despite the fact that there was sufficient space. One of them is San Giovanni in Oleo, a small church built not far from the Porta Latina, in the place where Saint John the Baptist was said to have been martyred by being plunged in boiling oil. If it is true that this chapel was built by Borromini and does not date back to the fifth century, as has been supposed, it is clear that the ancient tradition was still alive in the seventeenth century: according to it, a church with a centralized plan was a place imbued with spirit, where faith triumphed over the flesh.

The church of Sant'Andrea al Quirinale, built by Bernini between 1558 and 1561, falls within the same tradition. It has an oval plan, imposed in this case by the narrowness of the site, with a door at one end of the short axis of the ellipse. Opposite the door is the high altar. The cupola has paintings depicting the martyrdom of Saint Andrew, whose soul rises toward heaven and is welcomed by the Holy Spirit. This small church, which Bernini regarded as his masterpiece, is a place of meditation, too small to accommodate a large congregation. Nor was that the intention of the architect or of Prince Camillo Pamphilj, who commissioned the work. Innocent X, who was the prince's uncle, had sided with the Jesuits in a theological dispute. It is not surprising, therefore, that in Sant'Andrea al Quirinale, erected in memory of the Pamphilj pope, we find depictions of saints belonging to the Society of Jesus: Saint Francis Xavier and a young Jesuit who had died recently, Stanislas Kostka. This is how Prince Camillo, husband of the Donna Olimpia who was reputed to have robbed the pope on his deathbed, wished to immortalize his uncle, by recalling his fight for orthodoxy. Clearly, Sant'Andrea al Quirinale was not really a *domus ecclesiae* but a graceful oratory. The size of the site on which it was built was immaterial.

The same is true of Sant'Agnese in Agone, which was also intended as a monument

The cupola of the chapel of Sant'Ivo della Sapienza by Borromini takes up the multifoil plan of the building: two superimposed triangles forming a star.

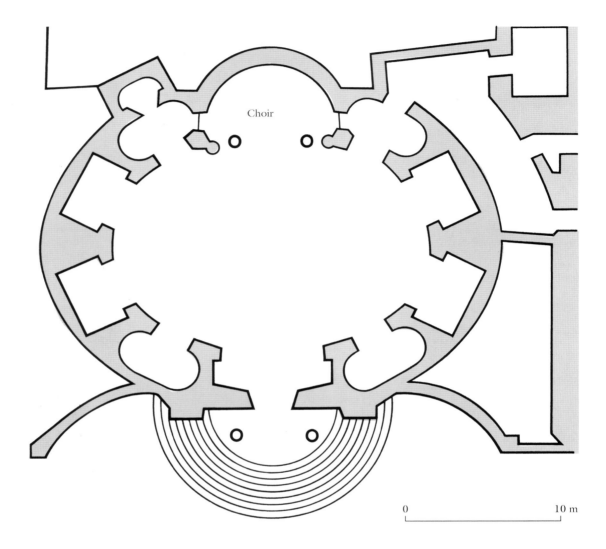

Choir

0 10 m

Entablature and high
altar of Sant'Andrea
al Quirinale, built
and decorated by
Bernini in 1678.
The lighting of the
altar by a lantern
invisible from the
entrance heightens
the effect of the
"glory" embellishing
the back wall. Cher-
ubs fluttering in the
golden rays of the
glory seem to be
hooking the altarpiece
to the marble frame.

to the glory of the Pamphilj, and stands in the immediate vicinity of the palace on the Piazza Navona that still bears their name. This church, too, has an elliptical centralized plan in which the entrance and the altar are situated at opposite ends of the short axis. Before the alterations ordered by Innocent, who planned to have his tomb there, the church had opened on to Via dell'Anima, and the chancel faced the Piazza Navona. Innocent X reversed this arrangement. From now on the façade was to be aligned with the palace and was to be integrated with the square. It was itself to be a funerary chapel. In one of the many projects produced for the heirs of Innocent X, who died in 1655, two years after the work had begun, this intention appears clearly. Bernini, who took over responsibility for the work at that time, had the idea of placing the pope's coat of arms on

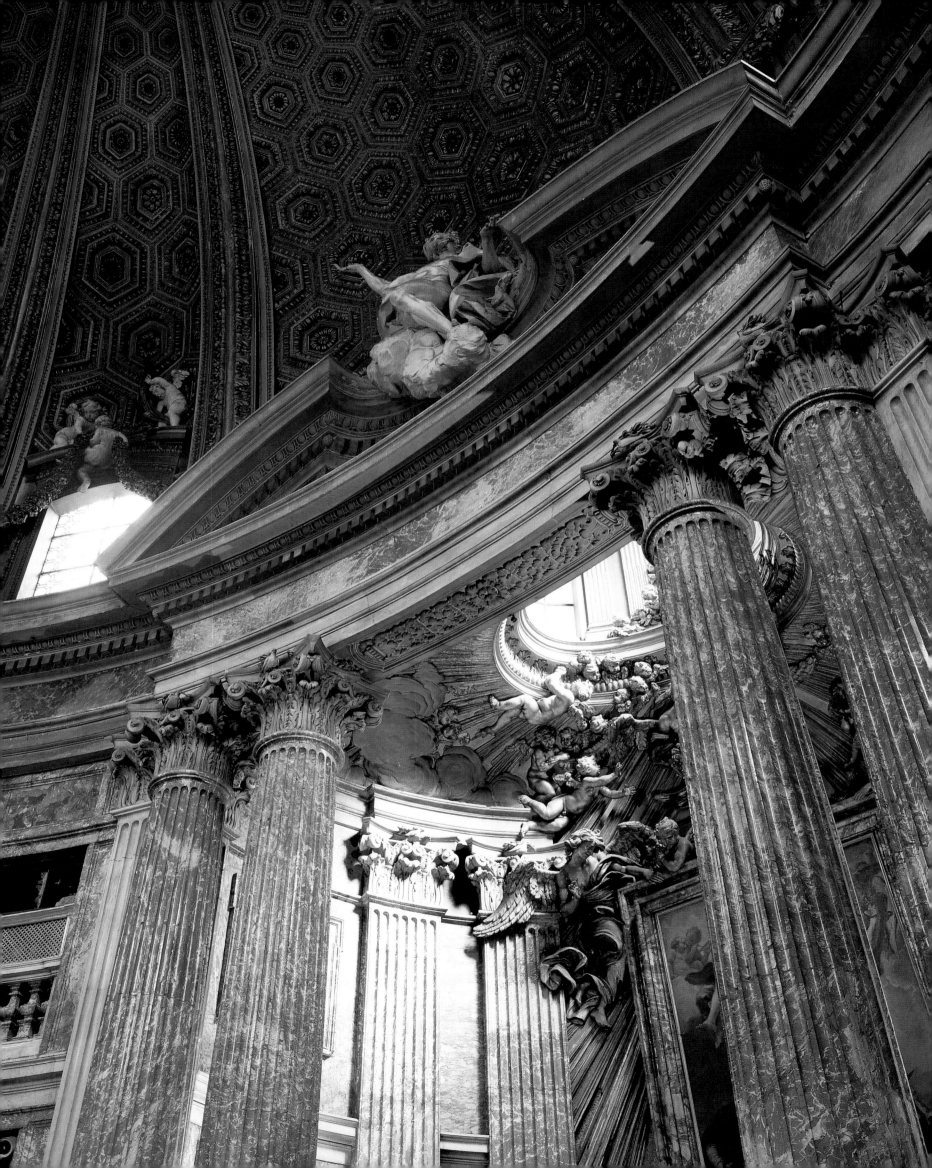

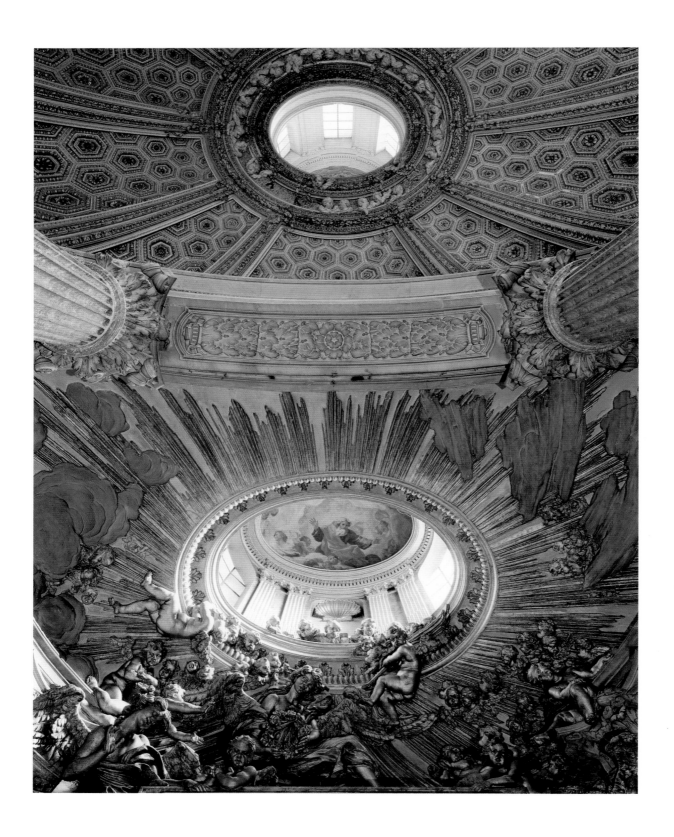

The masterly geometry of the coffering of the ribbed vault of Sant'Andrea al Quirinale, contemplated by a garland of small angels. In the background, the lantern and glory of the high altar, from which descend cascades of cherubs, symbols of the Baroque in Bernini's work.

OPPOSITE: Chapel of Saint Stanislas, one of the peripheric chapels of Sant'Andrea al Quirinale.

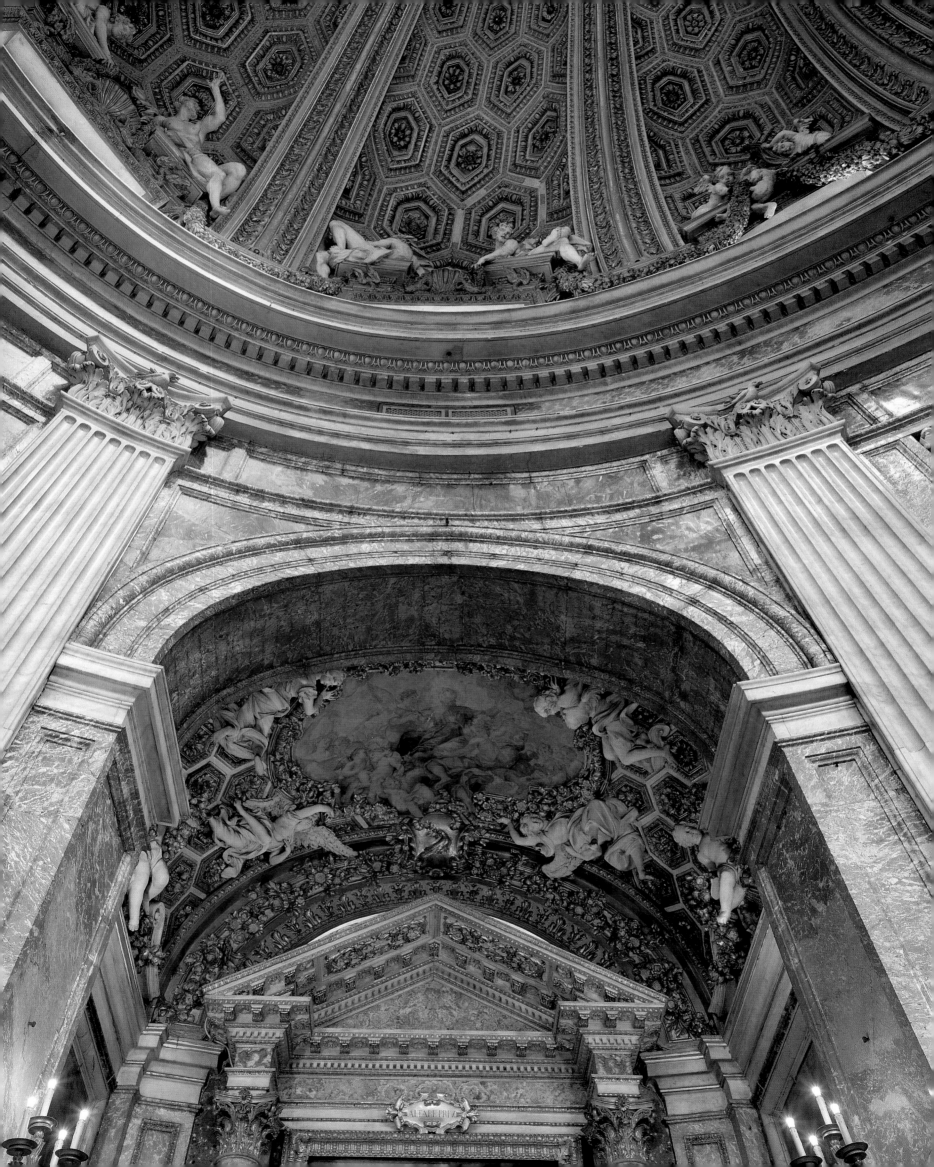

The elliptical cupola
of San Carlo alle
Quattro Fontane,
built by Borromini
in 1634, gives an
impression of great
height thanks to the
narrowing depth
of the coffering
toward the lantern,
which sheds light
into the building and
in which floats the
Holy Spirit, the only
touch of color.

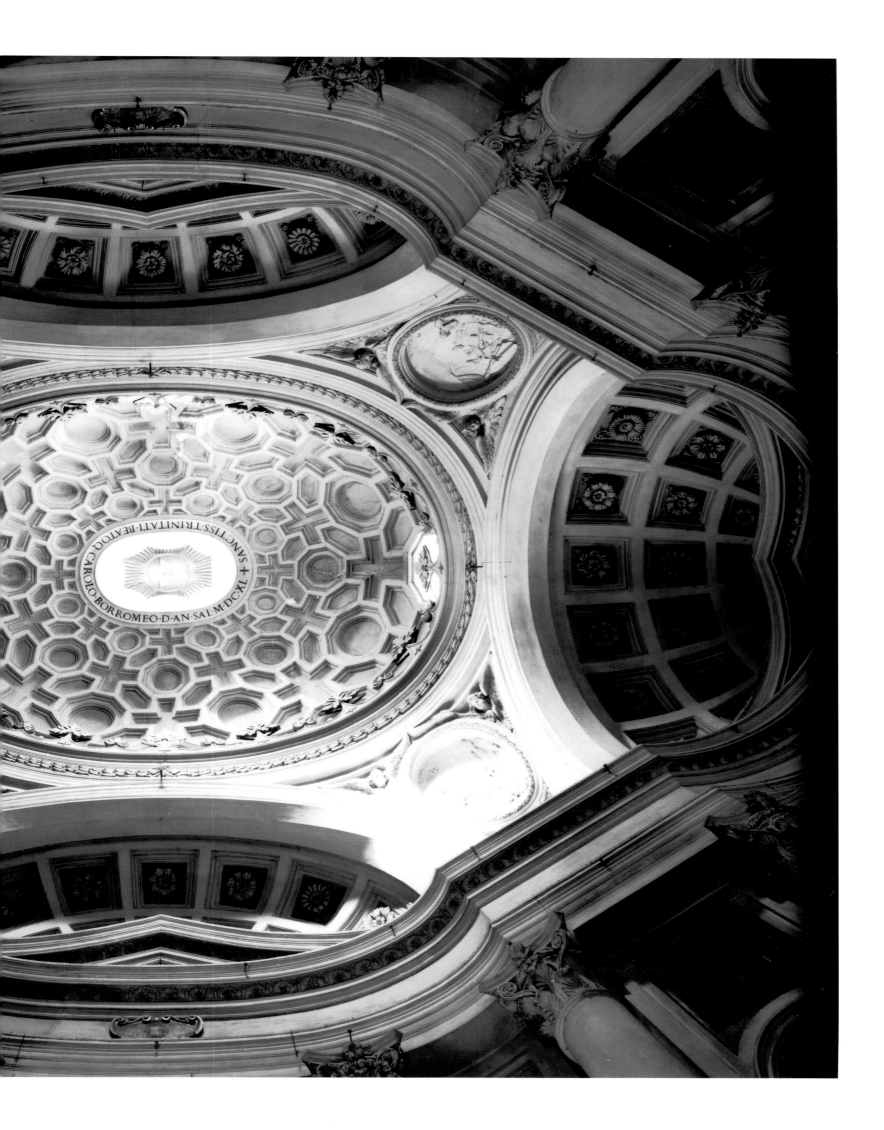

the pediment above the main door. It would be held by two angels, symbolizing the immortal fame and eternal life that were to reward Innocent X for his struggle to assert the primacy of the spiritual over the temporal. As late as 1729, when the pope's tomb was finally completed, almost eighty years after his death, two statues were placed on it, one symbolizing spiritual power and the other temporal power. Sixteen years after the papal bull proclaiming the doctrine of "Unigenitus," it seemed opportune to remind the spectator through these images of the part Innocent X had played in the long struggle between the papacy and the king of France, at that time the most powerful in Christendom. Through its shape and its relatively modest dimensions, which did not provide room for large crowds, Sant'Agnese in Agone symbolized spiritual power. It was a place of prayer and meditation, which Saint Peter's had ceased to be when the centralized plan for the reconstruction of the old basilica had been abandoned in favor of the Latin cross, making it a place of welcome for all the Christians of the world—a symbolism perfectly understood and expressed by Bernini in his use of the famous colonnade.

Contemporary with (and next to) Sant'Andrea al Quirinale, and contemporary with Sant'Agnese in Agone, is the church of San Carlo alle Quattro Fontane. It is built on a very cramped site where its centralized plan is used to best advantage. This was a monastery church and only needed to accommodate small groups; it is a place for meditation and prayer, not for preaching. The oval cupola derives its mystical meaning from this.

A number of other churches can be seen as reflecting the same spirit and intentions, each being built for a limited group of worshipers in the same period: Santa Maria Maddalena, on the Campus Martius, for the community of "Ministers of the Sick"; Sant'Antonio dei Portoghesi, also on the Campus Martius; and San Nicola dei Lorenesi, not far from Santa Maria della Pace. All these are oratories, meeting places intended—at least in the cases of Sant'Antonio and San Nicola—for the use of foreigners living in Rome brought together by a common devotion to their national patron saint. Santa Maddalena was set aside for monks and nuns performing the same charitable works.

The Church Triumphant

As we have seen, a large number of churches dedicated to meditation and intended to foster an awareness of the divine presence were built in Rome in the century of the

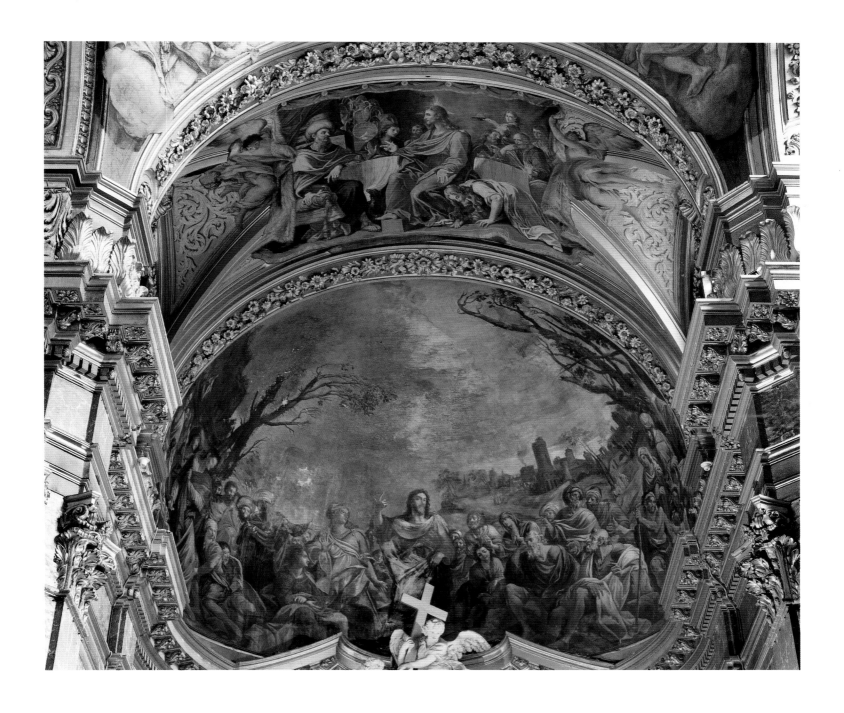

Apse fresco in the
church of Santa Maria
Maddalena, painted
by the French artist
Joseph Parrocel
(1674).

Church of Santa
Maria Maddalena,
begun in 1673 by
Fontana and contin-
ued by Antonio
De Rossi and Carlo
Quadrio. The nave
forms a single hall
with an oblong plan
and a very short
transept. The crossing
is covered by a cupola
without drum. The
very rich decoration
reflects the artists'
desire to stir the
congregation's
imagination.

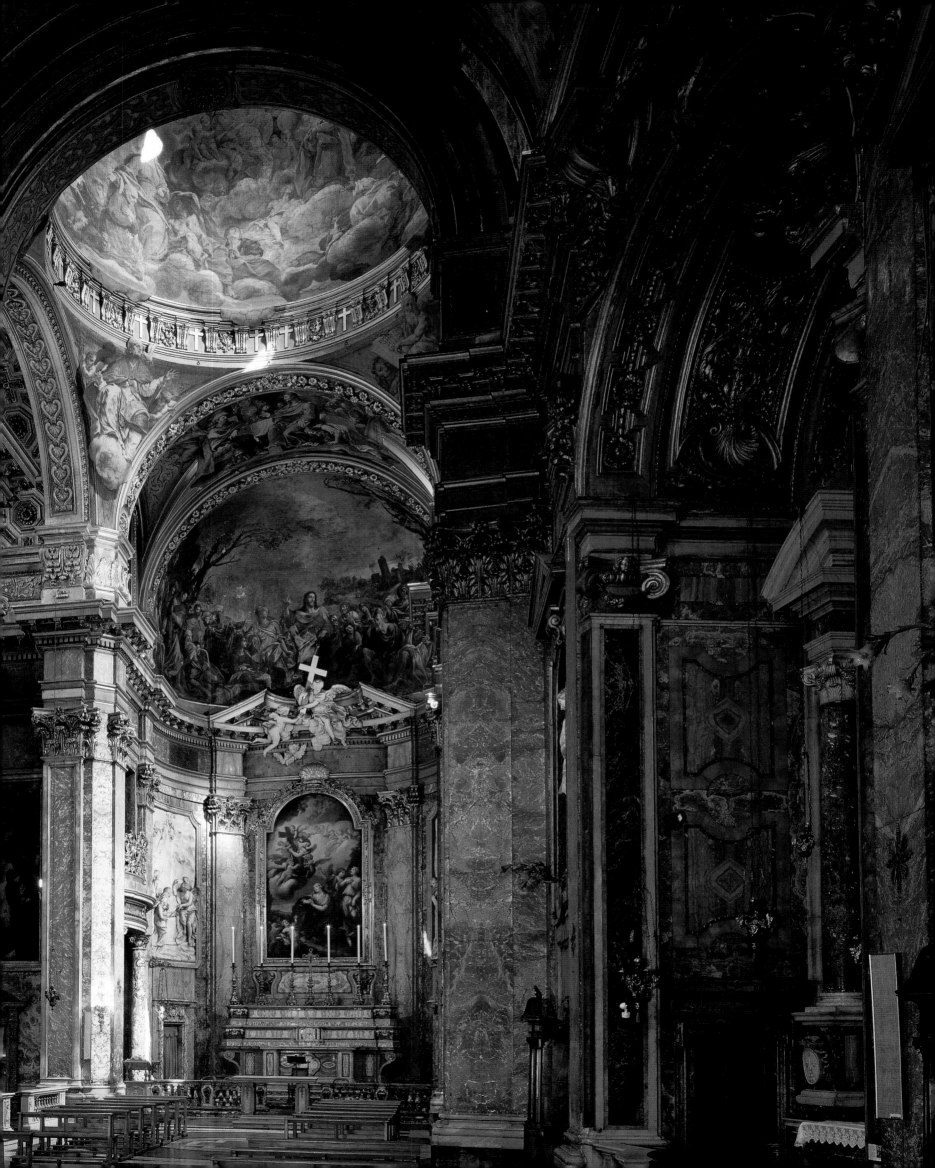

The organ loft of
the church of Santa
Maria Maddalena,
surmounted by a
gallery or *cantoria*
with undulating
forms and sumptu-
ous decoration,
is a fine example
of eighteenth-
century art.

OPPOSITE: Pendentive
of the cupola of Santa
Maria Maddalena.

Reformation and the years that followed. But in the same period other, much larger churches were also erected, better adapted to the purpose of propagating and consolidating the faith.

Of course, such churches had always existed. That of San Luigi dei Francesi is a magnificent example. It was built for the French colony in Rome, already numerous at the end of the fifteenth century, when the kings of France and the emperors were competing for influence with the papacy. Leo X, a pro-French pope, began the work on a church dedicated to Saint Louis, the French saint par excellence. At this time the plan was for a centralized church, propitious to meditation, but the work was broken off, most likely due to the crisis provoked by the imperial threat in the years before the sack of Rome. When the works were resumed after the sack of the city in 1527, a basilican plan was adopted, perhaps because an influx of French was anticipated (France being the major ally of the papacy, at least up to the crisis of Jansenism).

Following the same impulse, the Counter-Reformation and the Council of Trent gave rise to churches responding to the various ways in which the Church wanted to influence believers. These churches all had naves and aisles, and so were able to receive large assemblies. They all took up the same motifs, which had been established conventions for more than a century. All had domes; the cupolas, open at the top, admitted a diffuse, unreal light that seemed to come from some heavenly realm of souls. On all available surfaces were images intended to reaffirm the faith: episodes taken from the lives of the saints showing the birth of their vocation, their triumph over the forces of evil, the saintly serenity of their deaths or their violent martyrdoms. These were large-scale compositions, like that adorning the vault of the Gesù, which shows the universe lit up by the holy name of Jesus. This is a "modernized" version of the scene of Judgment, more "realistic" than the fresco in the Sistine Chapel, where the symbolic value of the images has priority over verisimilitude in the depiction of bodies. Here, the triumph of Jesus is deliberately optimistic; there are no damned souls, and eternal life is promised to all who follow the teaching of the order. This gives rise to a somewhat vague impression of a crowd in which people are lost and do not seem responsible for their fates. They vanish in a multitude whose salvation now depends only on the revelation proclaimed by the followers of Saint Ignatius.

Between Michelangelo's vault and that of the Gesù there are barely eighty years,

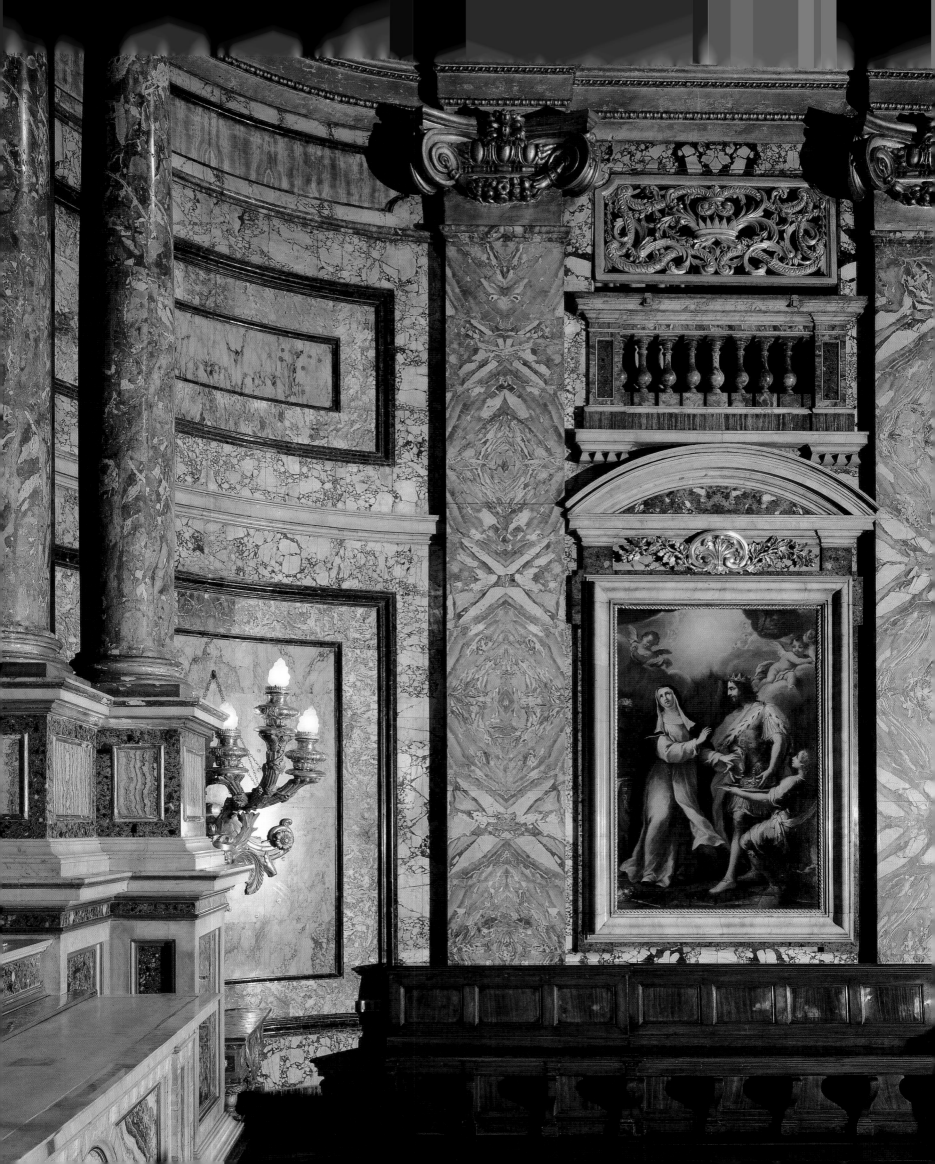

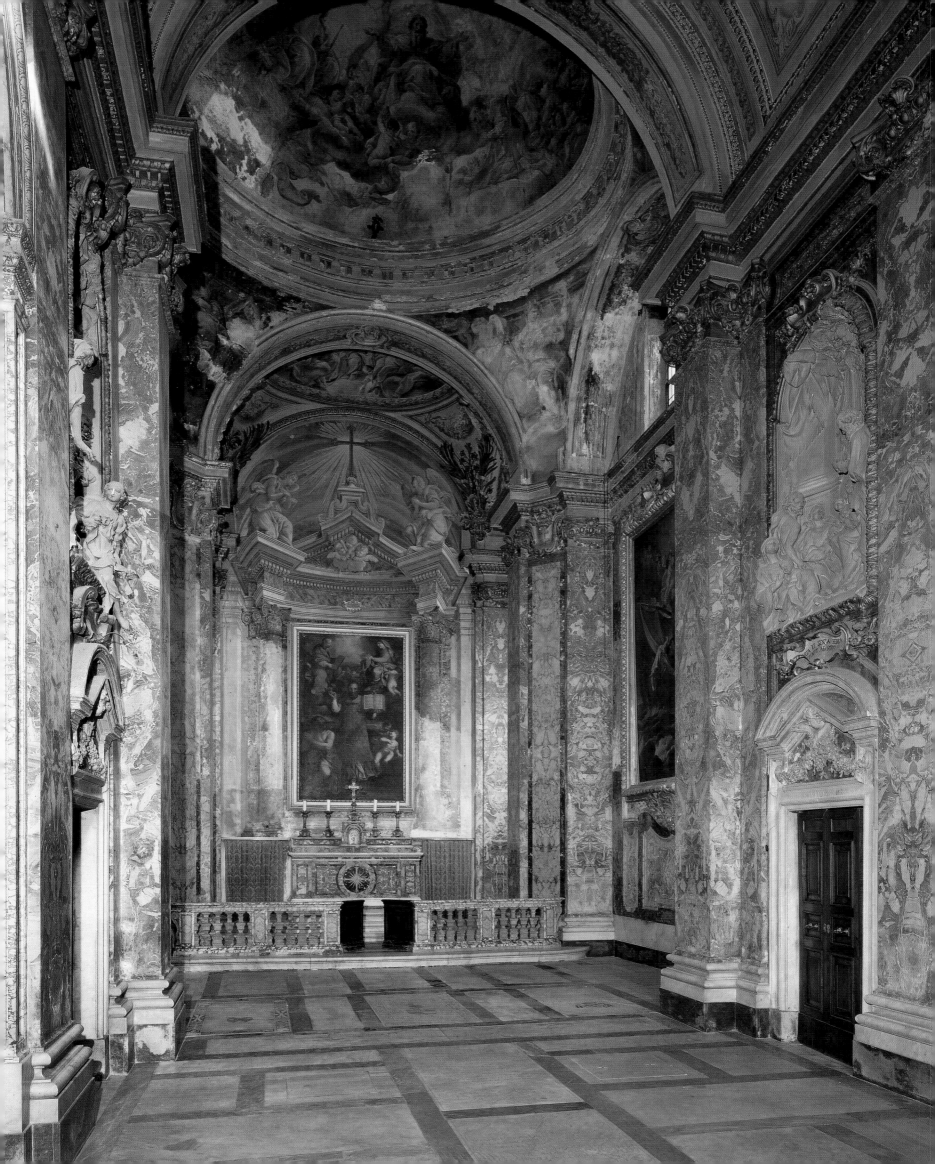

The church of San Nicola dei Lorenesi was built between 1623 and 1636, and the nave was brilliantly decorated in the eighteenth century. The stucco reliefs (right) are fine examples of the rococo style.

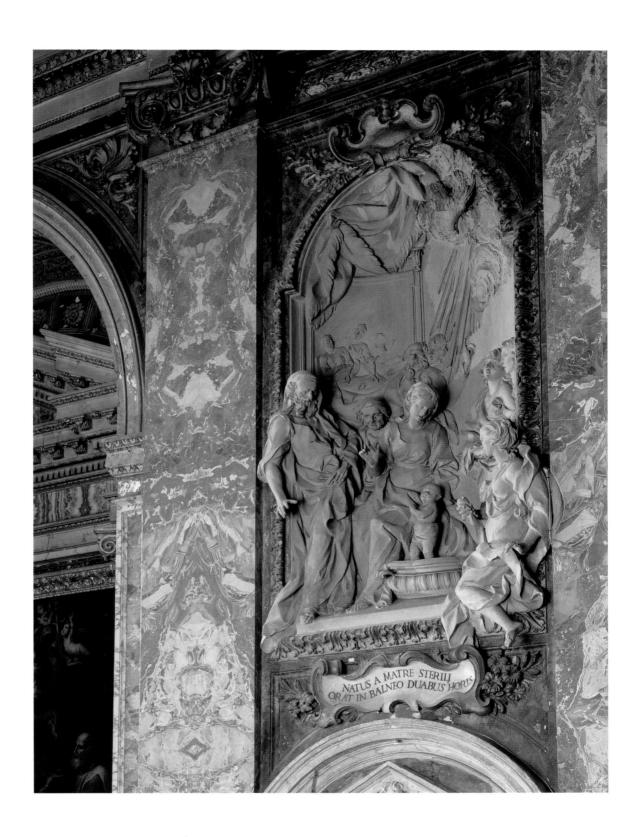

NATUS A MATRE STERILI
ORAT IN BALNEO DUABUS HORIS

San Luigi dei Francesi

The church of San
Luigi dei Francesi,
begun in 1518, was
completed in 1589.
The building, with
three aisles and side
chapels but no tran-
sept, was decorated
with marble, stucco,
paintings, and gilding
under the direction
of Antoine Dérizet
between 1756 and
1764. The vault,
painted by Charles-
Joseph Natoire in
1756, represents
the Apotheosis of
Saint Louis.

yet these are two different universes. In the Gesù
there is hardly room any more for "fear and trem-
bling." The Church is triumphant. It is enough to
follow its teaching to attain eternal glory.

This new emphasis on the Church's role in
spreading doctrine, and the primacy given to
preaching, had a number of consequences that were
reflected in the architecture and decoration of
churches. About 1585 the old church of Santo Ste-
fano Rotondo, which Gregory XIII had given to
the Jesuits, was redecorated with a large fresco de-
picting scenes of martyrdom. The intention was to
prepare the novices of the order to confront the
torture that might await them, not only in barbaric
countries but in Europe itself, in Germany, England,
and all the regions affected by the Reformation. Martyrdom was the price of the exalted
mission promised to the disciples of Saint Ignatius.

One of the first churches built in the spirit of the Counter-Reformation was Santa
Maria in Vallicella, called the "Chiesa Nuova" (New Church). It was part of a group
comprising an "oratory"—although in this case that meant a library and a conference
room in which religious concerts in the spirit of the music of Palestrina were given. (The
Council of Trent had first wished to banish all music from religious ceremonies, but on
hearing the music specially composed by Palestrina during the Council, the pope
changed his mind and music was accepted once again as a form of prayer.) It is no sur-
prise that the decoration of the Chiesa Nuova includes several paintings by Rubens, in
which Saint Domitilla, accompanied by Saints Nereus and Achilleus, each holding the
palm marking them out as the elect, are particularly noticeable. The temptations of
austerity have been thoroughly forgotten!

The church of Sant'Ignazio, dedicated to the founder of the Jesuit order, was to
serve as a chapel for the Collegio Romano, a study center erected for the Jesuits by order
of Gregory XIII at the end of the sixteenth century. At that time it was felt that, to
ensure the triumph of the Church, it was enough to send out preachers whose words

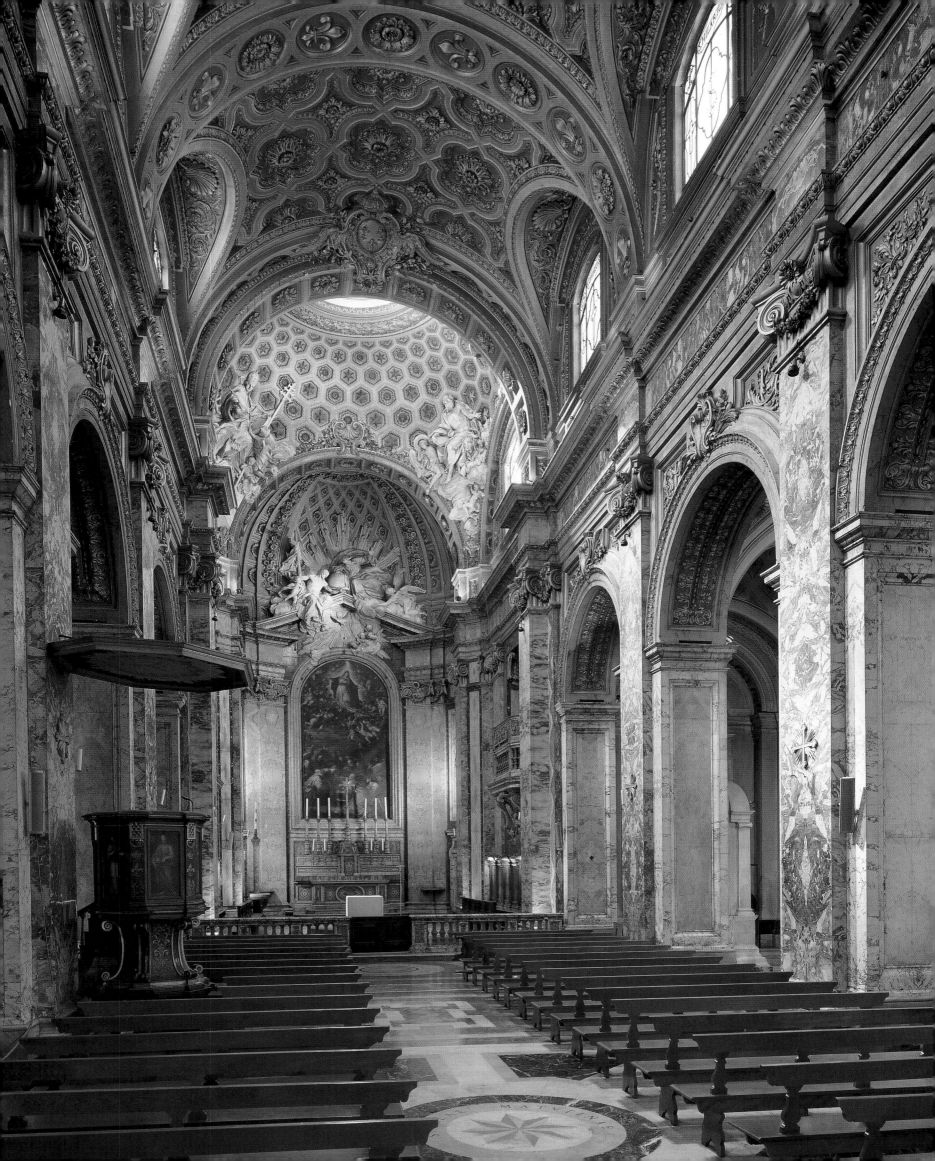

would convert all men. This sentiment, which might be regarded as a product of declining humanism, heralded the optimism that was to emerge in different forms in the Age of Enlightenment. Was not Voltaire brought up by Jesuits in his adolescence? It's true, however, that the church of Sant'Ignazio was not finished until 1685—quite late in the seventeenth century.

By then it was already twenty years since the finishing touch had been put to Sant'Andrea della Valle, the dome of which (finished in 1622) was smaller only than that of Saint Peter's. Owned by the Theatine order, whose task was to continue the "purifying" spirit of the Counter-Reformation, it can be regarded as another version of the Gesù, as it has the same ample proportions and the same single nave without aisles, so that nothing obstructs the gaze of the congregation. As in the Gesù, there were numerous side chapels opening on to the nave; in them, each person could have masses said for any desired purpose and, if he was prominent, could acquire the right to have his tomb built there, on which a sculptor would place his image or that of a saint, a symbol, or a virtue. We still find here, for example, a chapel of the Strozzi and another of the Barberini.

The time when the Roman nobles disputed the authority of the pope and built fortresses to protect themselves against popular uprisings was past. Papal power was undisputed. At the end of the sixteenth century Sixtus V gave material form to this victory he had finally won over the city, at the same time that Saint Peter's ceased to be a shrine and became the largest basilica in Christendom. The city itself was now a network of streets. These large thoroughfares laid out by Sixtus V went from basilica to basilica, radiating from Santa Maria Maggiore toward San Lorenzo fuori le Mura, Santa Croce in Gerusalemme, and the Lateran. The Coliseum (a place made sacred by martyrs' blood), the Column of Trajan (where the statue of the emperor, tolerant as he may have been, was replaced by that of Saint Peter), San Paolo fuori le Mura, and Trinità dei Monti served as milestones. Meanwhile, the domes—those already existing and those constantly being built—added a final touch of animation to the spectacle of the city when seen from the right bank of the Tiber. There is nothing in this panorama that is not a reminder of the triumph of the Christian religion.

Within this scenery set up during the pontificate of Sixtus V is another church, the dome of which, flanked by a strange campanile resembling that of the Sapienza, rises on

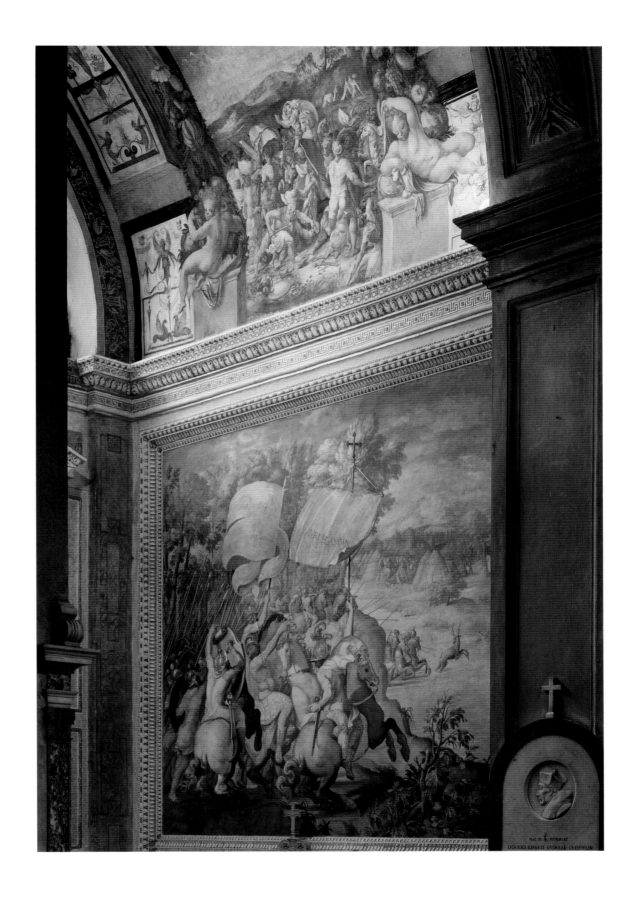

Frescoes of the third chapel of the right aisle of San Luigi dei Francesi, eighteenth century.

Fresco in the vault of
the third chapel of the
right aisle of San
Luigi dei Francesi.

CLODOVEVS IVBET
RESTITVI VRCEO
REMIGIO

DEO CLOTILDIS
SI VICERO PERPETVA
IN FIDE CREDAM

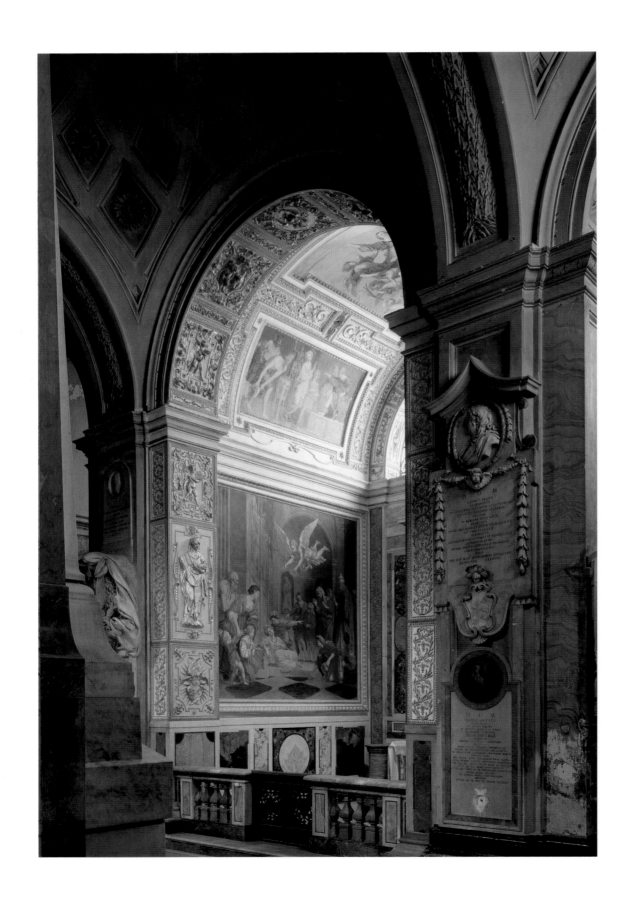

Frescoes of the chapel of Saint Cecilia in San Luigi dei Francesi painted by Domenichino in 1614. On the right, Saint Cecilia distributes her wealth; above, an angel crowns the saint and her betrothed, Saint Valerius. Left, the death of Saint Cecilia; on the vault, Saint Cecilia refuses to offer sacrifices to the pagan gods.

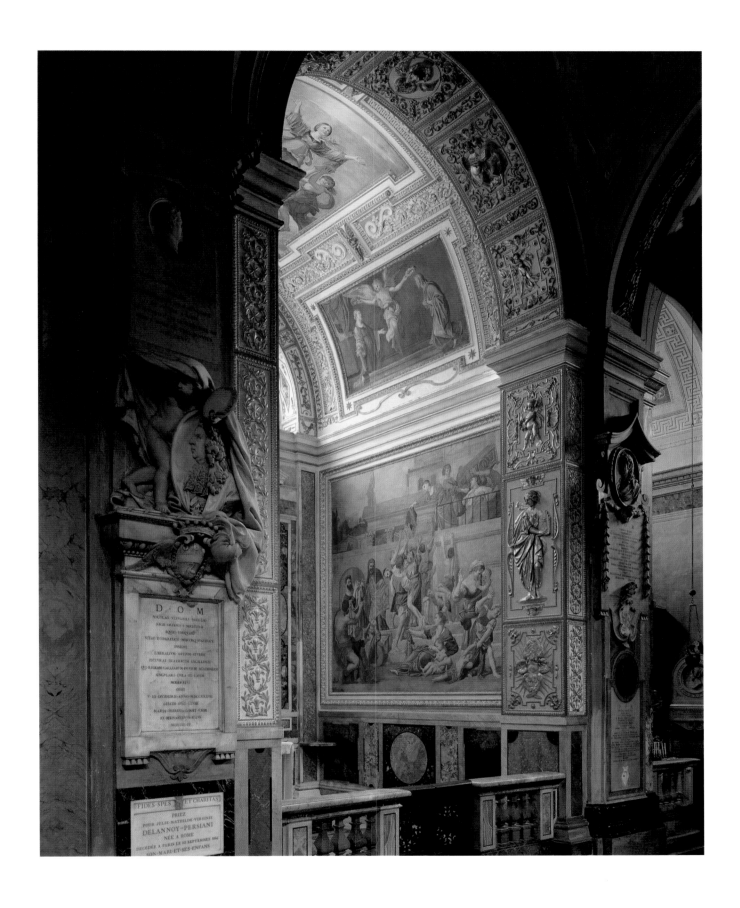

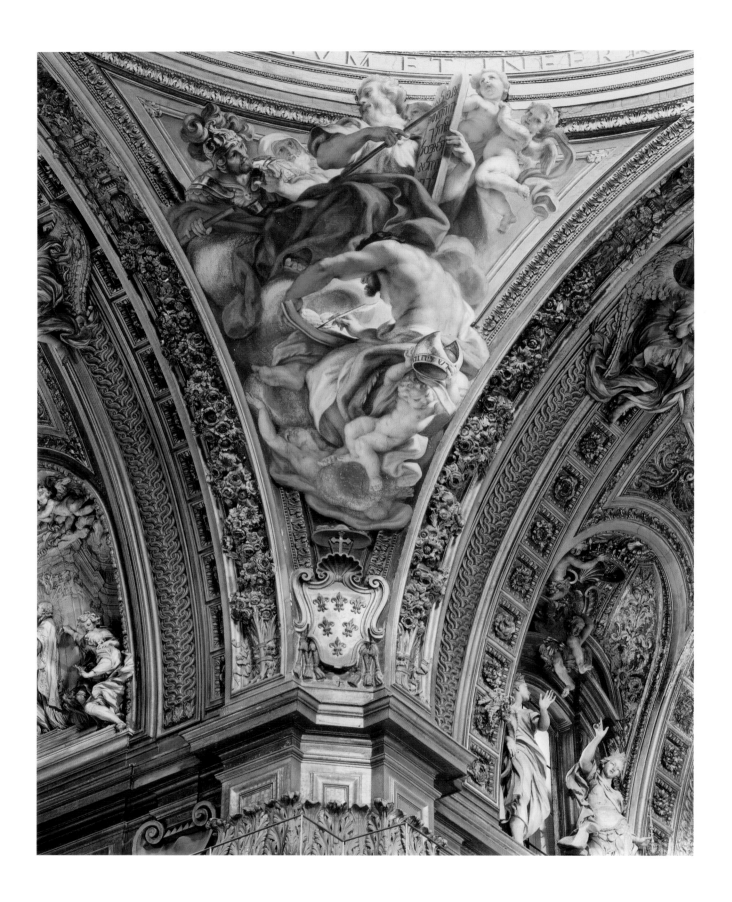

the slopes of the Pincio, at the point where the houses began in the Middle Ages. This church of Sant'Andrea delle Fratte was the domain of angels. In it the angels carved by Bernini for the Ponte Sant'Angelo had found refuge when it was thought they needed shelter from the weather. The choice was all the happier since other angels were depicted on the campanile and the dome. Rome and its churches live in harmony with these servants of God.

At the time of the Republic the Romans had the reputation—which they shared with the Ethiopians, if we are to believe Homer—of being the most pious of mortals. As we have seen, they have continued to deserve this reputation down through the centuries. In Rome the world of the divine is superimposed on that of humans. The very soil of the city is sacred. Here, divine power is manifest. From the first days of its foundation Rome had been attentive to the divine. It was ready to hear the message of revelation and to welcome it. Two of its major virtues, *pietas* and *fides,* are translated into stone in its buildings.

Church of the Gesù

Pendentive of the cupola of the church of the Gesù painted as a trompe l'oeil by Baciccia between 1676 and 1679.

Many churches, as we have seen, were founded and built around a clearly defined spot marked by some divine intervention. In the same way, in pagan times, there had been a custom of building a wall around a place struck by lightning, to isolate it. In Christian times, when the dialogue between heaven and earth was understood differently, churches were built on locations where a soul had lifted itself up to God, either through the torment of martyrdom or through the momentary illumination of a celestial vision. Thus there is the church at Golgotha and the chapel at Emmaus, as there is the church of Sant'Andrea on the Via Flaminia or Santa Maria della Pace.

For a long time the church, the *domus ecclesiae,* was a meeting place where Christians assembled, where they were strengthened in their faith, delivered from their doubts, confirmed in their hopes. The Epistles of Saint Paul bear witness to this. There was also the cult of the dead. This was certainly not new for a people that had believed firmly since

Vault of the nave of the Gesù. Originally without decoration or paintings, the church built by Vignola for the Society of Jesus between 1568 and 1582 was decorated about 1676–90. Baciccia painted the vault frescoes of the Triumph of the Name of Jesus, whose warm colors and lighting reveal a Venetian influence. The illusion is created by clouds, rays, trompe l'oeil, and figures stepping out of their frames. The stucco figures are by Antonio Raggi.

antiquity in a kind of afterlife that they sought to capture and prolong in images. With the advent of Christianity the images did not disappear; they merely became the privilege of those who were thought to have attained eternal life. This may help us to understand why the frenzy of iconoclasm spared Rome. It collided with too many solidly rooted feelings. How could the images of saints be broken while, all along the roads, the faces of people dead for centuries could be seen sculpted in stone? Inside the churches, once they were allowed to be built, the whole *ecclesia* formed by the living and the dead together was reconstituted around the cult of the saints.

Such was the spirit that seems to have presided over the building of the oldest churches. They were meeting places for the living, but also for those others who had passed into a realm of peace. Once this was believed, as it was by the faithful, everything became clear. The great figures from the Bible appeared on the walls of churches. These were the forerunners who guaranteed the existence of another life, an invisible life that the sculptors and mosaic artists rendered perceptible. The decoration of the Baroque churches, the theatrical character of which can sometimes seem so alien, is in agreement with an intention that can be traced back to the origins of sacred art. The world it creates, in its realism and even in the excesses of the feelings expressed, is offered to us as a model. The faces give us access to souls in which we are invited to recognize ourselves. And to the extent that this is a superhuman world, it teaches us to transcend ourselves.

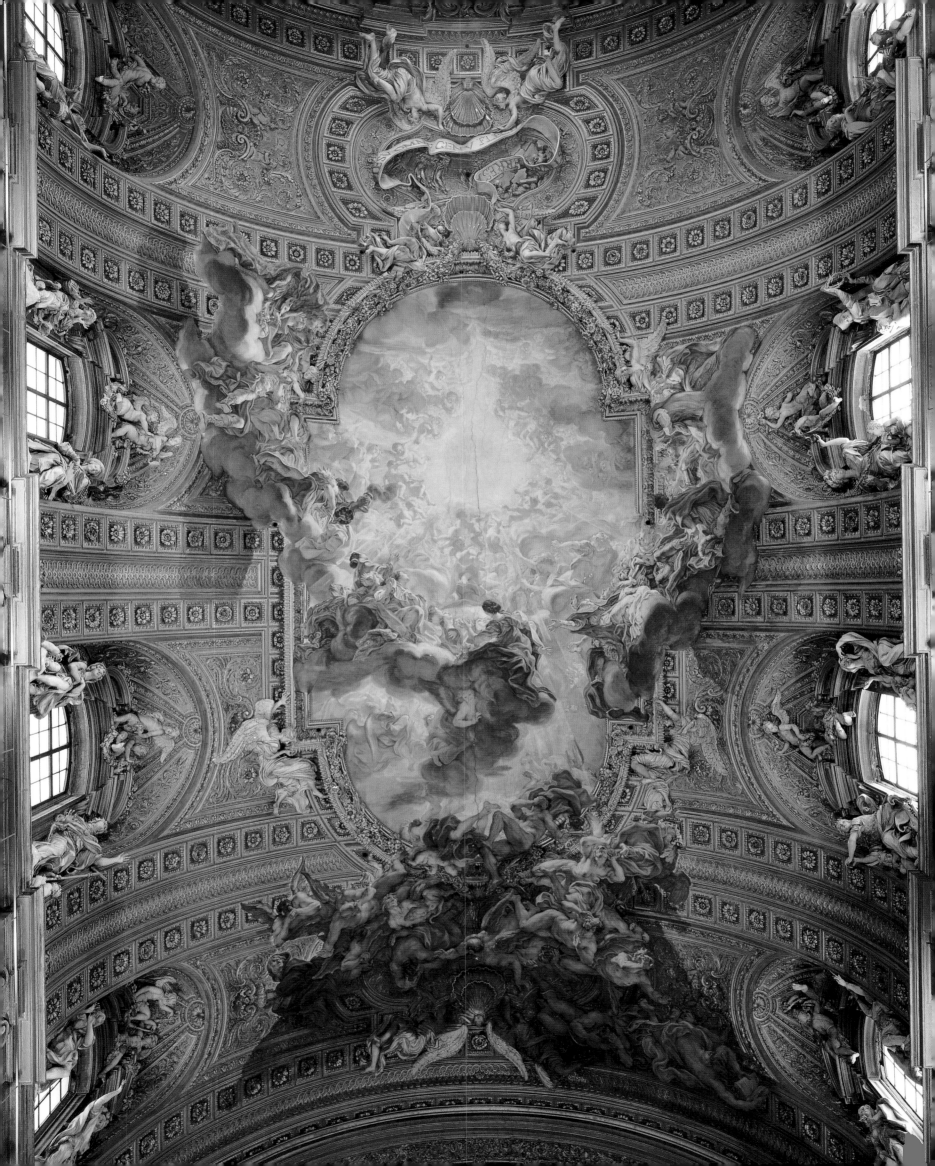

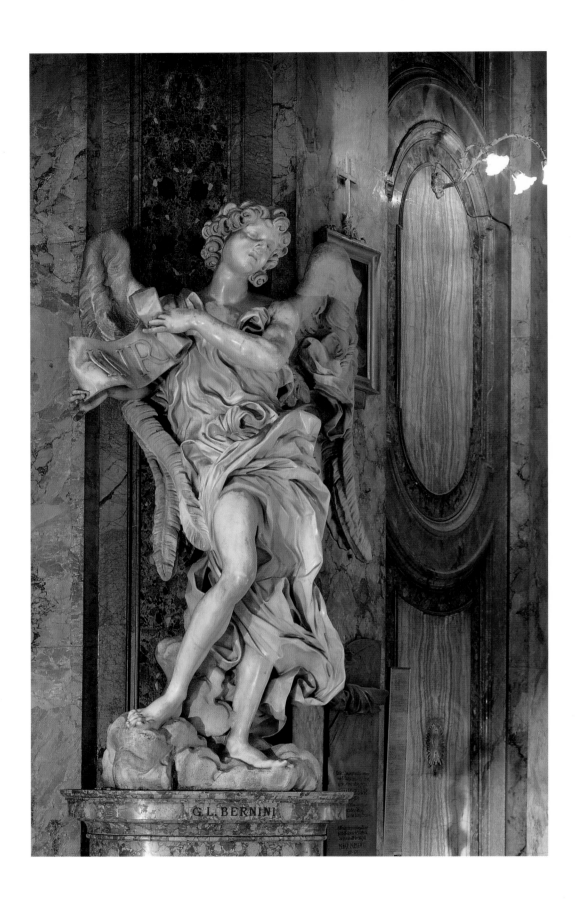

G.L.BERNINI

One of the two angels situated on each side of the entrance of the choir of Sant'Andrea delle Fratte, originally sculpted by Bernini for the Ponte Sant'Angelo in 1669. They were considered so beautiful that only copies were exposed to the open air.

OPPOSITE: In the church of the Gesù, a marble group on the right side of the altar of the chapel of Saint Ignatius, representing Religion Triumphing over Heresy, by Pierre Legros (1696–1700).

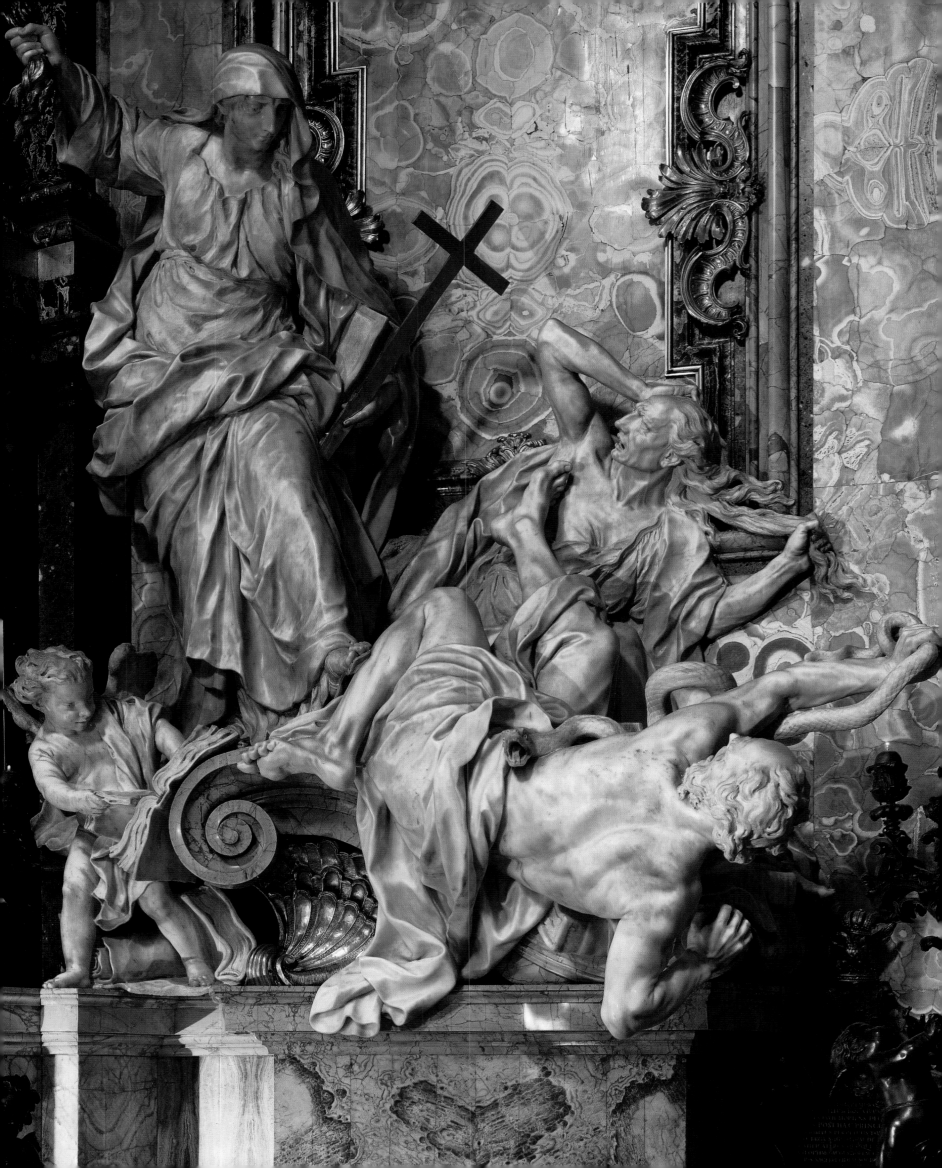

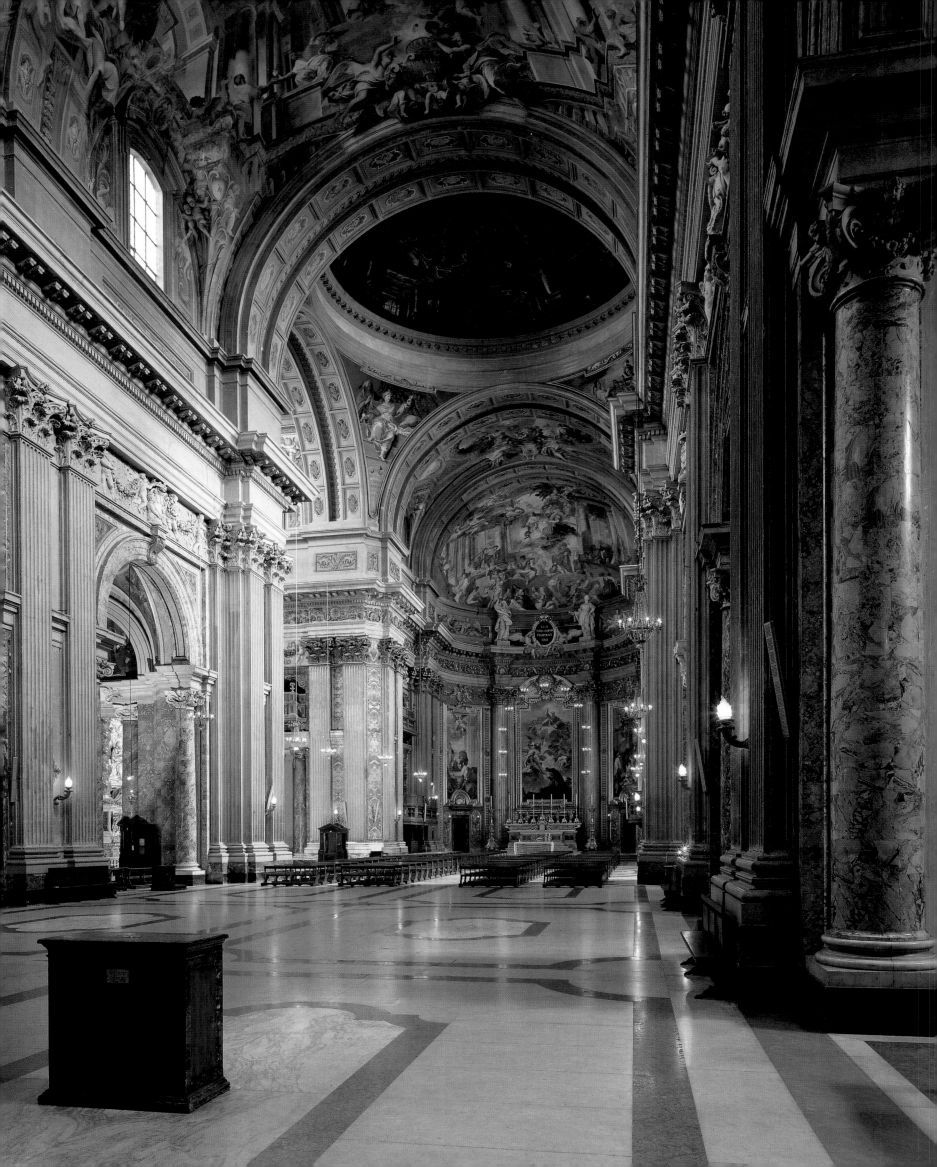

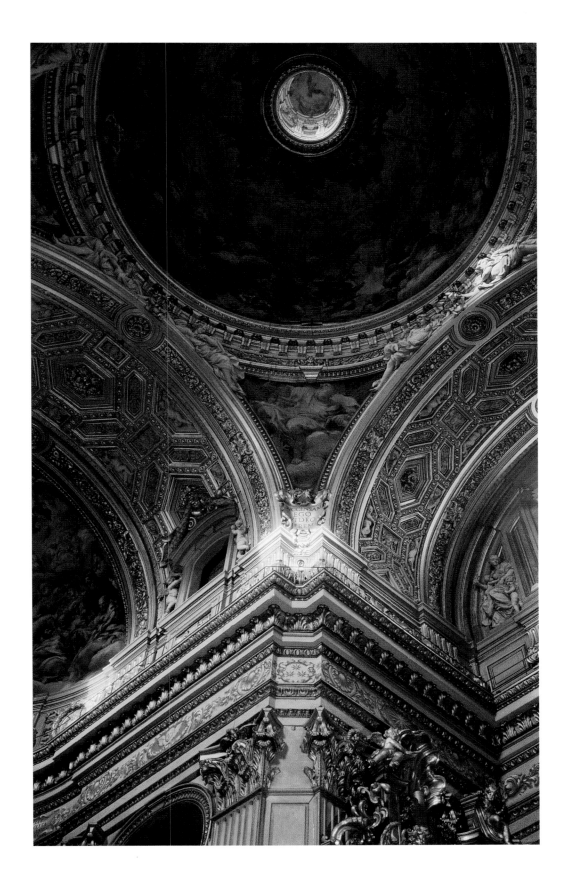

OPPOSITE: Nave of the church of Sant'Ignazio, begun in 1626 to plans by the Jesuit Orazio Grassi. The large hall, vaulted over the short transept, reflects the same preoccupation as at the Gesù: to allow the congregation to see and hear the preacher from all points.

Cupola of the Chiesa Nuova (Santa Maria in Vallicella), built between 1575 and 1605 by Matteo da Città di Castello, then by Martino Longhi the Elder, for the Congregation of the Oratory of Saint Philip Neri.

153

Vault of the nave of the church of Sant'Ignazio, painted in trompe l'oeil perspective by Andrea Pozzo in 1694. The subject, the missionary activity of the Jesuits, expresses the pride the Society of Jesus took in its contribution to the rise of the Church. From the breast of Christ, lost in the clouds and brandishing a sword, a ray shoots forth, striking Saint Ignatius and then spreading to the four corners of the earth to illuminate them with the light of the Gospel. The walls and columns of the church are artificially prolonged, appearing to open on to the sky through perspective effects that are correctly aligned only when seen from a precise spot marked on the floor.

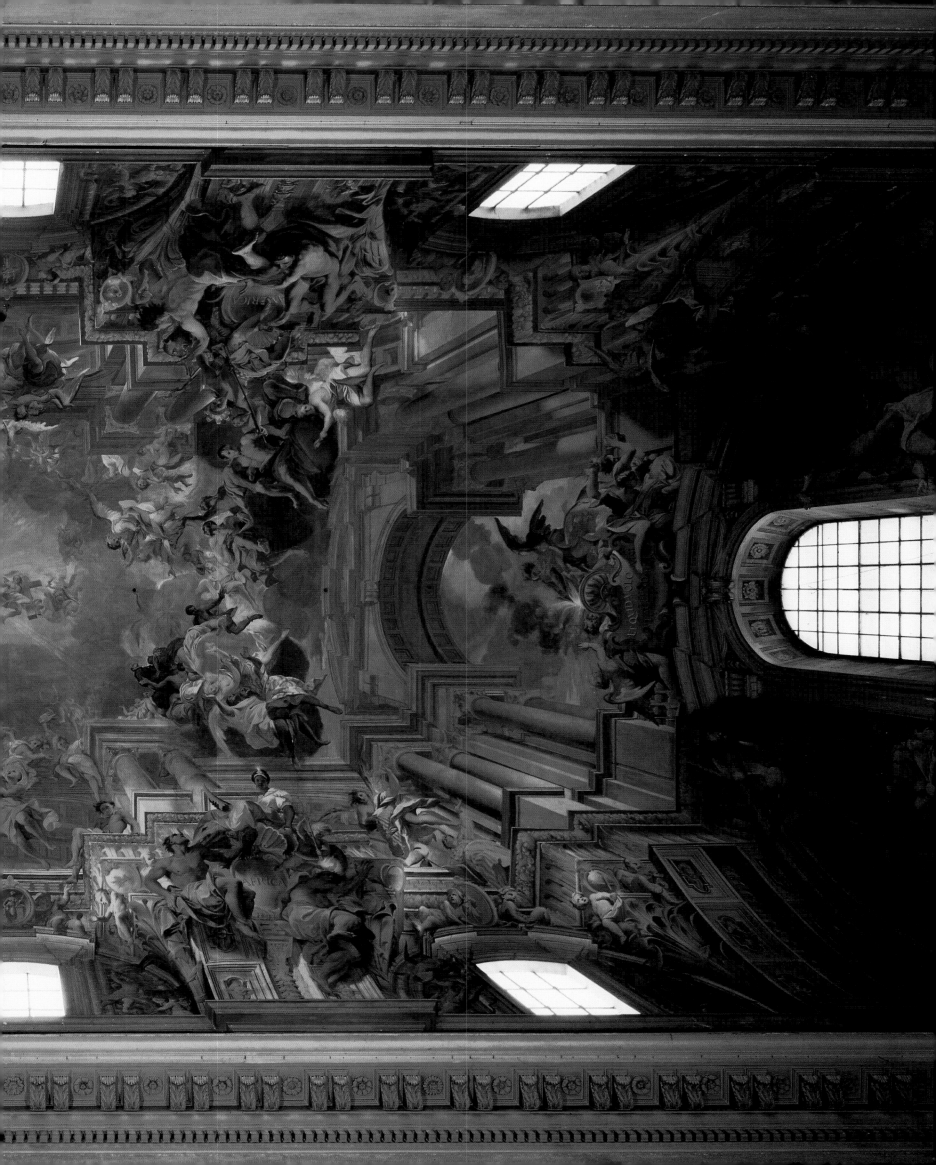

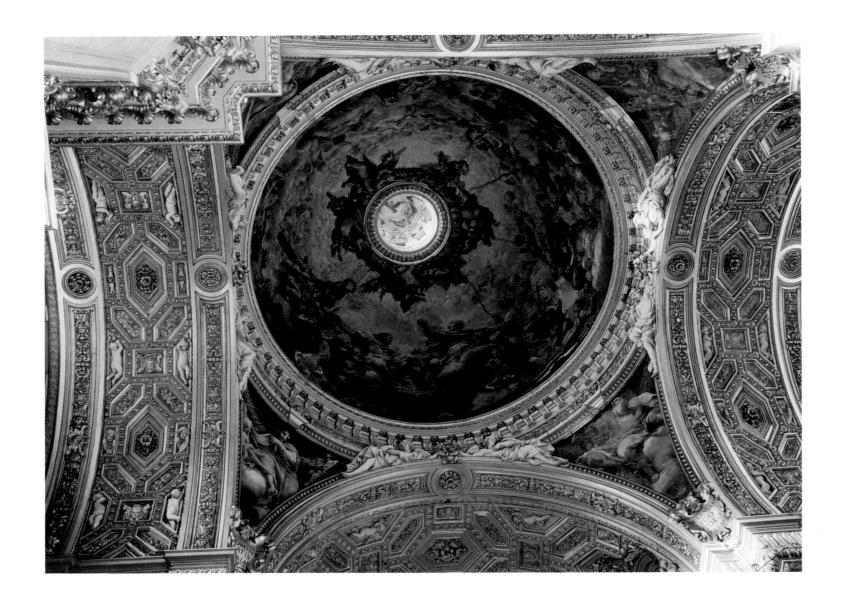

Cupola of the Chiesa
Nuova (Santa Maria
in Vallicella), painted
by Pietro da Cortona
from 1648 to 1651.
The painter has de-
picted Christ present-
ing the instruments of
the Passion to God
and causing the pun-
ishment of humanity
to cease. On the pen-
dentives are the four
prophets—Isaiah,
Jeremiah, Ezekiel, and
Daniel (1659–60).

OPPOSITE: Cupola
and apse of the church
of Sant'Ignazio,
painted by the Jesuit
priest Andrea Pozzo
(1684–85), a theore-
tician of perspective
and master of trompe
l'oeil. On the apse
is the famous fresco
of the miracles said
to have occurred
through the interces-
sion of Saint Ignatius.

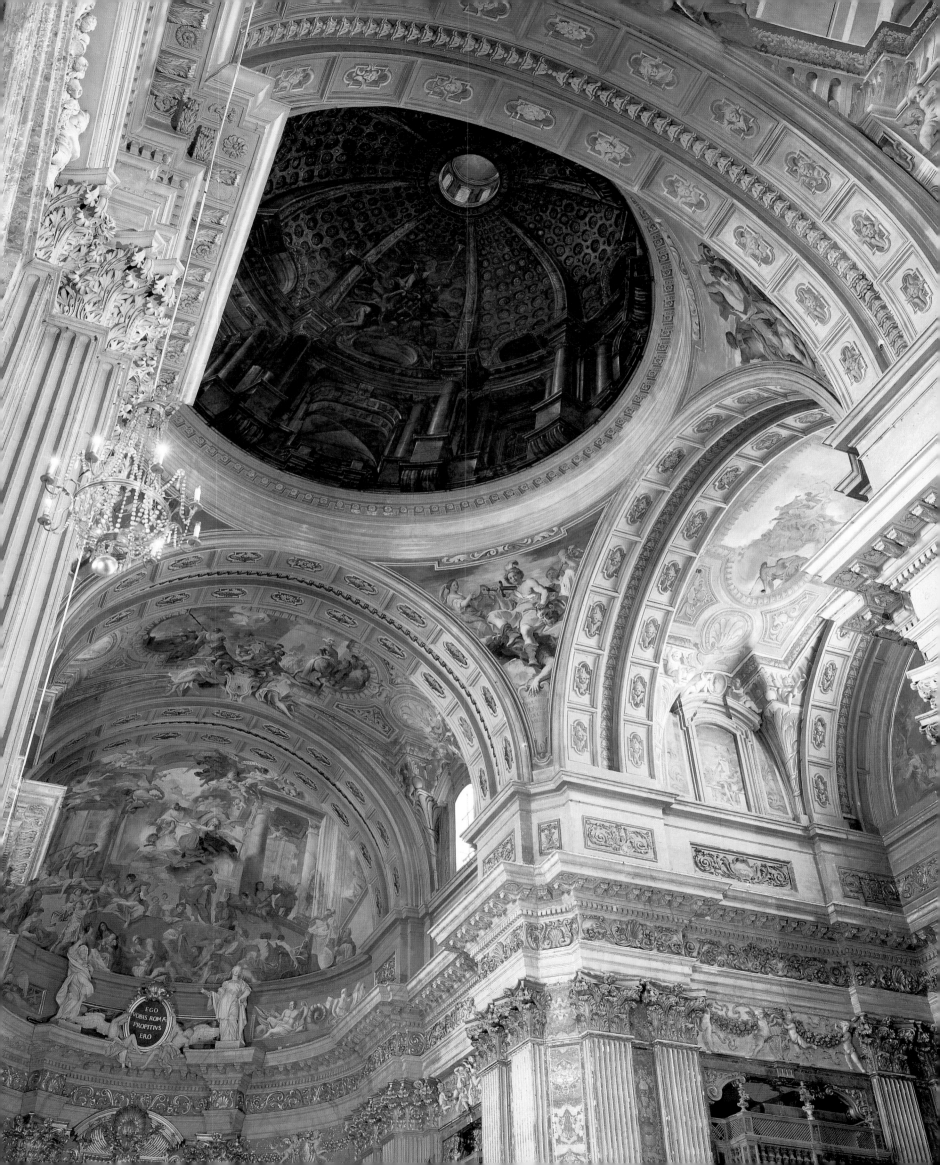

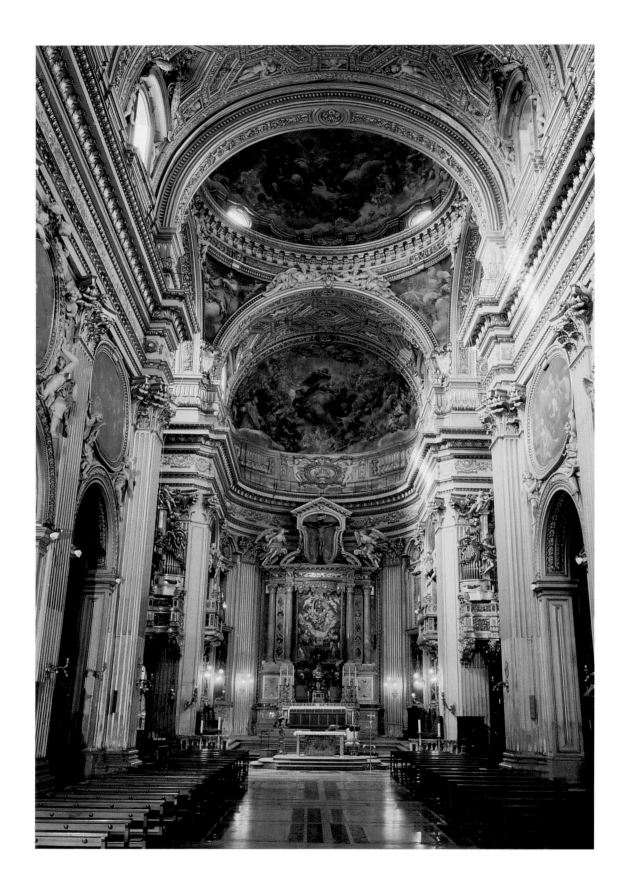

Nave of the Chiesa
Nuova (Santa Maria
in Vallicella) built by
Martino Longhi the
Elder. Narrow side
aisles link chapels that
are rounded inside
but hidden on the
outside by straight
walls. Pietro da
Cortona carried out
the apse decoration of
the Assumption.

OPPOSITE: The chapel
of Saint Ignatius in
the church of the
Gesù, created by
Andrea Pozzo from
1696 to 1700. The
gold, the green and
white marble, the
gilt bronzes, and the
silver statue of Saint
Ignatius of Loyola
surmounting the
funerary urn of
lapis lazuli make this
altar a most remark-
able work.

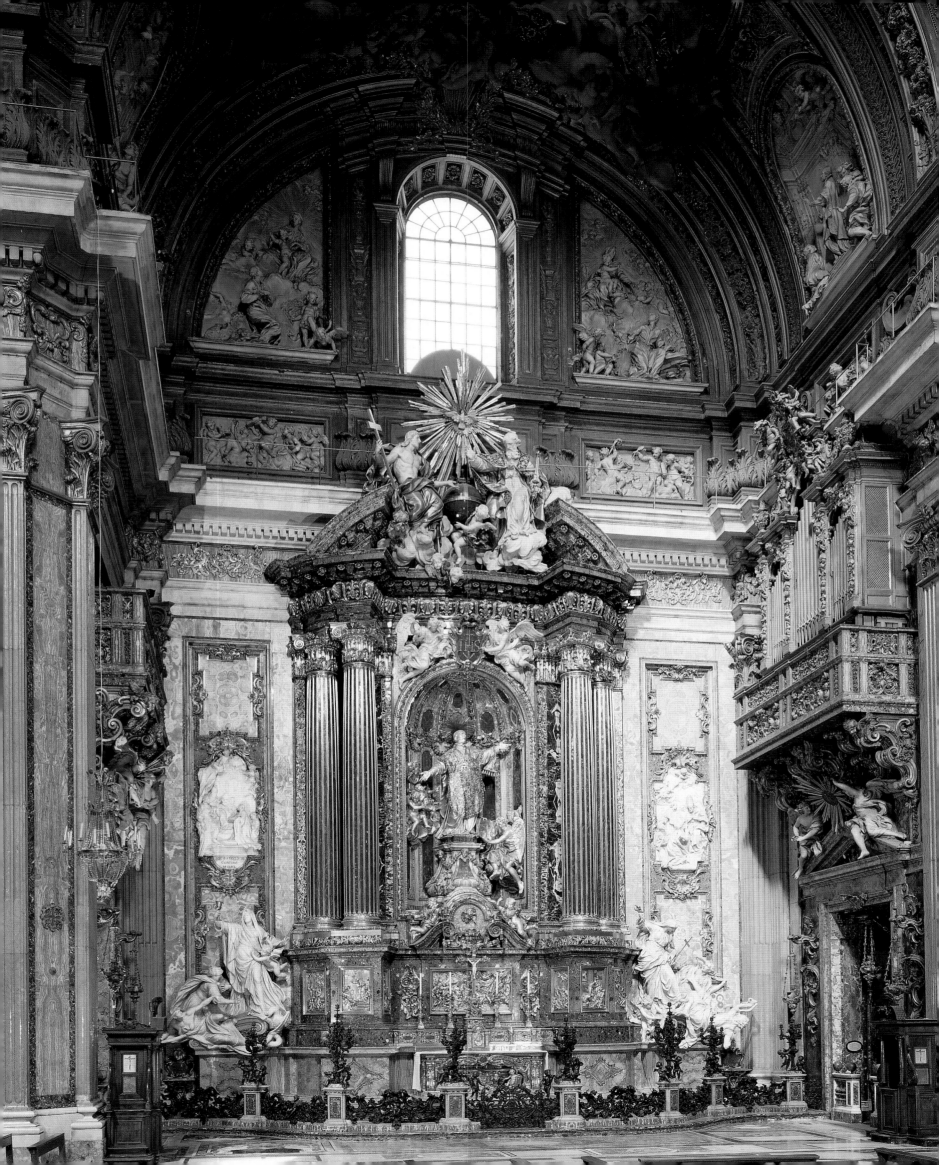

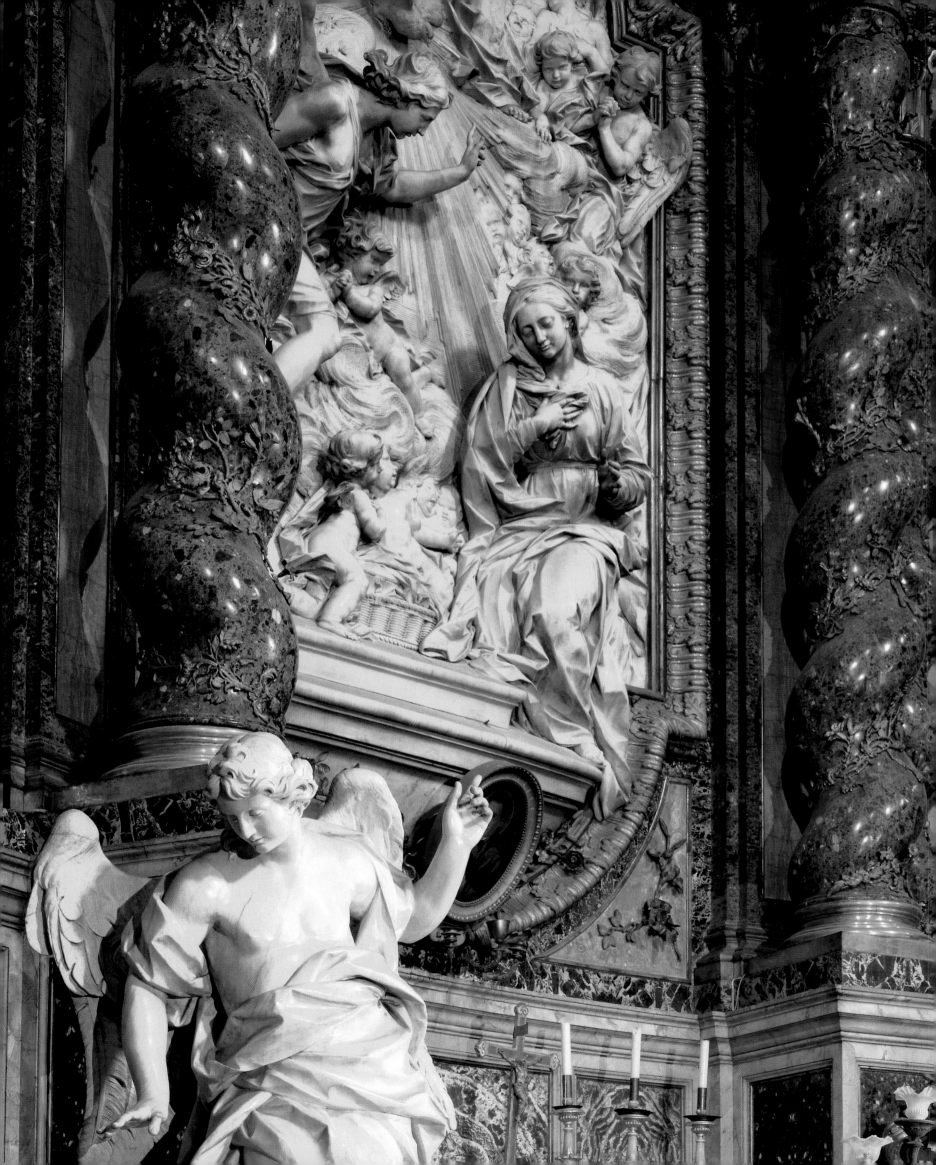

OPPOSITE: High
relief in white marble
executed by Filippo
della Valle in 1750
for the altar of the
Annunciation in the
transept of the church
of Sant'Ignazio.

Detail of one of the
two angels by Bernini
at the entrance to
the chancel of
Sant'Andrea delle
Fratte (1669).

Roof of the crossing
of the transept of
Sant'Ignazio, painted
in trompe l'oeil
perspective on a
horizontally stretched
canvas by Andrea
Pozzo, to replace
the dome that
was never built.

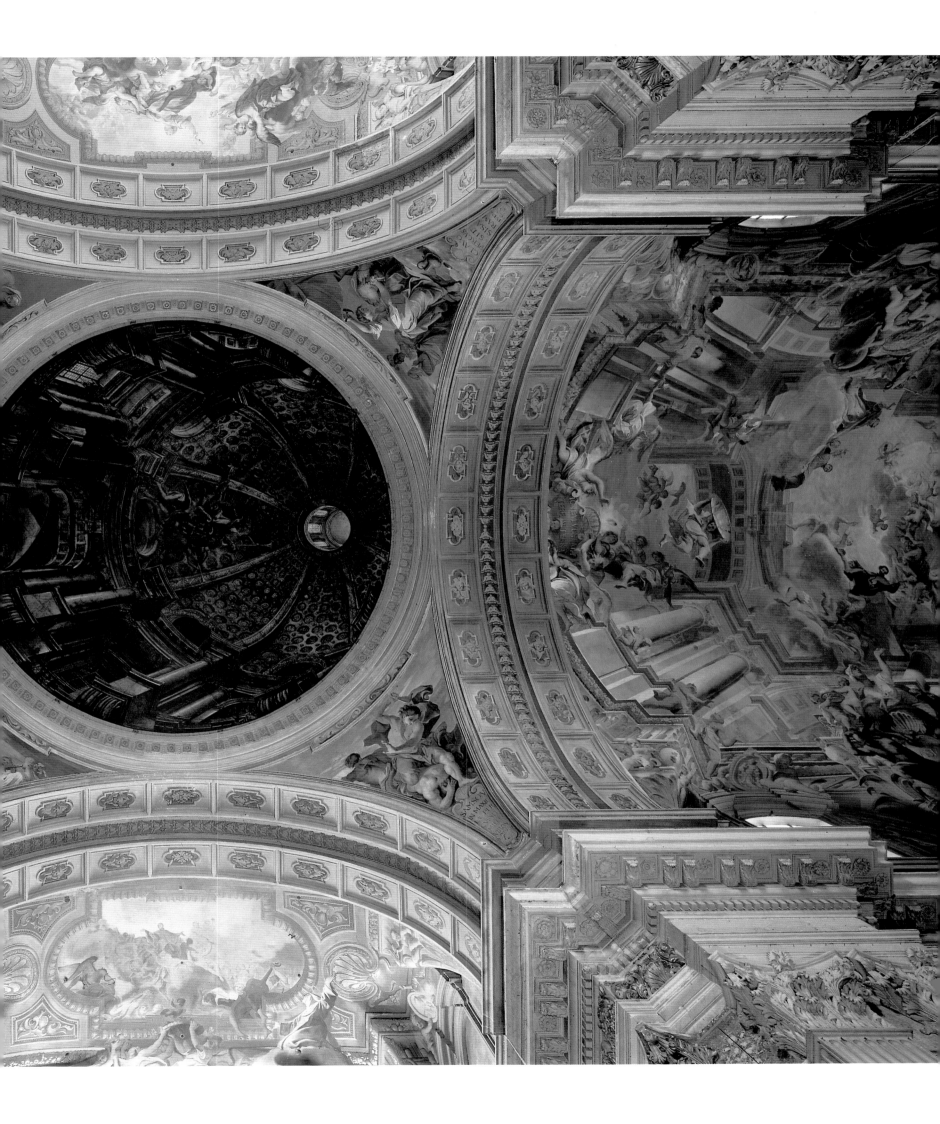

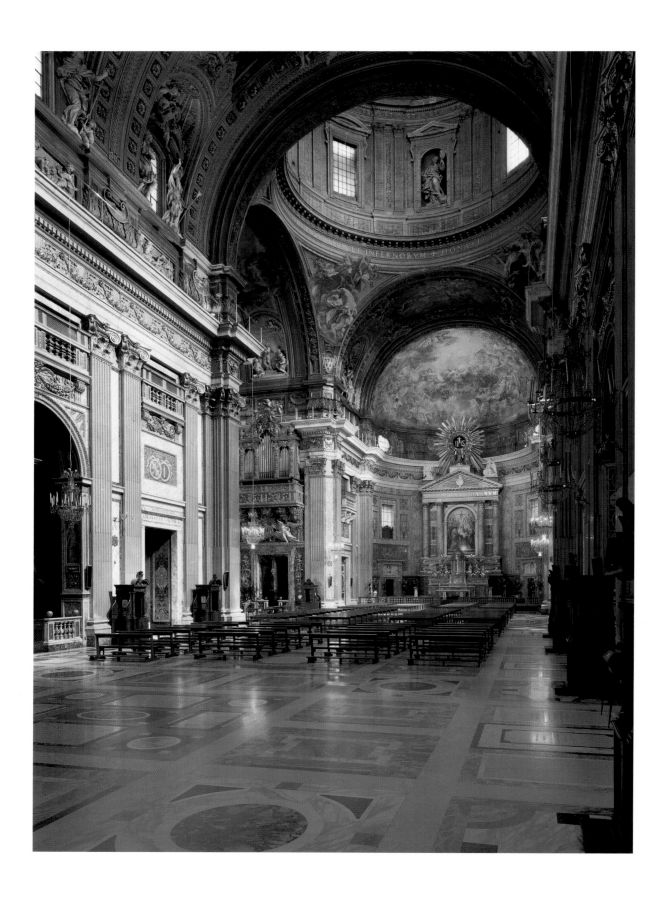

Nave of the church
of the Gesù by
Vignola, a huge hall
where nothing
obstructs the view.
The ample propor-
tions and especially
the width of the hall,
designed for large
congregations, affirm
the triumph of the
Church and con-
tributed to the influ-
ence of the Society
of Jesus.

OPPOSITE: Chapel
in the right aisle
of Sant'Ignazio.

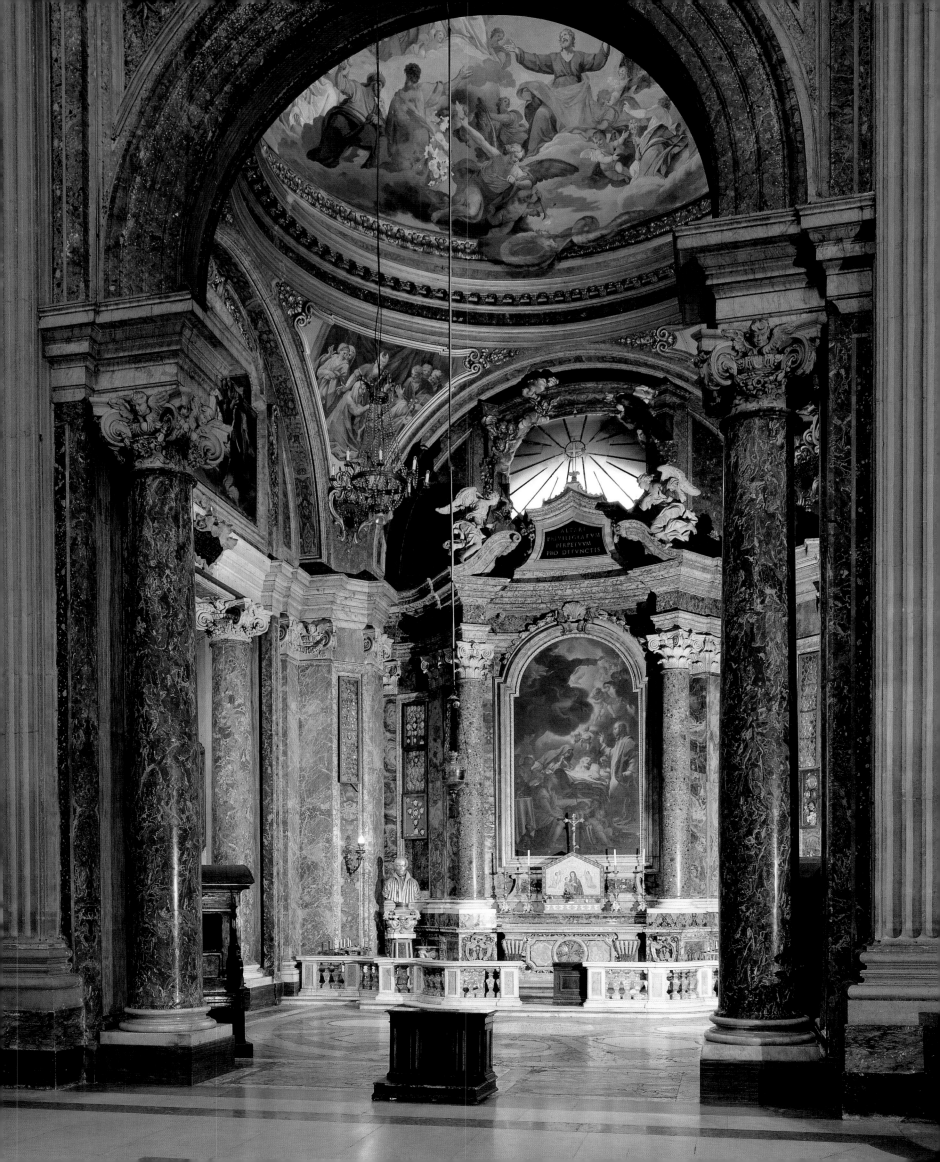

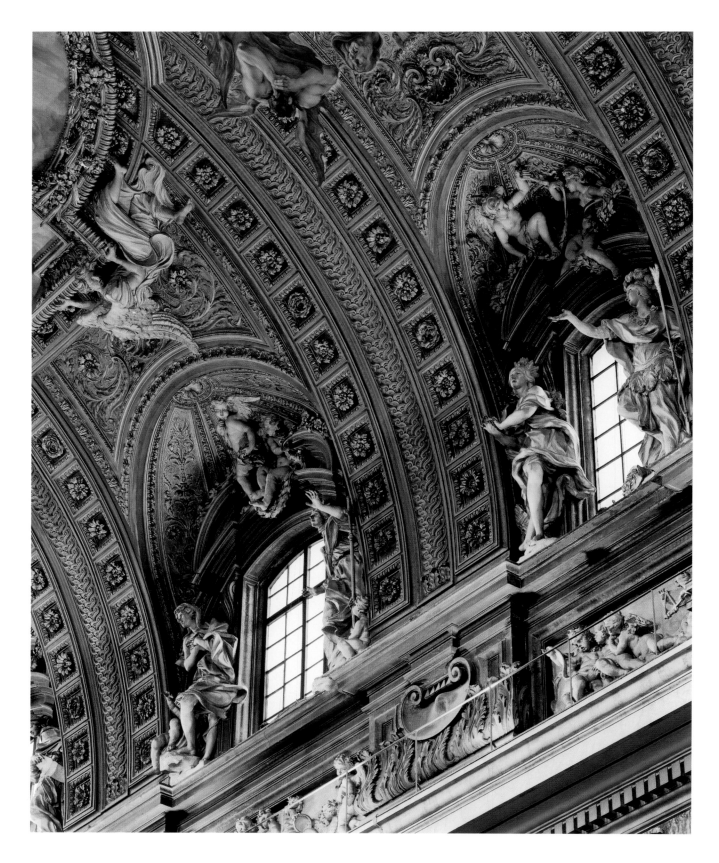

Detail of the nave vault of the church of the Gesù.

Enclosure of the altar consecrated to Saint Francis Xavier in the right transept of the Gesù.

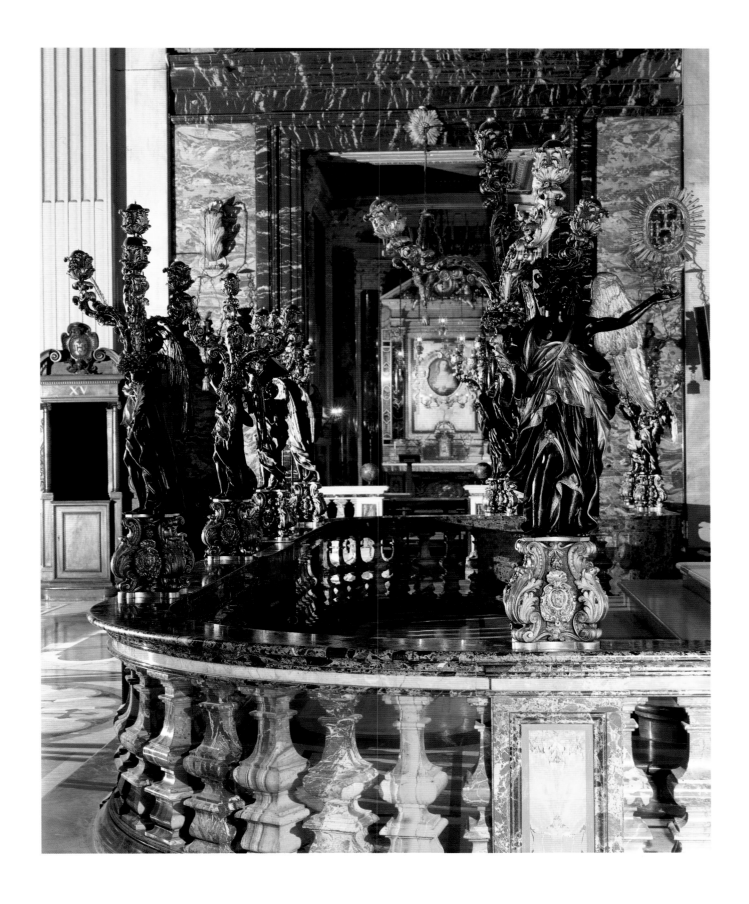

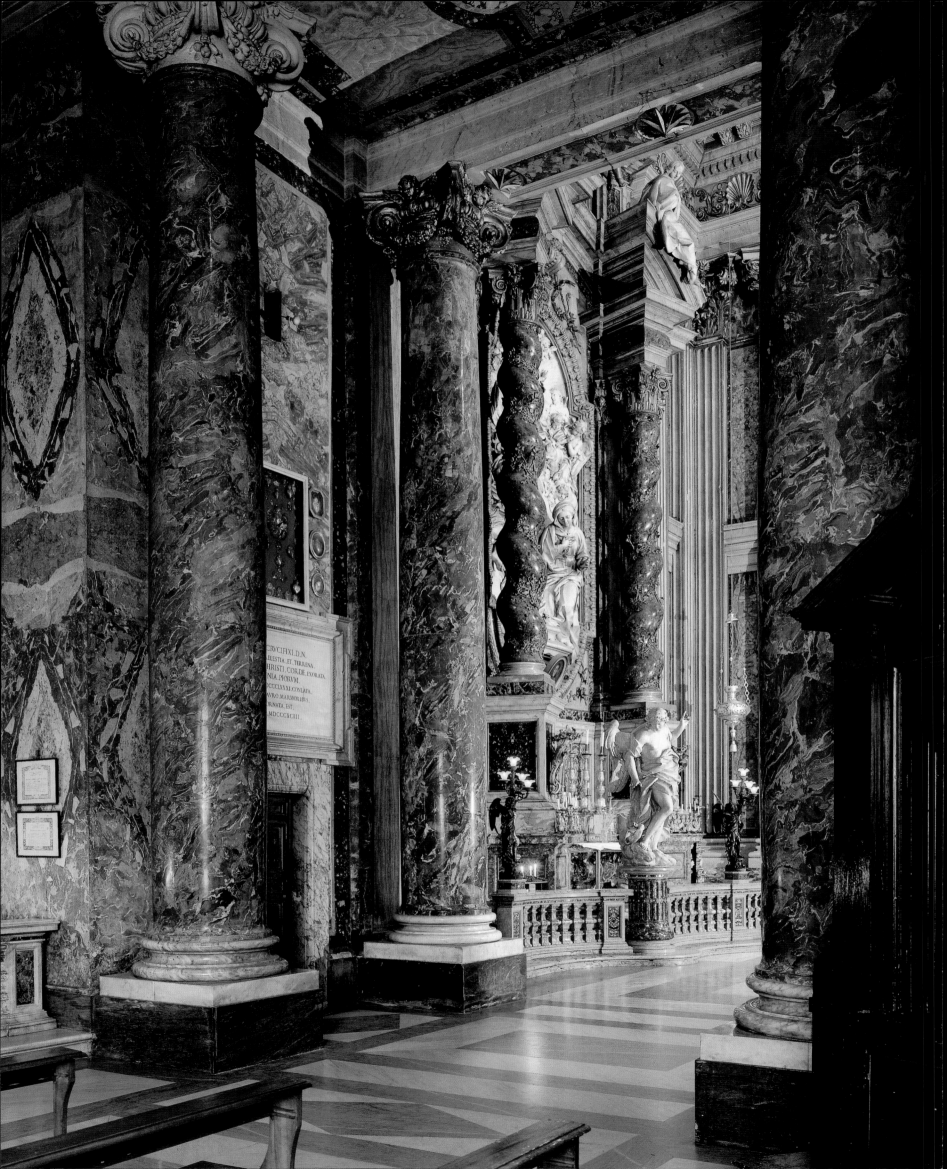

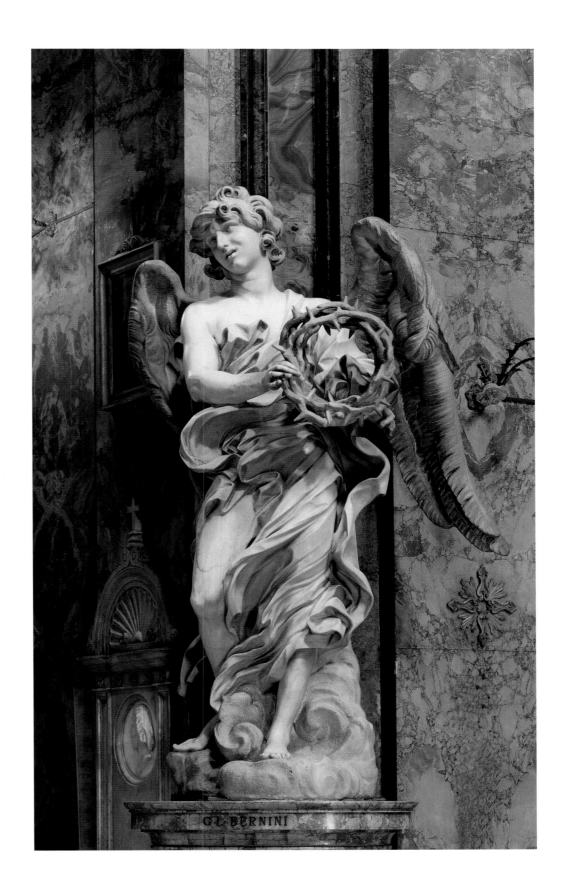

OPPOSITE: Three-quarter view toward the altar of the Annunciation in the left transept of Sant'Ignazio.

An angel sculpted by Bernini at the entrance to the chancel of Sant'Andrea delle Fratte (1669).

Enclosure of the altar
of the Annunciation
in the left transept
of Sant'Ignazio,
executed by Filippo
Valle in 1750.

OPPOSITE: Church of
the Gesù, Barbarians
Adoring the Faith,
by Jean-Baptiste
Théodon. Group on
the left of the altar
of Saint Ignatius
(1696–1700),
depicting one of
the Jesuits' evange-
lizing missions. The
rococo balustrade
is embellished
with cressets.

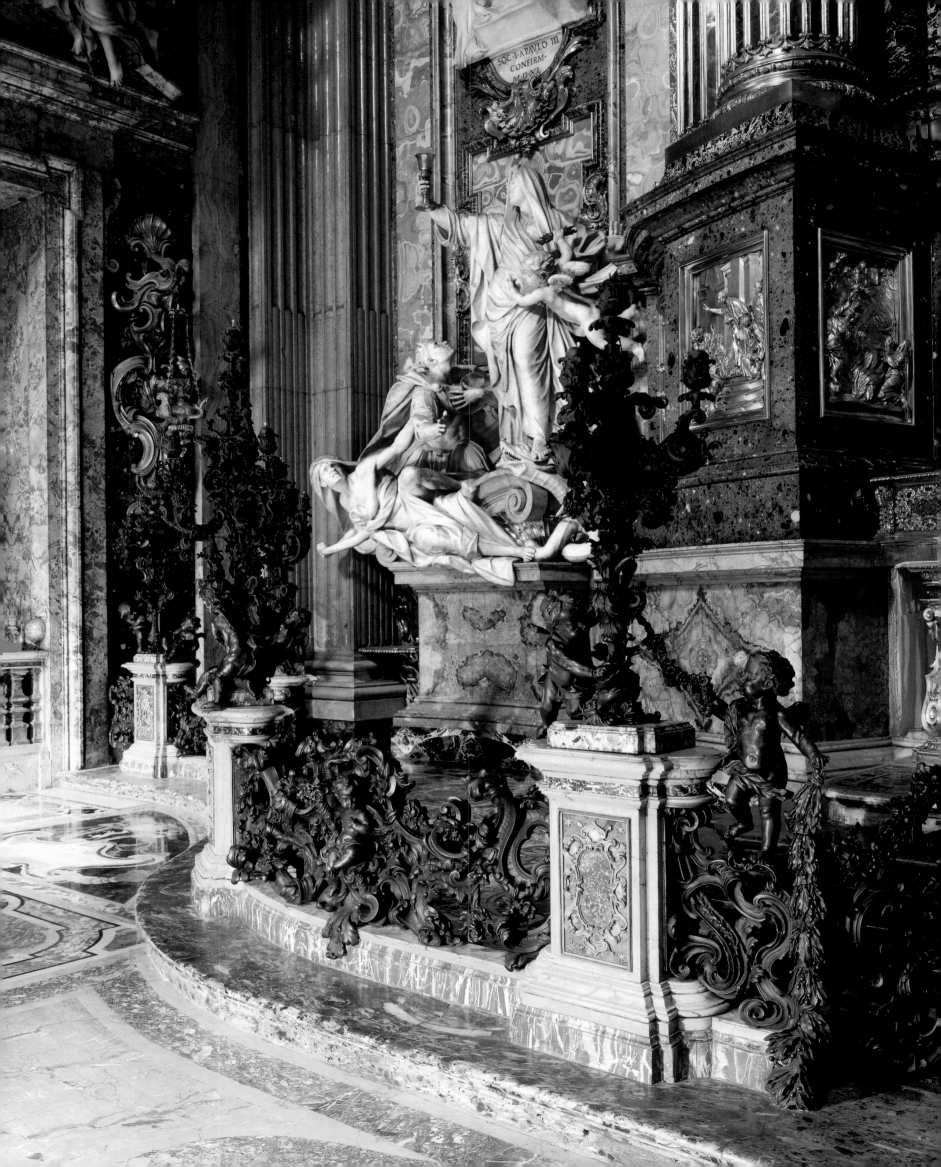

Piazza di SPAGNA

PANTHEON

QUIRINAL

28

29 22

VIMINAL

8

4

ESQUILINE

10

CAPITOL

FORUM

PALATINE

2

11

32

LATERAN

3

CAELIAN

6

13

AVENTINE

CARACALLA

14

19
20

9

5

SELECTED BIBLIOGRAPHY

Abgelis d'Ossat, G. de. *Romanità delle cupole paleo-cristiane*. Rome, 1946.

Armellini, M., and C. Cecchelli. *Le chiese di Roma dal secolo IV al XIX*, 2 vols. Rome, 1943.

Blunt, A. *Guide to Baroque Rome*. London, 1982.

Le chiese di Roma illustrate. Collection edited by C. Galassi Paluzzi and C. Pietrangeli. Rome, 1935.

Huelsen, C. *Le chiese di Roma*. Florence, 1927.

Krautheimer, R. *Corpus basilicarum romanarum*. Vatican City, 1934.

Lemerle, P. "A propos des origines de l'édifice culturel chrétien." *Revue archéologique*, 1949, pp. 167ff.

E. Mâle. *L'Art religieux après le concile de Trente*. Paris, 1932.

———. *Rome et ses vieilles églises*, 2d ed. Rome, 1992.

Mariani, V. *Le chiese di Roma*. Bologna, 1963.

Matthiae, G. *Le chiese di Roma dal IV al X secolo*. Rome, 1962.

Pietri, C. *Roma Cristiana: Recherche sur l'Eglise de Rome, son organisation, son idéologie, de Miltiade à Sixte III (313–440)*. Rome, 1976.

Roma Cristiana. Collection edited by C. Galassi Paluzzi, 6 vols. Rome, 1961.

Toubert, H. *Un Art dirigé: Réforme grégorienne et iconographie*. Paris, 1990.

NOTES

1. C. Pietri, *Roma cristiana* (Rome, 1976), pp. 85ff.

2. P. Hros, *Aurea templa: Recherches sur l'architecture religieuse de Rome à l'époque d'Auguste* (Rome, 1976), p. 125.

3. Ibid., pp. 129–43.

4. E. Mâle, *Rome et ses vieilles églises*, 2d ed. (Rome, 1992), p. 52f.

5. Ibid., p. 93.

6. H. Stierlin, *L'astrologie et le pouvoir* (Paris, 1986), pp. 112f.

7. Ibid.

8. Mâle, *Rome*, pp. 89f.

9. Ibid., p. 213.

10. Cf., e.g., C. Mango, *Architecture byzantine* (Paris, 1993).

11. Mâle, *Rome*, p. 127.

The Imprimerie Nationale
and Caroline Rose
express all their thanks to the Institut de France
for extending their hospitality at the Villa Medici
during Mrs. Rose's visit in Rome.
They would also like to thank Mme Vanda Biffani, Francine
van Hersten, and Igor Gaillet.

LIST OF CHURCHES ILLUSTRATED

(numbers refer to pages)